Mastering the Nikon D300

Darrell Young - Author

Darrell Young (*DigitalDarrell*) is an information technology engineer by trade and has been an avid photographer for over 35 years. He has a rather large family, with his wife and five children, so he has a constantly interesting flow of photographic opportunities. In fact, his entire family uses Nikon cameras to pursue what has become a cohesive family hobby.

Darrell delights in using Nikon's newest digital cameras but if pressed, he will admit to being a "closet" film user too. Living next to the Great Smoky Mountains National Park has given him a real concern for, and interest in, nature photography. Darrell loves to write, as you can see in the Resources area of the Nikonians.org community. He joined the community in the year 2000, and his literary contributions led to his invitation to become a Founding Member of the Nikonians Writers Guild.

Mastering the Nikon D300

Darrell Young

Darrell Young (aka Digital Darrell)

Editor: Gerhard Rossbach
Editor (Nikonians): Tom Boné
Copyeditor: James W. Johnson
Layout and type: Jan Martí, Command Z
Cover design: Helmut Kraus, www.exclam.de
Printer: Friesens Corporation, Altona, Canada
Printed in Canada
Cover photo: Nikon, U.S.A.
Back cover photo: Victor Newman (vfnewman)

1st Edition
© Nikonians.org 2009
Rocky Nook Inc.
26 West Mission Street Ste 3
Santa Barbara, CA 93101-2432

Library of Congress Cataloging-in-Publication Data

Young, Darrell, 1958-
 Mastering the Nikon D300 / Darrell Young. -- 1st ed.
 p. cm.
 ISBN 978-1-933952-34-5 (alk. paper)
 1. Nikon digital cameras--Handbooks, manuals, etc. 2. Single-lens reflex cameras--Handbooks,
manuals, etc. I. Title.
 TR263.N5Y68 2008
 771.3'2--dc22

 2008040080

Distributed by O'Reilly Media
1005 Gravenstein Highway North
Sebastopol, CA 95472

This book is printed on acid-free paper.

Table of Contents

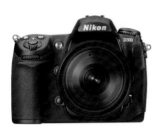

Foreword

Nikonian Darrell Young, known to us for many years as Digital Darrell, has consistently been a source of instructional wisdom delivered with a touch of friendly humor.

His extensive collection of informative and valuable articles can be found on the "Resources" pages of the Nikonians website.

This work represents yet another progression in the rapid growth of our international community of photographers from all walks of life, recently exceeding 140,000 members from nearly 150 countries. It is a way to further confirm Nikonians' vocation in education, introducing books as a new communication channel in addition to Nikonians eBooks, our more than 70 existing interactive forums, The Nikonian eZine, Nikonians Academy workshops, Nikonians newsblog, Nikonians podcasts, etc.

Nikonians has earned a reputation as a friendly, reliable, informative, and passionate Nikon users community thanks in great measure to members like our own Digital Darrell, who have taken the time to share the results of their experiences with Nikon imaging equipment, despite the pressures of their day jobs.

The Nikonians community has long been known as a worldwide home for welcoming Nikon users, and Darrell's specialty is his ability to share his knowledge in the written word, always with the spirit of a friendly uncle talking with you in the comfort of your own living room.

Darrell's easy and friendly approach is appreciated by the increasing number of our community members who have been fortunate enough to acquire the extraordinary Nikon D300 DSLR. The camera is a spectacular piece of highly technical photographic engineering, and Darrell cuts through the technical jargon to help his readers understand not only the camera, but also the wealth of photographic advantages it can deliver thanks to the ingenuity of Nikon Engineering.

We would like to congratulate Darrell for his work on this project. Special thanks goes to Tom Boné, Nikonians Chief Editor, who has streamlined the publication process in this first Nikonians Press book published in association with Rocky Nook.

Bo Stahlbrandt (bgs) and J. Ramón Palacios (jrp)
Nikonians Founders
www.nikonians.org

Preface

I grew up looking at pictures.

Ever since I was a baby my mother took hundreds of photographs of our family life, capturing small pieces of time frozen in little negative squares. Today, I can still look back at those images and they awaken memories that would otherwise be forgotten.

In 1968, my dear Mom gave me my first Brownie Hawkeye camera, and that little camera ignited a fire in me for taking pictures. I remember my mother's words of instruction, "Load the film in a dark place, never open the film door until after you rewind, and keep the sun behind you when you shoot".

From that day forward I often carried a camera with me. I took the fuzzy pictures of a 13-year-old as I hiked up the Roosevelt Mountain in Rockwood, Tennessee, USA, with my brother Steven and a friend named Scott. Every major event of my life has a few frames attached.

As an adult, I began photographing my own family, and to this day I've been documenting the growth of my five children. From my earliest memories, photography has been a part of my life, and I'll keep on shooting as long as I am able.

The year 1980 was a milestone for me; that's when I got my first Nikon camera. It was a nearly new Nikon FM, and I reveled in its incredible build, and the unbelievable images it produced. Before then, I had been shooting with Kodak 110 and 126 cameras, and although those images have priceless personal value, they would win no contests. I graduated from negatives to transparencies in 1981, as I realized that even sharper and less grainy images could be created in those delightful little two-inch squares. I loved film, and shot a lot of it. I wanted to shoot even more, but the cost of raising kids took precedence over the cost of film and processing.

The year 2002 changed everything for me photographically. I had been playing around with a Kodak P&S digital camera, and I finally got a Nikon Coolpix 990. While the pictures were fun and easy to make, they did not equal the quality of my 35mm images, so I viewed digital photography only as a toy. Then Nikon released the 6 MP D100, and Digital Darrell was born. Never before had I shot so many images. With the "free" use of the camera, I took thousands of photographs that I would never have considered taking with expensive film, and thus I moved to a new level of photography in the process. Digital cameras can offer an educational course in photography within themselves.

My love of digital photography grew, as did my relationship with the world's premier Nikon User Community, www.Nikonians.org. I came on board as a charter member in late 2000, and after my D100 arrived I really become involved as a member. I wrote a camera review that J. Ramón Palacios liked, (JRP is one of the co-owners of the Nikonians.org website, along with Bo Stahlbrandt) and he asked me if I'd like to write a few articles for Nikonians.org. At that time, I didn't even know I was a writer! Thank you, JRP!

I practically lived on Nikonians.org, spending hours there each day, first as a moderator, then as founding member of the Nikonian Writer's Guild. JRP asked me to write as often as I could, and he posted my articles for others to read. Wow, did my ego swell!

In 2005, I bought yet another of Nikon's excellent workhorse cameras—the D200. This camera seemed to reflect a direction toward a truly professional build in a smaller bodied camera. It has a high, 10 MP resolution, a weather-sealed frame, and a flexible feature set that includes the ability

to fully use Non-CPU lenses, such as Nikkor AI and AI-S primes. I used this camera on an almost daily basis, as a "carry" camera, since the size was reasonable and the image quality outstanding. Generation Two!

Then in 2007 my photographic world was tremendously enriched. Nikon released a camera that made my eyes pop, and my Nikon Acquisition Syndrome (NAS) become overwhelming. The Nikon D300! This is third-generation 12 MP digital photography! This is the affordable, yet professional-level tool for passionate creativity!

I opened that user's manual of 421 pages and read some of it. "Wow, what a complex camera", I thought. I struggled to understand how the autofocus and other systems worked. All these modes, and banks, and custom settings! Over the next few weeks, as I learned this new and extremely powerful camera inside and out, I began writing chapters of this book, partially to teach myself how to use the complex and very flexible features of the D300, and also to help you master your new D300.

Additional help is available to you at the world's premier Nikon User's Community, Nikonians. org. This truly is an International Community of over 140,000 Nikon users. Talk about a Nikon resource! As a Nikon user, you are probably already a member, but if you are not, please log on to www.Nikonians.org and become at least a Silver member. Nikonians.org is a goldmine of photographic knowledge for Nikon users and is unmatched by any other resource available.

This book is a joint effort to offer a resource to you that will help you understand the complexities of the important, most-used features of Nikon's latest "wonder camera". It's also designed to help you have some fun with your D300.

I feel greatly privileged to be a Nikonian, to have such knowledgeable and friendly associates, and to help provide yet another, much requested resource in the form of a printed book. I hope you enjoy this book and that you greatly benefit from it, and most of all that you find joy in using your chosen photographic tool ... the Nikon D300.

Keep on capturing time ...

Digital Darrell
(Darrell Young)

Using the Nikon D300

Digital imaging changed my photography. For the last six years I've been on a technological and artistic trip that I've come to treasure: Nikon® digital imaging!

I will begin by offering a background perspective introducing both the camera and my own personal viewpoint. Let me reminisce.

Since I was just a kid, I've always enjoyed photography. However, the cost of film processing kept me from shooting nearly as much as I wanted to. Raising a family through the 80s and 90s didn't leave much money for extras.

I've had all sorts of film Nikons, from my first, a Nikon FM (1980) to my last, a Nikon F5 (2004). But, one Nikon changed everything, and my photography hasn't been the same since.

Nikon D100 - Generation 1

I bought my first digital SLR Nikon back in Fall 2002, when I got the *Generation 1* Nikon D100. Man, was that camera cool! All my friends had digital envy when they saw it. I no longer needed film, and I was able to shoot until I was satisfied. It changed my photography forever. Experimentation was now affordable, and I learned a lot from being able to view my images immediately. I discovered that a digital camera could be a short, fast course in improving one's photography.

At the time, I still had wet darkroom equipment, but that was soon gone. I discovered Photoshop, bought a color inkjet printer, upgraded my computer with more memory and a faster video card, and set up a nice digital darkroom. My 6-megapixel D100 could make sharp medium-sized enlargements, which were pretty close to what 35mm film could do.

Soon my hard drives were overflowing with many thousands of digital images. I bought bigger hard drives, and soon filled them up too. My "digital imaging" had just begun!

Nikon D200 – Generation 2

In 2005, my NAS (Nikon Acquisition Syndrome) overcame me and I was one of the first in line for the new Nikon D200, featuring 10.2 megapixels! Nearly double the resolution of my first DSLR.

This camera was even more "professional" in build, with seals and gaskets providing protection like my pro film Nikon F5 had before. The body was bigger and more robust, with an alloy frame, robust shutter, and many more internal controls.

About this time I discovered the Nikon Creative Lighting System (CLS), and loved to use the D200 as a "commander" for my SB-800 and SB-600 flash units. I also got into stock photography about this time, so I started carrying the D200 with me everywhere I went.

I was amazed at how much nicer the 2.5 inch monitor was, with its 230,000 dots of resolution. The images looked so much clearer and warmer on that larger monitor. My D100's tiny LCD screen now seemed a bit obsolete. I eventually gave the D100 to my daughter to replace her point & shoot digital.

The images from the D200 were more efficient too. I could make big enlargements now without too much trouble and felt that they were giving me a better look than 35mm film.

Being somewhat of a techno-geek, all this luxurious camera technology was also helping me enjoy my photography. When I wasn't out taking images, I could play with the camera, scroll through the menus, and think about taking pictures.

I wanted even more, and Nikon answered. I bought a Nikon D2X pro-level DSLR camera. Wow! This D2X is like driving a Porsche. "I'll never need another camera," I thought to myself. I never expected what came next.

Nikon D300 – Generation 3

When the D300 hit the market, I thought, "Well, this is a nice camera, but with my D200 and D2X, I probably don't need one." With the help of Nikonians.org contacts and the support of Nikon's USA press relations organization, I was given the opportunity to field-test a D300. I used this experience to write some of the detailed "menu" sections of this book. It seemed like a desirable camera, although a bit complex, as it sat there next to my computer as a reference device for chapter creation.

In fact, the D300 was so complex that I didn't have enough time with it to write a detailed book. So, I figured I'd just go ahead and buy one to complete the book. After it was done, I could always give the D300 to my wife as a present, right? It didn't quite work out that way!

In April, I decided to take a little trip with my family to Hunting Island, South Carolina, a beautiful coastal island with a 5-mile white sand beach bathed in Atlantic Ocean sunrises. I fully intended to use my Nikon D2X to shoot a lot of great travel stock images, and maybe grab a few frames with the D300.

The first day out, I was on the beach at 6:30 a.m. with the D2X on a tripod waiting for the sunrise. I carried the D300 over my shoulder just in case I wanted to take some handheld shots. The sun came up in all its orange glory and I shot some great images with my D2X. Since it was on a tripod, and had an 80-400mm lens on it, I couldn't use it for much more, so I started shooting with the D300.

I took a few pictures and thought how smooth the shutter sounded. The images on that 3-inch monitor looked like actual pictures. I was shooting some really beautiful shots, and enjoying it. I can't explain how exactly, but the D300 "felt different" from my D200. Something about it just felt more professional, smoother and faster. I hate to admit it, but by the end of a couple of hours of walking around with the D300, I was head over heels in love with the camera. Why? Look at this image *(Figure 1)*, for instance:

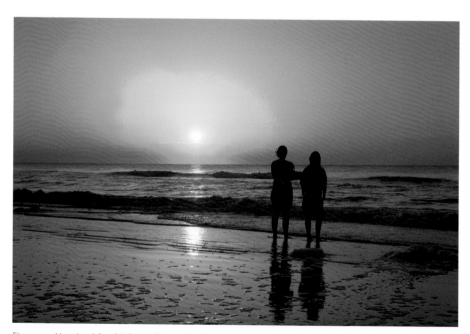

Figure 1 – Hunting Island Atlantic Ocean Sunrise

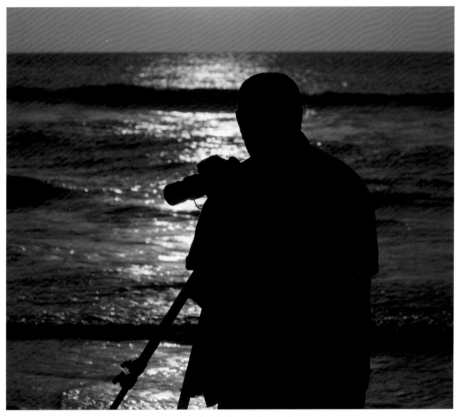

Figure 2 – Photographer Watches a Hunting Island Atlantic Ocean Sunrise

I was taking pictures that curled my eyelashes! I was walking around with this camera taking images that were so captivating, I couldn't believe what I was seeing. I was using Nikon's latest technology and my eyes to create some of the best images of my life.

That 3-inch 920,000 dot LCD monitor was simply amazing. I could see my images in great detail by zooming all the way in past the 100% pixel-peeping level.

The sensor, at 12.3 megapixels captures twice the resolution of the D100 I started with back in 2002. In printing, I've found that the D300 meets or exceeds anything I've done with my film medium-format cameras. Way better than 35mm film!

It kind of makes me sad to admit this to you, but my D2X has now become a backup camera body for my D300. I barely used the D2X for the rest of that trip, and I came back with over 1500 absolutely premium images of the island. Since then, the camera has literally gone everywhere I go. People have become accustomed to "Darrell with his Nikon." I just smile, and take their picture.

This D300 is absolutely a stock shooter's dream machine. The body size is not too small, nor too large. It feels well balanced in my hand, and shoots with a smoothness that has lit a new fire in my blood for imaging.

In fact, the image in *Figure 2* expresses a certain emotion that a picture can say better than words. Have you ever felt this way?

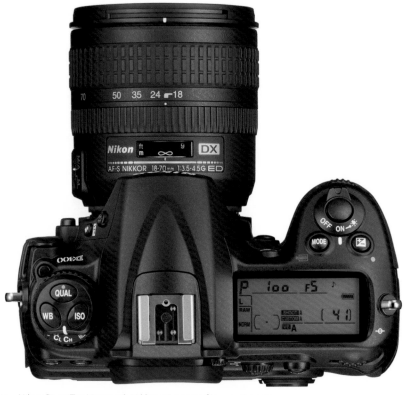

Figure 3 – Nikon D300 Top View with Nikkor 18-70mm f/3.5-4.5G Lens

Instead of simply reviewing the D300, I'd like to discuss only the new things I've found. These things are interesting for people who enjoy camera technology. *Figure 3* shows my favorite view of a D300.

One thing I'd like to mention before I go into the new features is something that might sound a little weird to some, but speaks to why I now use the D300 over the D2X most of the time. The D300 is basically a miniaturized D2X, for the following reasons:

1. It has the same type of CMOS DX sensor, with the same basic resolution.

2. The D2X shoots natively at 5-frames per second, while the D300 does 6-frames per second. (or 8-frames per second with the MB-D10 Battery pack).

3. The shutter has been tested out to the same number of actuations as the D2X (150,000).

4. It has the same types of seals and gaskets protecting it from the weather.

5. It has even more color depth with 12-bit (like the D2X) or 14-bit.

6. It has a 100% viewfinder, like the D2X.

7. It has virtually all the functionality of the D2X in a smaller body, similar to the professional film Nikon F6.

My conclusion is that the D300 is like a small D2X. In fact, it has deeper color depth, more powerful autofocus, better metering, a much better monitor, a wider ISO range, and tremendously better image-noise control. The D300 is, in many ways, better than the D2X. It has become my "carry" camera of choice. It truly is a near-professional camera! Now, let's look at some of my favorite new features in the D300.

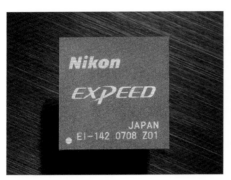

Figure 4 – Nikon D300 EXPEED Image Processor

Figure 5 – Sony 12.3 Megapixel CMOS Sensor

EXPEED Image Processor

The EXPEED microprocessor found in the D300 is a new invention for Nikon's newest DSLRs (*Figure 4*). Not only does it compress and transmit the RAW image data, but it also performs noise-reduction, dynamic-range, and color-algorithm adjustments on stored JPEGs.

The EXPEED does what it implies, by moving data off the sensor chip with "extra speed." The D300 needs that speed because, not only can it shoot in the normal 12-bit color depth that other cameras use, but it also has a 14-bit mode that captures sixty-four times the color information.

Plus, the name sounds extra cool. Most of the major camera brands are creating names like this. For instance there's Sony's Bionz, Canon's Digic, or Pentax's PRIME image processors. Being that I am a Nikon guy, I favor the name EXPEED...don't you?

12.3 Megapixel DX CMOS Sensor

A major factor in the D300's excellent image quality is the new Sony 12.3 effective megapixel CMOS sensor. It captures RAW data with up to 14-bits of color for each of the red, green, and blue channels. Most other DSLRs in this class only capture at 12 bits per channel. This gives the D300 an advantage in reproducing finer color gradations, better shadow details, and a wider dynamic range. *Figure 5* shows the sensor used in the D300.

The D300's 12+ megapixels gives me an image file that is sharp and colorful enough to make enlargements out in the 16x20 inch range and larger. This used to be the sole territory of medium-format film cameras.

With this level of resolution, the camera will not become immediately obsolete when another camera arrives on the scene. Like with 35mm film of old, this image size has enough resolution to cover the greatest majority of reasons to take a picture. Even if a newer camera comes out with higher resolution later (or sensor size like the new Nikon D700) the D300 will remain useful for many years.

6 or 8 Frames per Second

If you are an action, sports, or wildlife shooter, you can now use a smaller body and still get the high speed frame-rates you need to capture fast-moving subjects. If shutter speeds are high enough, the D300 shoots at 6 frames per second with only a single EN-EL3e battery. The MB-D10 Battery Pack adds a little extra amperage flow capacity and allows the camera to jump up to 8 frames per second. I just went to YouTube.com and searched on "Nikon D300 Shutter" and found several videos that allow one to hear the sound of a Nikon D300 firing at 8 frames per second. If you don't have a D300 yet, or an MB-D10 Battery Pack, check out the videos. It's impressive!

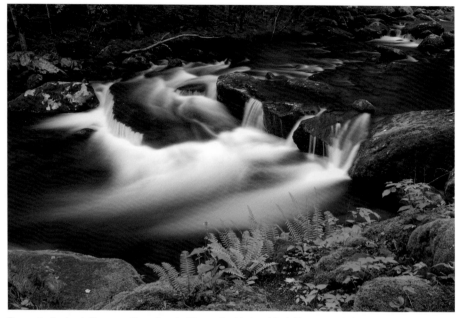

Figure 6 – Spring in Tremont, Great Smoky Mountains National Park, Tennessee, USA at 100 ISO

If you have an 8 or 16 gigabyte (or higher) compact flash memory card, you can hold hundreds or even thousands of images on one card. The D300 is plenty fast, and your card will hold the results. Try it out for yourself.

More on Bits and Memory

The above information is only true in 12-bit RGB mode. If you switch your camera to 14-bit RAW mode, the maximum frame rate drops to 2.5 frames per second, since the EXPEED processor is forced to move four times more data (4096 levels per RGB channel compared to 16384 levels per channel). You can set the 12/14-bit depth under the *Shooting Menu* using the *NEF (RAW) recording* selection.

Noise Control

If you are just now entering the digital world, think of "noise" as the digital equivalent of the "grain" you worked with in film, but this time with the addition of some really ugly extra color speckles here and there.

However, when I'm shooting stock photos I want noiseless images if I can get them. When I look at a beautiful nature scene, my eyes don't see a bunch of noise floating around in that deep blue sky, so I don't want my images to have any noise either!

So far, I've found that the D300 controls noise very well when I shoot JPEGs and let the EXPEED processor do its adjustments. The other day, I was shooting images in an indoor auditorium. The speaker was half a football field away from me, so I was using a 400mm Vibration Reduction (VR) lens. I was not allowed to use a tripod, so I had to rely on the VR to help me keep the images sharp. Under the available light, I had to crank the ISO up to 3200 to get enough shutter speed to successfully capture the image. I took several frames, and they seemed awfully nice looking on my little camera monitor. Later at home, I pulled them up on the computer screen, and let me tell you, I was simply amazed. I've never seen an ISO 3200 image look this good before. I was used to seeing my D2X images at that ISO, and there is no comparison. I mean that. The D300 images at ISO 3200 were

somewhat noisy, but the noise didn't impact the edges of the color changes the way I was used to. Sharpness didn't seem degraded at all. I normally don't shoot at high ISOs like that, but the circumstances required it, and I was able to come away with some reasonably clear images.

When I'm out shooting nature, I often take the D300's ISO below the normal 200, to the L 1 setting, which is approximately ISO 100. I had grown used to my D2X images at ISO 100, which makes noiseless images at low ISO. When I saw the D300 images at the same ISO 100 setting, I realized that it was very much the same as the D2X. There is virtually no noise in a D300 image at ISO 100. The only words that can describe the images are smooth and colorful. I shoot stock mostly at ISO L 1, and have had excellent results. Here, in *Figure 6*, is an image shot at ISO 100 in the Tremont area of Great Smoky Mountains National Park in May.

This image has excellent dynamic range and detail in the shadows and highlights, and virtually no noise.

Live View

At first I didn't see any point to Live View, but after using the camera for a while, I've found distinct uses for it. My favorite way to use Live View (where you see the image using the Monitor LCD instead of the normal viewfinder) is while shooting macro images.

I was shooting a Pipevine Swallowtail (Battus philenor) Butterfly on a tree in Great Smoky Mountains National Park. I had the D300 on a tripod, using an older AI-Nikkor 200mm f/4 manual focus lens, on a bellows, to do larger than life-sized macro. I was using my normal viewfinder, when I suddenly realized that this would be a lot easier if I could stand back a little bit. I turned on Live View mode and was amazed at how easy macro shots were when I was not hovering over the camera so closely. Here is the result of that shoot taken while using Live View mode (*Figure 7*).

For this type of shot, I was able to focus in *Live View* very accurately, and I think I'll find other ways to use it.

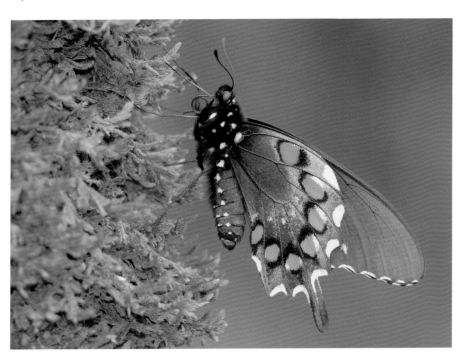

Figure 7 - Pipevine Swallowtail (*Battus philenor*) Butterfly in Macro

3-Inch Monitor

This is one of the reasons that I started using the D300 over my D2X. I made some images on the D2X, and they looked okay on the monitor. I shot similar images on the D300 and realized that I could see more detail on the screen.

The D2X has a 235,000 dot screen resolution, while the D300 has 920,000 dots. That's nearly 4 times more resolution! In fact, the little monitor on your D300 is roughly the tiny equivalent of an XGA resolution computer monitor (1152X768). The color saturation and contrast is great too. What you see on your camera monitor is pretty much what you'll see on your big monitor later at home.

This has allowed me to be more aggressive in deleting files. I was used to shooting a huge number of images so that I could weed through them later to find the best ones. The monitors on previous cameras just didn't have enough resolution to show tiny flaws in the images. With this new XGA-level resolution, I can see very clearly when an image has a problem, delete it immediately, and then re-shoot it. I find that I'm now often deleting over half of the images I normally would have taken home with me and stored on my overloaded hard drives. The images I do keep are higher quality, since I've been able to validate them in the field.

Fine-tuning

In previous cameras, you'd often heard of people complaining how this lens or that lens had back focus issues on their camera. Or, someone would complain that they felt that their meter underexposed or overexposed, so they kept 1/3 stop of compensation dialed in all the time.

The Nikon D300 solves this issue. Later in this book, you'll read about how to fine-tune your light meters, your autofocus, and other parts of the camera. If you have an obsessive personality like I do, you'll probably enjoy fine-tuning your D300. Add that to the ability your camera gives you to remap buttons, and you can make the D300 into a very "personal" shooting device.

Sensor Dust Cleaning

The D300 has a high-frequency "ultrasonic" vibration dust removal system. The camera wiggles the low-pass filter in front of the sensor at a very high frequency to dislodge dust particles. Many people don't realize that the sensor itself is not exposed to dust. It is covered by the filter, which gets dusty over time. A dust-removal vibration system is expected in cameras these days.

Let me quote Nikon's website:

"Dynamic integrated dust reduction system: Self-cleaning ultrasonic sensor unit minimizes degradation of image quality due to dust particles."

Sounds good to me, and it seems to work pretty well, too!

In addition to the vibration cycle, the filter is coated with a Tin Oxide coating that is anti-static in nature and helps prevent dust from sticking to your sensor.

I've read articles that claim that this is not particularly effective in some cameras. All I can say is that since I've had my D300 I've only seen one dust spot on a series of pictures. I had just come back from the beach, and expected to find lots of sandy dust on my sensor. However, I only found that one tiny spot.

I immediately fired up the vibrating dust removal system and then made some test shots. The dust spot was gone. That's been my total experience with dust and the D300. Since that time, I have my D300 set to clean the sensor on startup and shutdown.

I don't like dust! You probably don't like it either. Good thing we bought a D300, huh?

Picture Control

Under the Shooting Menu you'll find the Set Picture Control selection. We'll cover this in detail later in this book, but for now I wanted to mention it, since I think it is quite clever.

There are four settings in Set Picture Control:

1. *Standard*
2. *Neutral*
3. *Vivid*
4. *Monochrome*

These settings each give you a different look to your image. I shoot in Neutral most of the time, because I find that it gives me a little lower contrast and some extra dynamic range.

Since I will cover this later, let me just make a comparison here. If you want your camera to emulate certain famous films of old, here are my opinions about what these modes do for you:

1. **Standard** - Quite similar to *Fuji Provia*, with its mildly saturated colors and reasonable contrast.
2. **Neutral** – Very similar look to *Fuji NPS* or *Kodak Portra* film. Lower color saturation, lower contrast.
3. **Vivid** – I bet you couldn't guess that I was going to mention *Fuji Velvia* here. This mode gives you intense colors that really pop scenics, flowers, and anything that needs high-contrast color saturation. The contrast is quite high, which means that shadow detail suffers. But, you get some very satisfying blacks from this mode, that when set side-by-side with intense color, really make powerful nature scenes. This will also help when you are shooting on a very low contrast overcast day and want to add some snap to your images.
4. **Monochrome** – You can select from normal Black & White (*B&W*), or use the toning control to set any one of seven tints available for *Sepia* (warm-golden), *Cyanotype* (cool-bluish), *Red, Yellow, Green, Blue Green, Blue, Purple Blue,* and *Red Purple*. Each of the tints allows you to fine-tune the saturation of the tint, from mild to heavy.

With the D300's *Set Picture Control*, you can control the look of your images in a way not possible with many other cameras.

Active D-Lighting

If you've worked with Nikon Capture NX, you are probably familiar with the D-Lighting system. If you aren't, then let me tell you about what the camera can do.

When I am shooting JPEGs, I'll usually have the *Normal* setting enabled. What this does is try to extend the dynamic range of an image, so that the shadows retain detail, and the highlights don't "blow out."

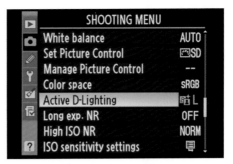

D-Lighting in the D300 does two things:
1. Controls shadow detail
2. Controls highlight detail

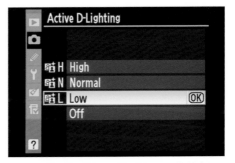

There are three settings under the *Active D-Lighting* section of the *Shooting Menu*:
1. *High*
2. *Normal*
3. *Low*

It actually works pretty well. I find that the camera retains highlight detail better than without it, which gives me more control. I can push my histogram closer to the right edge without losing my highlights. It also tends to lower the contrast in the image by bringing out detail in the darker areas. Amazingly, it does this quite well without adding a lot of noise in the process. This EXPEED Image Processor is quite powerful, and is a foreshadowing of things to come in the future.

How would you like a camera that will allow you to shoot 12 stops of light range, which is enough to cover the detail in shadow and highlights on a sunny day? From my own unscientific experimentation, I believe that the D300 gives me at least seven stops of range in most instances.

51-Point Auto Focus

The D2X and D200 both have 11 autofocus points. The D300 gives you 51, which allows you to move the little active AF point all over the place in your viewfinder. I find that it allows me more flexibility in finding just the point I want to meter, or focus on.

With so many points it takes longer to get your AF point onto the subject with your D300's *Multi selector*. If you want you can make the D300 use 11 points instead, so that it acts like your previous Nikon.

When using the D300's *Dynamic area AF* mode, the abundance of AF points allows the D300 to more accurately track a moving subject. In fact, I've found it amazing how stubbornly the D300 will hang onto a bird flying through the air, for instance. I guess I shouldn't be amazed though, since the D300 is using the 51 AF points and the color of the subject to track it.

12-Bit or 14-Bit Color Depth

Up to now, our Nikon DSLRs have used a 12-bit color depth to contain the red, green, and blue colors of the subject (RGB). Twelve bits allows

us to have 4096 levels of color for each of the three color channels in our image. That means that there can be 4096 levels of red, 4096 levels of green, and 4096 levels of blue.

Once you switch the camera to 14-bit mode in *NEF (RAW) recording* on the *Shooting Menu*, your D300 will now record four times more data in each color channel, or 16384 levels for each of the Red, Green, and Blue channels. That will necessarily do two things:

1. Slow the frame rate of the camera significantly, since it is processing 64 times more data.

2. Make the image's file size increase, since each image has 64 times more color information.

What do you gain from shooting in 14-bit mode? Better images, mainly. You won't see a tremendous difference in normal images. However, the image can contain finer color gradations, better shadow details, and a wider dynamic range, since there is significantly more color data being stored for each channel.

Even if some of today's software can't fully take advantage of the additional color levels, maybe improved software in the future will. I'd much rather have the 14-bits of data, than the 12-bits of data for my type of shooting.

Color Data and Frame Rates

Just remember that the camera's frame-rate will be impacted by all that extra color data. It might not be an efficient choice if you shoot sports or extreme action, since the camera's frame rate will be affected significantly, dropping from 6 frames per second to 2.5 frames per second.

Lossless Compressed NEF (RAW)

NEF or RAW files can be quite large, since they contain all the available information about the image in a 12- or 14-bit file.

There has been much discussion about whether the previous version of NEF image file

compression caused a loss of quality, or not. Nikon called it "visually lossless," since you weren't supposed to be able to see the difference between an image shot as a compressed file and one shot as an uncompressed file. However, some have claimed that highlight detail was affected somewhat by the compression.

Nikon solved that problem completely, by offering the normal *Compressed, Uncompressed*, and a completely new *Lossless compressed* selection under the *Shooting Menu's NEF (RAW) recording* "type" selection.

The new lossless compression does not compress the image as much as normal compression, but it does so in a lossless way, similar to the way a ZIP file works in your computer. Now you can compress your images without worry about mildly damaging your image details. Here are the two types of compression, and their file size reduction percentages:

1. **Lossless compressed** – Images are compressed with a "non-reversible" algorithm. The file size of the image is reduced by 20-40% with no effect on image quality.
2. **Compressed** - Images are compressed with a "reversible" algorithm. The file size of the image is reduced by 40-55% with almost no effect on image quality.
3. **Uncompressed** – Images are not compressed. I leave my D300 set to *Lossless compressed* all the time. If there is no effect at all on image quality, why store larger files for no good reason?

Exposure Delay Mode

The D300 has a Mirror Up mode *(MUP)* that allows you to raise the mirror with the first shutter release press, then take a picture with the second press. This allows you to use a tripod, raise the mirror, wait for vibrations to die down, then fire the shutter. Significantly sharper images can be the result.

The D300 also has an *Exposure delay mode* that allows you to raise your mirror between

shots, like with MUP mode, but only requires a single shutter button press, instead of two.

In the D200 and D2X, the mirror delay was ½ second. So you could frame your subject, press the shutter release, the mirror would raise, and ½ second later the shutter would fire. Many have felt that ½ second wasn't long enough for vibrations to die down fully, so Nikon increased the delay to 1 full second on the D300.

One second should give vibrations time to dissipate before the shutter fires. This is not adjustable, and always defaults to one second. *Custom Setting d9* turns *Exposure delay mode* on and off.

Retouch Menu

Retouch Menu allows people who do not like working on a computer, or who find themselves in the field where a computer is not available, to "manipulate" or post-process their images.

This is discussed in detail in **Chapter 8** of this book. For now, just be aware that you can do many in-camera adjustments that used to require a computer. You can "retouch" your images as soon as you take them, and the camera creates a completely new image with the results. The new image is saved to your memory card with the next available image number in the series of images on your card. Your original image is not changed in any way.

Here is a list of actions you can perform through the the *Retouch Menu*:

- D-Lighting
- Red-eye correction
- Image trimming (cropping)
- Conversion to monochrome
- Applying filter effects
- Modifying the color balance
- Overlaying two images

So, if you are in the wilds of the Serengeti plains of Africa and want to do a little post processing, your D300, with its crisp XGA resolution monitor, will be happy to let you have at it.

My Menu

My Menu allows you to take your most-used functions of your camera menus and put them in one place. You can then quickly go set those menu items without having to scroll around the hundreds of menus and screens in the D300.

My Menu is your menu!

100% Viewfinder Frame

This is one of the marks of a true near-professional camera. When you look into the viewfinder, you expect that the image you see is what you'll get later in the computer.

Unfortunately, on lesser cameras, the viewfinder is often only 95% or less of the actual image you'll capture. That can be aggravating, since you might pick up something on the edge of your image that the viewfinder doesn't even show you. Not with the D300, though. Like other professional cameras such as the F5, F6, D2X, and D3, your D300 has a cool 100% viewfinder.

What you see, is what you get!

Rubber Covers Instead of Lost Screw-On Caps

I have re-purchased so many of those little screw-on port caps over the years, that I could buy a new camera with the amount I've paid. After a while, I just unscrewed the little caps and tossed them in a dresser drawer, because within 10 seconds of taking one off in the field, it mysteriously beams up to the mother ship.

I've bought piles of them for about $4 USD on eBay, plus about $10 for shipping. But no more! Nikon has wisely given us cool rubber caps that are attached to the body. If you hate caps of any type, just snip them off. I use them, since they don't get lost, and are easy to open and close. I figure they may protect my camera from moisture and dirt, so I'll continue to use them. Thank you for the rubber caps, Nikon!

HDMI Device Port

Remember back when we used to have slide shows? You'd invite your family and friends over to look at projected slides from times when everyone was still young and slim.

You've probably been shooting digitally for several years now, and have hundreds of pictures. You might have wanted to do an old-fashioned slide show, but didn't want to invest in an expensive digital projector. Nikon comes to the rescue!

The D300 can be hooked up directly to your HD television, or other high-definition video device. The new HDMI port under the rubber flap on the side of your D300, along with the included EG-D100 video cable (in your D300 box), allows you to connect your camera to your TV or VCR. A later chapter will go into more detail about this new capability.

Now you can use your large screen HD TV to do a new-fashioned slide show, with old-fashioned style. So, buy some popcorn and pizza, then invite the friends over for some slide viewing fun. Be sure to take some more pictures!

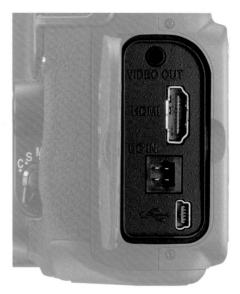

Figure 8 – HDMI Device Port

My Conclusions

Well, we have come to the end of the first chapter in your new *Mastering the Nikon D300* book.

I want to thank you for purchasing this book, and I invite you to contact me with any questions or comments you might have.

http://www.YoungImaging.com/D300

Also, I hope that you, as a Nikon user, will join Nikonians.org, the world's premier Nikon User Community. Here you will meet over 130,000 fellow Nikon users, and will be able to join in community discussions about nearly anything Nikon. See this webpage for a tour of Nikonians. org and information on how to become a Nikonian:

http://www.Nikonians.org/tour1.html

The next 8 chapters of this book will give you a very detailed and personal look at each menu in the Nikon D300, as well as virtually every screen in the camera. When you use this book, always have your D300 within reach, so that you can immediately apply the things you are reading. If you do that, they'll stick with you longer. Also, keep your "EN" User's Manual close, since I give page numbers for extra reference points.

The Nikon D300 is a very complex camera. It is also my favorite Nikon DSLR by far. If you'll take the time to learn about the most needed features for your style of photography, the camera will become a tool that allows you to truly bring passion to your photography. I know it did to mine!

Keep on capturing time ...

Darrell Young

Exposure Metering, Exposure Modes, and Histogram

My first Nikon was an FM back in about 1980. It used a basic center-weighted meter, and everything else was completely manual. In a way, I miss those simple days of old.

I became a proponent of digital SLRs back in August of 2002 when I bought my first serious DSLR, the Nikon D100. I left the film world in a hurry and never looked back. I rejoiced so much in Nikon digital imaging that I gained the nickname of *Digital Darrell* in the Nikonians.org community. Later, I bought a D200 and my rejoicing became even more exuberant.

Fast-forward a few years and I now find myself with the most accurate and powerful DSLR I've ever owned. Yep, it's the same one you have, the Nikon D300. I also own a Nikon D2X, but recently it stays in the camera bag as a backup to my D300. Yes, the D300 is that good!

The images from the D300 are simply superb thanks to the flexible exposure metering systems, exposure modes, and histogram capabilities.

Figure 1- Wide view: Metering selector set to Matrix

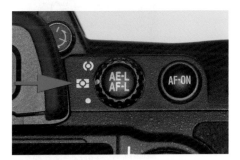

Figure 2– Close up: Metering selector set to Matrix

Metering Systems

The basis for the Nikon D300's exposure meter is a 1005-segment RGB sensor that meters a wide area of the frame. When used with a G or D Nikkor lens containing a CPU, the camera can set exposure based on the distribution of brightness, color, distance, and composition. Most people leave their D300's set to Matrix metering, and enjoy excellent results. Let's look more closely at each of the Nikon D300's exposure meters.

The meter selector is conveniently located on the back of your D300.

Figure 1 shows the exposure *metering selector* control set to *Matrix* mode. You can turn the small ring surrounding the AE-L/AF-L button to one of the three settings. The top setting is *Center-weighted metering* mode, the middle is *Matrix metering* mode, and the bottom is *Spot metering* mode.

(See pages 102-103 in the D300 User's Manual)

3D Color Matrix II Meter

The Nikon D300's Matrix metering mode is actually the *3D Color Matrix II* metering system, one of the most powerful and accurate automatic exposure meters in any camera today *(Figure 2)*.

There are characteristics for many thousands of images stored in the camera. These characteristics are used (along with proprietary Nikon software and complex evaluative computations) to analyze the image appearing in your viewfinder. The meter is then set to provide very accurate exposures for the large majority of your images.

A simple example of this might be a picture where the horizon runs through the middle of the image. The sky above is bright, and the earth below is much dimmer. By evaluating this image, and comparing it to hundreds of like images in the camera's database, a meter setting is automatically set for you.

The meter examines four critical areas of each picture. It compares the levels of *brightness* in various parts of the scene to determine the total range of EV values. It then notices the *color* of the subject and surroundings. If you are using a G or D CPU lens, it also determines how far away your lens is focused so that it can tell the *distance* to your subject. Finally, it looks at the *compositional* elements of the subject.

Once it has all that information, it compares your image to tens of thousands of image characteristics in its image database, makes complex evaluations, and comes up with a meter value that is usually right on the money, even in complex lighting situations.

However, I'd like to qualify that with the following considerations.

Fine Tuning Matrix Metering

Like all digital cameras, the Nikon D300 tends to be a bit conservative when light values get too bright. If the D300 encounters a situation where the light values exceed the range of the sensor, it will tend to expose for the highlights and let the darker areas of the image lose detail. We'll talk more about this in the Histogram section of this chapter. In all cases, it tries to keep the bright values from "blowing out" by preventing the meter from fully approaching pure white with no detail. In my experience, the D300 tries to keep the exposure from 1/3 to 1/2 stop below the maximum white value.

Fortunately, Nikon has given us a way to fine tune the *Matrix meter* to closely match our type of shooting. As a stock shooter for Photoshelter.com, I'm always concerned about shooting images as noise free as possible. Because of that fact I generally try to expose as close to the maximum brightness I can get without completely blowing out the highlights. Underexposure means noise so I tend toward the highlight or bright edge of normal exposure

to keep noise under control. I've found that running my D300 about ½ stop over what the *Matrix meter* suggests gives me images that have no serious blowout and very little noise. From time to time I have a little problem with white subjects, but generally I do well a half stop over.

If you want to experiment with fine tuning your *Matrix meter* to see what you can get away with, please refer to **Chapter 6 – Custom Setting Banks**, and see the section entitled *Custom setting b6 – Fine tune optimal exposure*. This setting allows you to fine tune each of the exposure meters individually in 1/6th stops. I leave my D300 set to 3/6 stops over exposure, which equals a half-stop. Don't be afraid to experiment with your D300, since you can always change your fine-tuning back to zero.

You might find that ½ stop is too much for your liking or that you don't need any compensation at all. The point is that you are not limited with this camera. You can use the *Matrix meter* with factory settings or fine tune endlessly.

Using Flash with Matrix Metering

When you are using flash with matrix metering, you might find that the D300 is especially conservative. I have used the built-in pop-up speedlight, an SB-600, and an SB-800 with my camera, and it consistently underexposes by about 1/3 stop in Matrix metering.

To overcome this perceived tendency in my D300, I have reprogrammed my D300's FUNC button to activate the *Spot meter* while I hold the button down (*see Custom setting f4 – Assign FUNC* button). With this adjustment, I find that a good spot-reading directly off my subject gives me nearly perfect exposures using flash.

Center-Weighted Meter

If you're a bit old-fashioned and were raised on a classic center-weighted meter, and still prefer that type, the D300's exposure meter can be transformed into a flexible center-weighted meter with a variable sized weighting that you can control *(Figure 3)*.

The *Center-weighted* meter in the D300 meters the entire frame, but concentrates most of the metering into an 8mm circle in the middle of the frame. If you'd like, you can make the circle as small as 6mm or as large as 13mm. Let's examine the *Center-weighted* meter more closely.

Using *Custom Setting b5*, you can change the size of the circle where the D300 concentrates the meter reading (see *Chapter 6 – Custom Setting Banks*). If you'd like, you can even completely eliminate the circle and use the entire viewfinder frame as a basic averaging meter.

As mentioned previously, the circle is normally 8mm in size in your viewfinder. However, by using *Custom Setting b5* you can adjust this size to one of the following:

1. 6mm (.24 inch)
2. 8mm (.32 inch)
3. 10mm (.39 inch)
4. 13mm (.51 inch)
5. Avg – Entire Frame

The *Center-weighted* meter is a pretty simple concept. The part of your subject that's in the center of your D300's viewfinder influences the meter more than the edges of the frame.

Where's the Circle?

You can't see any indication of a circle in the viewfinder, so you'll have to imagine one.

Here's how *(Figure 3A)*: Locate your current AF sensor in the middle of your viewfinder. The

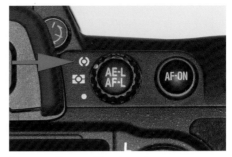

Figure 3 – Close up: Metering selector set to Center-weighted

length of the little rectangle you see is about 2.5mm (.10 inch) in size. If you imagine about three of these little rectangles side-by-side, that's about the same size as the default 8mm circle, which at .32 inches is about 1/3 of an inch. The 13mm maximum size circle, at .51 inches, is about 1/2 inch wide.

Primarily, just remember that the center area of the viewfinder provides the most important metering area, and you'll do fine. For information on fine tuning *Center-weighted metering, see Custom Setting b6 – Fine tune optimal exposure* in Chapter 6 of this book.

What About the Averaging Meter?

If you set your meter to "Avg" in *Custom setting b5* (fully averaging), the entire viewfinder's light values are averaged to arrive at an exposure value. No particular area of the frame is assigned any greater importance. The exposure value is an average of the light values in the entire frame *(see Figure 3A, screen 5)*.

This is a little bit like matrix metering, but without the extra smarts. In fact, on several test subjects, I got remarkably similar meter readings between Avg and Matrix. Matrix should

 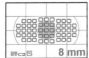 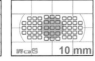 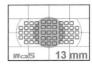 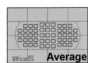

Figure 3A – Series of imaginary red circles on the viewfinder, and averaging full frame

do better in difficult lighting situations, since it draws on a database of image characteristics to compare with your current image, and it looks at color, distance, and where your subject is located in the frame.

Spot Meter

Sometimes no other meter but a spot meter will do. In situations where you must get an accurate exposure for a very small section of the frame, or must get several meter readings from different small areas, the D300 can, once again, be adjusted to fit your needs (*Figure 4*).

The D300's *Spot meter* consists of a 3mm circle surrounding the currently active auto focus (AF) point. That's evaluating only 2% of the frame, so it is indeed a "spot" meter. Since the spot is surrounding the currently active AF point, you can move the spot meter around the viewfinder within the 51 AF points (*Figure 4A*).

How big is the 3mm spot? Well, the spot meter barely surrounds the little AF point rectangle in your viewfinder. It is rather small at .11 inches. When your D300 is in *Spot meter* mode, and you move the AF point to some small section of your subject, you can rest assured that you're getting a true spot reading.

In fact, you can use your spot meter to determine an approximate EV range of light values in the entire image. You can do this by metering the lightest spot in the frame, and the darkest spot. If this value exceeds a 4 or 5 stop difference, you've got to decide which part of your subject is most important to you, and meter only for it. Something is going to "blow out."

On an overcast day, you can usually get by with no compensation since the range of light values are often within the recording capability of the sensor. On a bright sunny day the range of light exceeds what your sensor can record by as much as two times. This range can often be as much as 12 stops total, while your sensor can only record a maximum of 6 or 7 stops!

Don't let the numbers make you nervous. Just remember that spot metering is often a

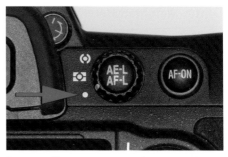

Figure 4 – Close up: Metering selector set to Spot meter

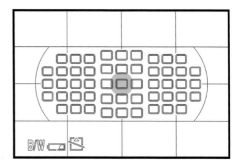

Figure 4A – Viewfinder view of the 3mm spot

trade-off. You trade the highly specific ability to ensure a certain portion of an image is "spot-on" for the ability of the camera's multiple "averaging" skills to generally get the correct exposure throughout the frame. The choice is yours, depending on the shooting situation.

If you spot-meter a person's face standing in the sun, the shadows around that person will contain little or no data. The shadows will often come out as solid black in the final image. On the other hand, if you spot meter for the shadows instead, the person's face is likely to "blow out" to solid white. We'll discuss this in more detail later in this chapter, when we explore the Histogram.

Use your spot meter to get specific meter readings of small areas on and around your subject, make some exposure decisions yourself, and your subject should be well exposed. Just remember that the spot meter evaluates only for the small area that it sees, so it cannot adjust the camera for anything except that one tiny

area. Spot metering requires some practice to learn, but it is a powerful tool to balance exposure values in your images.

For information on fine tuning *Spot metering, see Custom Setting b6 – Fine tune optimal exposure* in Chapter 6 of this book.

Exposure Modes

(See pages 104-113 in the D300 User's Manual)
I mentioned my old Nikon FM in the beginning of this chapter. I remember that camera with fondness, since that was when I got really serious about photography. It's hard for me to imagine that it has already been nearly 30 years since I last used my FM! Things were simpler back then. Now that I think about it, I remember my grandma saying something similar about her Brownie Hawkeye.

When I say simple, I mean that the FM had a basic center-weighted light meter, a manual exposure dial, and manual aperture settings. I had to decide how to create the image in all aspects. It was a camera with only one mode – "M" or manual.

Later on, I bought a Nikon FE, and was amazed to use its "A" mode, or Aperture Priority. I could set the aperture manually and the camera would adjust the shutter speed for me. Luxury! The FE had two modes: M-Manual, and A-Aperture Priority.

A few more years went by, and I bought a Nikon F4. This camera was loaded with features, and was much more complex. It had four different modes, including the two I was used to, M & A, and two new modes, S-Shutter Priority, and P-Programmed auto. I had to learn even more stuff! The F4 was my first P,S,A,M camera.

This progression leads us to the D300.

The point is that today's cameras are amazingly complex compared to cameras only a few years ago. In fact, the D300 is probably the most complex camera I've ever used! Let's examine how we can use that complexity and express it as flexibility for our benefit. The D300 is also a P,S,A,M camera, which is the abbreviated progression of modes. We'll look at those modes next.

There are two controls that you must use together to set the various modes on the camera: The *MODE* button and the *Main command* dial.

Hold the *MODE* button down with your shutter-release finger, and use your thumb to rotate the *Main command* dial. You'll notice in the upper left corner of the Control Panel LCD that the mode (P,S,A, or M) scrolls as you turn the command dial *(see Figure 5)*.

Now, let's discuss each exposure mode in detail.

P - Programmed Auto Mode

Programmed auto mode (P) is designed for those times that you just want to shoot pictures and not think much about camera settings. The camera takes care of the shutter speed and aperture for you, and uses your selected exposure meter

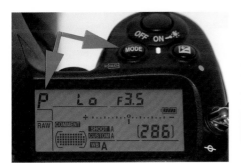

Figure 5 – MODE button, Main command dial, and Control Panel with P-Program mode selected

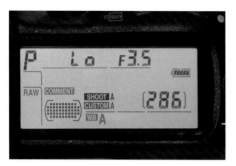

Figure 6 – Control Panel with P-Programmed Auto mode

type to create the best pictures it can without human intervention. *Figure 6* shows the P for *Programmed auto* mode followed by the shutter speed and aperture to the right of the P.

It is called *Programmed auto* because it uses an internal software program built into the D300. It tries its best to create optimal images in most situations. However, even Nikon's User Manual on page 106 calls this a "snapshot" mode. P mode can handle a wide variety of situations well, but I personally wouldn't depend on it for my important shooting. When I'm at a party and I just want to enjoy myself, get some nice snapshots, and not think about the camera, then P mode means "P" for party to me.

P mode actually comes in two parts: *Programmed auto* and *Flexible program*. Flexible program works similarly to A-*Aperture Priority Auto* mode. Let me explain.

Get Down Grandpa!

You're shooting at a family party and suddenly you see a perfect shot of grandpa dancing on the dinner table, and grandma standing on the floor behind him with her hand over her mouth. You (being a well-trained photographer) glance down at your camera and realize that the f/4 aperture showing on the *Control Panel* won't give you enough depth-of-field to focus on grandpa and still have a sharp image of grandma, who

by this time is tugging at grandpa's pant leg. With only seconds to spare you turn your *Main command* dial to the left. The D300 realizes that it is being called upon to leave snapshot mode and give you some control. It throws an asterisk up next to the P on the Control Panel (P*) to let you know it realizes that you are taking over and, since you are turning the dial to the left, it obligingly starts cranking down the aperture. Six clicks to the left and your aperture is now at f/8. As soon as the D300 detected that you were turning the command dial, it started adjusting the shutter speed to match the new aperture. With only milliseconds before grandma starts dragging grandpa off the dinner table you get the camera to your eye, compose, press the shutter, and the D300 starts grabbing frames. You get 18 frames off in the three seconds it takes grandma to get grandpa down from the table.

Does that make sense? What you did in my imaginary scenario was invoke *Flexible program* mode in your D300. How? As soon as you turned the *Main command* dial, the D300 left normal P mode and switched to P* mode, otherwise known as *Flexible program*. Before you turned the Main command dial, the D300 was happily controlling both shutter speed and aperture for you. When you turned the dial, the D300 immediately switched to *Flexible program* mode, put an asterisk after the P on the *Control Panel*, and let you have control of the aperture,

From P to P* and Back Again

If you have your D300 in P mode and turn the *Main command* dial to the right, the D300 goes into P* *(Flexible program)* mode, and starts counting clicks to the right. In order to get back into normal P mode, you have to turn the *Main command* dial back to the left that same number of clicks (up to 15 clicks).

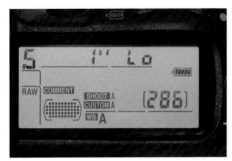

Figure 7 – Control Panel with S-Shutter Priority Auto mode

while it controlled only the shutter speed. In effect the D300 allowed you to exercise your knowledge of photography very quickly and only assisted you from that point.

When you enter *P*-*Flexible program* mode you control only the aperture, and the D300 controls the shutter speed. If you turn the *Main command* dial to the left, the aperture gets smaller. Turn it to the right and the aperture gets larger. Nothing happens if you turn the *Sub-command* dial. Nikon only gave you control of the aperture in *Flexible program* mode. Can you see why I say that *Flexible program* mode acts like A-*Aperture Priority Auto* mode?

The reason I know that the D300 is actually counting clicks is that I decided to count along one day.

Here's what I did. I set my D300 to P mode and got into a darker area where it was at maximum aperture. I then started cranking the *Main command* dial to the right, which should increase the aperture. Since I was already at maximum aperture, the D300 could not increase the aperture size, so it just sat there counting clicks instead. In order for me to get back into P mode, and remove the asterisk from the P*, I had to turn back to the left the exact number of clicks I turned to the right, (up to 15 clicks). You can also turn the camera off, or change modes to get out of the *Flexible program* mode.

S - Shutter Priority Auto Mode

Shutter priority auto is for those who need to control their camera's shutter speed, while allowing the camera to maintain the correct aperture for the available light. *Figure 7* shows the S for *Shutter Priority Auto* mode followed by the shutter speed and aperture to the right of the S.

If you find yourself shooting action, you'll probably be concerned about keeping the shutter speed high enough to capture an image without excessive blurring. Shooting sports, airshows, auto races, or anything moving quickly requires careful control of the shutter. Sometimes, too, you might want to set your shutter speed to a very slow setting for special effects, or time exposures.

Figure 7 shows the D300 in *Shutter Priority Auto* mode (S). To use the S mode, you select a shutter speed that you feel will work for your current shooting situation, and set it with the *Main command* dial. The D300 will now assist you by controlling the aperture to maintain correct exposure.

If the light changes drastically and the D300 cannot maintain a correct exposure, it will inform you by replacing the normal aperture reading with either HI or Lo. They mean what they imply: HI means there is too much light for a good exposure, and Lo means there is not enough light for a good exposure.

While you have your camera in S mode, you can set your shutter speed anywhere between 30 seconds and 1/8000 of a second. You can also set it at x250, which is one click below the slowest shutter speed on the dial (30s). For more information on x250, *see Custom setting e1* on page 288 of the *D300 User's Manual*.

A - Aperture Priority Auto Mode

Nature and macro shooters, and anyone concerned with carefully controlling depth-of-field, will often leave their D300 set to *Aperture Priority Auto* mode (A). *Figure 8* shows the A for *Aperture Priority Auto* mode followed by the shutter speed and aperture to the right of the A.

A-*Aperture Priority Auto* mode lets you control the aperture, while the D300 takes care of the shutter speed for optimal exposures. With newer AF-S and G lenses, to select an aperture you'll use the *Sub-command* dial. You can control the aperture from maximum to minimum just by using the *Sub-command* dial on the D300.

A Note on Lens Types

If you use an older AF lens with an aperture ring, set it to the smallest aperture on the lens, then use the *Sub-command* dial to change aperture instead of using the ring on the lens. If you have older non-CPU lenses, you'll have to use the aperture ring on the lens to control the aperture.

Depth-of-field (DOF) is an extremely important concept to understand for photographers. Simply put, it allows you to control the range of sharp focus in your images. Following is a review of DOF.

Understanding Depth of Field

Depth-of-field is one of those things that confuses a lot of new DSLR users. Yet, it is very important! I'm going to attempt to explain this concept using pictures. This topic transcends the actual DSLR being used – in fact my illustrations were created with my trusty Nikon D2X.

Let's say you are taking a picture of a friend, who is standing 6 feet (2m) away from you. About 6 feet behind your friend is another person. There is also a third person standing about 6 feet behind the second person. Three people total, each about 6 feet apart, with the friend in front *(see Figure 8A)*.

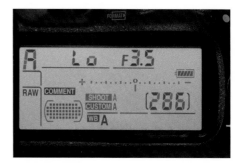

Figure 8 – Control Panel with A-Aperture Priority Auto mode

You are shooting with a 50mm f/1.8 lens. You focus on your friend's face, the young lady in red, and take a picture. It looks like the image in *Figure 8A*.

F/1.8 is an "aperture" number. An aperture is simply an opening in the front of your lens controlled by blades. It lets light come in through the lens to expose your D300's sensor. You can't see the aperture when you look in the front of your lens (usually) since your D300 allows you to focus with the aperture blades wide open and out of the way. The aperture closes down to its selected setting when you press the shutter release to take your picture, or press the depth-of-field preview button. This is the reason the viewfinder often gets darker when you press the *DOF Preview* button on your camera.

Apertures on your zoom lens probably start at about f/3.5 (big aperture), and stop at f/22 (small aperture). The bigger the aperture can get (the larger the opening) the "faster" the lens is considered. When you hear about a "fast" lens, someone is talking about a lens with a big maximum aperture opening. The 50mm f/1.8 lens is a fast lens.

Notice in *Figure 8A* that your friend (in red) is in sharp focus. The girl standing behind her, to the right, is not in focus, nor is the young lad even farther away to the left. This is the result of shooting with a big "aperture." F/1.8 is a big opening in the front of your lens. It also causes the depth-of-field, or "zone of sharp focus" to be shallow. Only the girl in front is in focus at f/1.8. Not much else is in focus, so there is very little depth-of-field. The depth-of-field in this

picture is much less than 3 feet (.91m) deep. probably more like 1.5 feet (.45m).

So what would happen if we closed the aperture down ("stopped" down) to a medium aperture like f/8? *Figure 8B* shows what that will do to the depth-of-field.

Remember, you are focused on the girl in front, and at f/1.8, a big fast aperture, the others were out of focus. Without changing your focus in any way, you adjusted your aperture to f/8. Something changed!

You focused your camera on the girl in front, but now the girl to the right is sharp too even though you did not change your focus control. The depth-of-field (or zone of sharp focus) now extends past the girl in front and covers the girl in back. The DOF got deeper.

However, also notice that the boy to the left is still not in focus. The background is not in focus either. The depth-of-field is deeper, but still not deep enough to cover all your subjects.

This image is the result of a medium aperture opening (f/8), not fast (f/1.8), and not slow (f/22). Now, let's consider what happens if we "stop down" or close the aperture to a small opening like f/22 *(Figure 8C)*.

Aha! Now everything in the picture is sharp. An aperture as slow and small as f/22 makes it easy to get sharp focus. Remember, you focused on the girl in front in all these pictures. At first only the girl in red was in focus (f/1.8), and as the aperture got smaller, more and more of the surroundings came into sharp focus (f/8 and f/22).

So, depth-of-field is simply the zone of sharp focus. It extends in front of and behind your focused subject, and gets deeper in both directions, toward the camera and away from it, as you "stop down" your lens. If you set your camera to *Aperture Priority Auto* (or *Manual* mode), you can adjust this powerful functionality to control what is in focus in your pictures. Don't forget that in this case you are also making trade-offs. All three images were shot at ISO 100, and once I started using the smaller apertures the camera needed to compensate by using longer exposure times. The f1.8 shot was at 1/6000 second. The f/8 shot was

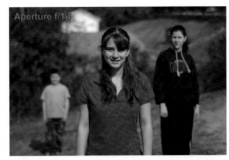

Figure 8A – 3 kids at f/1.8, - shutter speed at 1/6000

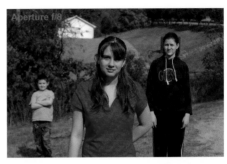

Figure 8B – 3 kids at f/8, shutter speed at 1/500

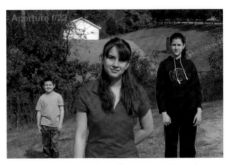

Figure 8C – 3 kids at f/22, shutter speed at 1/40

at 1/500 second. The f/22 final image required an exposure of merely 1/40 second. This was fairly easy to pull off under sunny skies with stationary subjects, but you can see where the shutter speed exposure compensations could get troublesome if these three subjects were playing ball or jumping around. This is when the experienced photographer takes advantage of the *Manual* mode.

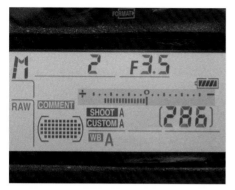

Figure 9– Control Panel with M-Manual mode and exposure display highlighted in red

M - Manual Mode

Manual mode takes a big step backwards to days of old. It gives you complete control of your camera's shutter and aperture, so that you can make all the exposure decisions, with suggestions from the exposure meter. *Figure 9* shows the M for *Manual* mode followed by the shutter speed and aperture to the right of the M.

Also, in *Figure 9*, notice the electronic analog exposure display that's highlighted in red. This display has a Plus sign "+" on the left, and a minus sign "-" on the right. Each dot on the scale represents 1/3 exposure value (EV) step and each vertical line represents 1 EV step.

You can control how sensitive the command dials are with *Custom Setting b2 – EV steps for exposure cntrl* (See Chapter 6). The factory default setting for *b2* is that the command dials change

A Note on Lens Types

With newer G lenses you can control the aperture from maximum to minimum just using the *Sub-command* dial on the D300. If you use an older AF lens with an aperture ring, set it to the smallest aperture on the lens, then use the *Sub-command* dial to change aperture instead of the ring on the lens. If you have older non-CPU lenses, you'll have to use the aperture ring on the lens to control the aperture.

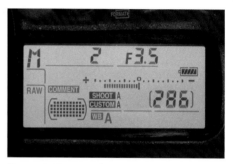

Figure 9A– Exposure display with 2 1/3 stops of overexposure

aperture or shutter speed in 1/3 EV steps. If you'd like, you can set *b2* to 1/2 or 1 EV step, instead.

When you are metering your subject, a bar will extend on this display from the zero in the center toward the plus side to indicate overexposure, or toward the minus side to indicate underexposure *(see Figure 9A)*. You can gauge the amount of over- or underexposure by the number of dots and lines the bar passes as it heads toward one side or the other. The goal in manual mode is to make the bar disappear. In *Figure 9A*, the bar is indicating 2 1/3 EV steps (stops) overexposure.

You'll adjust the aperture with the *Sub-command* dial, and the shutter speed with the *Main command* dial.

Histogram

Back in the "good old" film days we didn't have a histogram, so we had to depend on our experience and light meter to get a good exposure. Since we couldn't see the exposure until after we had left the scene we measured our success by the number of correctly exposed images we were able to create. With the exposure meter/histogram combination found in the D300, and the ability to zoom into our images with the high-resolution monitor on the back, the success rate we can experience is very much higher than ever before.

The histogram can be as important, or even more so, than the exposure meter. The meter sets the camera up for the exposure, and the histogram visually verifies that the exposure is a good one.

If your exposure meter stopped working you could still get perfect exposures using only the histogram. In fact, I gauge my efforts more by how the histogram looks than anything else. The exposure meter and histogram work together to make sure you get excellent results from your photographic efforts.

In *Figure 10* is a picture of the D300's histogram screens. The screen on the left is a basic informational screen with only a combined RGB histogram shown in white. It is always available on your camera by scrolling up or down with the *Multi selector* during image review.

The second histogram screen in *Figure 10* is actually a series of histograms. On the top is the Red channel, the middle is the Green channel, and the bottom is the Blue channel (RGB = Red, Green, Blue). On the left bottom is a white-colored histogram that is all three color channels combined. When you look closely at the "combined" histogram, it looks very similar to the Green channel.

Let's discuss the use of a histogram in detail.

Understanding the Histogram

Using the histogram screens on your D300's Monitor LCD will guarantee you a much higher percentage of well-exposed images. It is well worth spending time to understand the histogram, and it isn't as complicated as it looks.

I'll try to cover this feature with enough detail to give you a working knowledge of how to use the histogram to make better pictures. If you are deeply interested in the histogram, there is much research material available on the Internet. Although this overview is brief, it will present enough knowledge to improve your technique immediately.

Light Range

The D300's sensor can only record a certain range of light values, which is about 5 to 7 usable EV steps. Unfortunately, many of the

Figure 10 – Two D300 Histogram screens

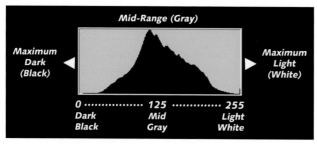

Figure 11 - Picture of basic histogram.

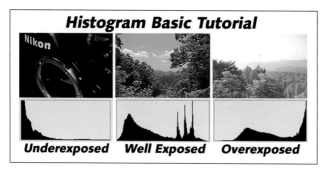

Figure 12 - Three Histograms – one underexposed, one correct, one overexposed.

higher contrast subjects we shoot can contain over 12-stops of light values. This is quite a bit more than it is possible to capture in a single exposure. It's important to understand how your camera records light so that you can better control how the image is captured.

Look at *Figure 11* closely. The gray rectangular area is a representation of an in-camera histogram. Examine it carefully! Think about it for a minute before reading on.

The histogram basically is a graph that represents the maximum range of light values your camera can capture, in 256 steps (0 = Pure Black, and 255 = Pure White). In the middle of the histogram are the mid-range values that represent middle colors like grays, light browns, and greens. The values from just above zero and just below 255 contain detail.

The actual histogram graph looks like a mountain peak, or a series of peaks, and the more of a particular color, the taller the peak. In some cases the graph will be rounder on top, or flattened.

The left side of the histogram represents the maximum dark values that your camera can record. The right side represents the maximum "lightness" values your camera can capture. On either end of the histogram the light values contain no detail. They are either completely black, or completely white.

The top of the histogram (top of mountain peaks) represents the amount of individual colors (a value you cannot control in-camera) so it is for your information only.

We are mostly concerned with the left and right side values of the histogram, since we do have much control over those (dark vs. light).

Simply put, the histogram's left-to-right-directions are related to the darkness and lightness of the image, while the up and down directions of the histogram (valleys and peaks) have to do with the amount of color information. I repeated this for emphasis!

The left (dark) to right (light) directions are very important for your picture taking. If the

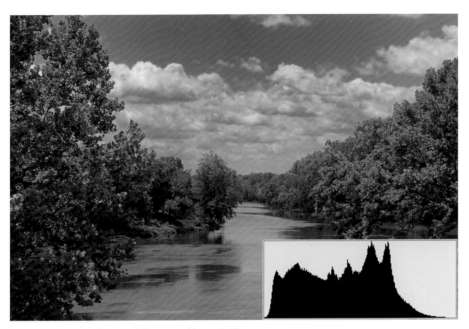

Figure 13– Image with Normal Histogram Mountain Shape

image is too dark, the histogram will show that by clipping off the light values on the left, or, if too light, by clipping on the right. This will become easier to understand as we look at well exposed and poorly exposed images. Check out the Histogram Basic Tutorial in *Figure 12*, and then we'll look at things in more detail.

When you see the three histograms next to each other, does it make more sense? See how the underexposed histogram is all the way to the left of the histogram window, and is clipped mid-peak? Then note the well exposed histogram, and how both edges of the histogram just touch the edges of the histogram window. Finally, see how the overexposed image's histogram is crammed and clipped on the right. You see how this might be helpful, so let's look at some histogram detail.

Image and Histogram Shape

Look at the image in *Figure 13*. It is well ex-posed, with no serious problems. The entire light range of this particular image fits within the histogram window, which means that it is neither too light nor too dark, and will take very little or no adjustment to view or print. It contains no more than four or five stops of light range.

Compare *Figure 13's* histogram to the left side of the histogram graph in *Figure 12*. See how the *Figure 13* histogram does not cram itself against the dark value side. In other words, the dark values are not clipped off on the left. This means that the camera recorded all the dark values in this image, with no loss of shadow detail.

Then look at the right side of the histogram graph, and note that it is not completely against the right side, although quite close. The image contains all the light values available. Every-thing in between is exposed quite well, with full detail. A histogram does not have to cover the

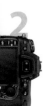

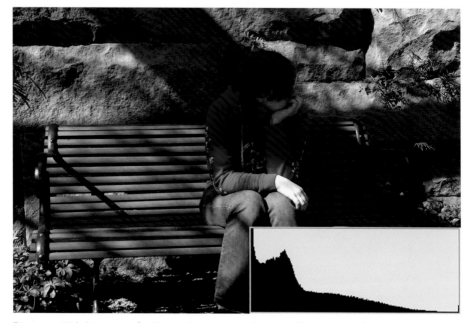

Figure 14 – Wide histogram of an image, showing an underexposed histogram to the dark side

entire window for the exposure to be fine. When there is a very limited range of light, the histogram may be rather narrow.

The image in *Figure 13* is a relatively bland image with smooth graduations of tone, so it makes a nice smooth mountain peak histogram graph. This will not occur every time, since most images contain quite a bit more color information. Each prominent color will be represented with its own peak on the histogram graph. The most prominent colors will have higher peaks, while the less prominent will have lower or no peaks.

As we progress into images with more color or light information, we'll see that the histogram looks quite different. Look at the image in *Figure 14*. This is an image that far exceeds the range of the D300's digital sensor.

Notice that, overall, this image is dark and looks underexposed. The histogram in *Figure 14* is crammed to the left, effectively being

clipped off. There are no gradual climbs like on a mountain range, from valley to peak and back to valley. Instead, the image shows up on the left side in mid-peak. It is "clipped." This is an underexposed image and the histogram reflects that well.

The most important thing to understand when you see a histogram like in *Figure 14*, with part of the peak clipped off on the left, is that *some or all of the image is significantly underexposed*.

Now look at a similar image in *Figure 15*. In this image, a larger aperture was used and more light was allowed in. We can now see much more detail. However, once again, the range of light is too great for the sensor, so it is now clipped off on the highlight side (right). The dark-side graph value is not clipped; instead the graph extends to the left dark-side edge but stops there.

The image in *Figure 15* shows more detail, but is not professional looking and will win no

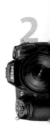

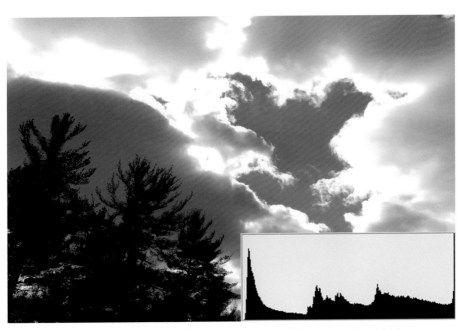

Figure 15 – Wide histogram of an image, showing an overexposed histogram to the light side

awards. The range of light is simply too great to be recorded fully. Many of the details are overly light, and that can be seen by the histogram's clipping on the right side. The most important thing to remember with this image's histogram is that when you see a histogram graph that is crammed all the way to the right and clipped, *some or all of the image is significantly too light.* Overall, a great deal of the image in *Figure 15* is recorded as pure white and the detail is permanently gone, or "blown out."

It is important is that you try to center the histogram without either edge being clipped off. This is not always possible, since often there is too much light range and the sensor or histogram window can't contain it. If you center the histogram, your images will be better exposed. If you take a picture, and the histogram graph is shifted far to the left or right, you can then retake the photograph, exposing in the direction of the opposite light value.

If there is too much light to allow centering the histogram, you must decide which part of the image is more important, the light or dark values. You must expose for the highlights, or you will lose detail in the light areas.

How Does the Eye React to Light Values?

The D300 camera, with its imaging sensor and glass lenses, is only a weak imitation of our marvelously designed eye and brain functions. There are very few situations where our eyes cannot adjust to the available light range, and we can see well in most cases. So, as photographers, we are always seeking ways to record even a small portion of what the eye and mind can see.

Since our eyes tend to know that shadows are black, and expects that, it is usually better to expose for the highlights. If you see dark shadows, that seems normal. We're simply not used to seeing light that's so bright that all detail is

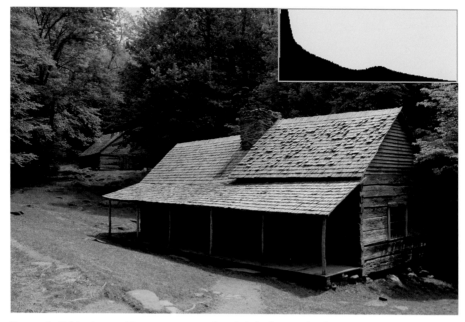

Figure 16 – Cabin picture with correct exposure but dark shadows, and its histogram.

lost. An image exposed for the dark values will look strange because most highlight detail will be burned out.

Your eye can see a range of light in comparison to your digital sensor. The only time you will ever see light values that are so bright that detail is lost is when you are looking directly at an overwhelmingly bright light, like the sun. So, in a worst case scenario, expose the image so that the right side of the histogram graph just touches the right side of the histogram window, and the image will look closer to what our eye expects.

Since photography's beginning, we have always fought with only being able to record a limited range of light. But, with the digital camera and its histogram, we can now see a visual representation of the light values, and can immediately approve of the image, reshoot it with emphasis on lighter or darker values, or see

that we must use a filter or multiple-exposure High Dynamic Range (HDR) imaging to capture it at all.

Computer Adjustment of Images

Looking at the image in *Figure 16*, taken in midday overhead sunshine, we see an example of a range of light that is too great to be captured by a digital sensor, but is exposed in such a way that we can get a usable photo later.

Notice in *Figure 16* how the dark values are clipped off, and dark detail is lost. But, look to the right side of the histogram and notice how the light values are not clipped off. So the camera recorded all the light values, but lost some dark values. Since our eye sees this as normal, this image looks okay.

If we were standing there looking at the cabin ourselves, our eye would be able to see much

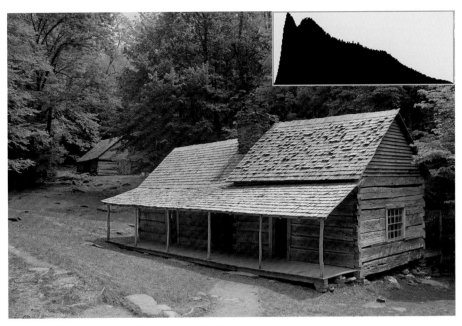

Figure 17 – Post-processed cabin picture and its histogram

more detail in the front porch area. But, the camera just can't record that much light range. If we want to get a bit more detail in the shadows than this image seems to contain, we can do it. Normally, a camera does not give us enough control to add light values on the fly, so we use the histogram to get the best possible exposure, and then adjust the image later in the computer. Some cameras can be "profiled" to capture light ranges more effectively in one direction or the other, but when you push one area, the opposite area must give. So, we need a way to take all this light and compress it into a more usable range.

We are now entering the realm of "post-processing," or of in-computer image manipulation. Look at the image in *Figure 17*. This is the exact same image as *Figure 16*, but it has been adjusted in Photoshop to cram more image detail into the histogram by compressing the mid-range values. Notice that the entire histogram seems to be farther right toward the light side. Also

notice that the mid-range peaks are basically gone. We removed a good bit of the mid-range, but since there was already a lot of mid-range there our image did not suffer greatly.

How this computer post-processing was done is outside the scope of this book, but it is not very hard. I do recommend, however, that you buy a program like Nikon Capture NX, Photoshop, Photoshop Elements, Lightroom, or another fine graphics program designed for photographers. Your digital camera and your computer are a powerful imaging combination, which can create a digital darkroom, where you are in control from start to finish, from clicking the shutter to printing the image. But, retreating from philosophy, let's continue with our histogram exploration.

Notice in *Figure 17* how the histogram edge is just touching the highlight side of the histogram window? A small amount of clipping is taking place, and you can see the slightly blown out

area on the peak of the cabin's roof. Sometimes a very small amount of clipping does not seriously harm the image. The photographer must be the judge.

The greater apparent detail in this image is the result of compressing the midrange of the light values a bit in the computer. If you compress or make the mid-range light values smaller, that will tend to pull the dark values toward the light side, and the light values toward the dark side. So, you will have more apparent detail in your image. It's like cutting a section out of the middle of a garden hose. If you pull both of the cut ends together, the other two ends of the hose will move toward the middle, and the hose will be shorter overall. Similarly, if you compress or remove the mid-range of the histogram, both ends of the graph will move toward the middle. If one of the ends of the graph is beyond the edge of the histogram window (or is clipped off) it will be less so when the mid-range is compressed.

We are simply trying to make the histogram fit into the frame of its window. If we have to cut out some of the middle, to bring both ends into the window, well, there is usually plenty in the middle to cut out, so the image rarely suffers. Remember, this is being done outside of the camera in a computer. You can't really control the in-camera histogram to compress values, but, you need to be aware that it can be done in the computer, so that you can expose accordingly with your camera's histogram. Then you will be prepared for later "post processing" of the image in your computer.

In fact, now that we have compressed the mid-range values, the above image more closely resembles what our eye normally sees, so it looks more normal to us.

In many cases, your progression from the shooting site to your digital darkroom can benefit if you shoot RAW (unprocessed) images (Nikon calls it Nikon Electronic Format – NEF).

A RAW digital image contains an adjustable range of light. With a RAW image you can use controls in Capture NX, Photoshop, or even the basic Nikon Picture Project software included with the D300 to select from the range of light within the big RAW image file. It's like moving the histogram window to the left or right over all that wide range of raw image data. You select a final resting place for the histogram window, capture the underlying RAW data, and then your image is ready for use.

This is an oversimplification of the process, but, I hope, makes it more understandable. In reality, the digital sensor records a wider range of light than you can use in one image. While you might be able to use about 5 stops of light range in a normal image, the digital sensor is recording probably about seven stops of light range. Although you just can't get all of that range into the final image, it is there in the RAW file as a selectable range. I prefer to think of it as a built-in bracket, since it works the same way.

This bracketed light range within the image is present to a very limited degree in JPEG, and a bit more so in TIFF images, but is the most pronounced in pure RAW images. That is why many photographers choose to shoot in RAW mode, instead of JPEG or TIFF.

My Conclusions

Your camera meter should be used to get the initial exposure only. Then you can look at the histogram and see if the image's light range is contained within the limited range of the sensor. If it is clipped off to the right or the left, you may want to add or subtract light with your *+/- EV compensation* button, or use your *Manual* mode. Expose for the light range with your histogram. Let your light meter get you close, then fine tune with the histogram.

The Nikon D300 has a Multi Selector that can be pressed right or left to scroll through the images you have already taken. You can also press

the Multi Selector up or down to scroll through the various informational modes, such as the histogram screen. When you take a picture of an important subject, find the histogram view of your image. If you can't find the screen with multiple histograms as shown in *Figure 10*, see the *Playback Menu – Display mode* and select *RGB histogram*.

There are also other Monitor LCD viewing modes that you can use along with the histogram graph, such as the *Highlights* (blinky blinky) mode for blown out highlights (*see the Playback Menu – Display mode* and select *Highlights*). This mode will cause your image to blink from light to dark in the blown out highlight areas. This is a rough representation of a highlight-value clipped histogram, and is quite useful for quick shooting. Using your camera's light meter, histogram, and the highlight burnout blinky mode together is a very powerful method to control your exposures.

If you master this method you will have a very fine degree of control over where you place your image's light ranges. This is sort of like using the famous Ansel Adams' black & white "Zone System" but it is represented visually on the Monitor LCD of your D300.

The manipulation of the histogram "levels" in-computer is a detailed study in itself. It's part of having a digital darkroom. Learn to use your computer to tweak your images, and you'll be able to produce superior results most of the time. Even more importantly, learn to use your histogram to capture a light-balanced image in the first place!

Your histogram is simply a graph that lets you see at a glance how well your image is contained by your camera. Too far left, and the image is too dark; too far right, and the image is too light. Learn to use the histogram well, and your images are bound to improve!

Multi-CAM 3500DX Autofocus

With each progressive generation of digital SLR cameras, Nikon has increased the number of focus sensors and area modes in the Autofocus (AF) system.

For instance, the Nikon D100's Multi-CAM 900 AF module has five sensors and two area modes, the Nikon D200's Multi-CAM 1000 has eleven sensors and four area modes. The D300's new Multi-CAM 3500DX has a full 51 autofocus sensor "points" but only three area modes, thereby making the AF system simpler to operate, yet more robust.

What do we gain from all these extra AF sensor points and more powerful area modes? Is there anything else new and different? As we progress through this chapter, we'll discuss these questions in detail, along with how your photography will benefit most from the new Multi-CAM 3500DX AF system.

What is the Multi-CAM 3500DX Autofocus Module?

It's a thoroughly improved, third-generation version of the excellent Multi-CAM 1000 autofocus module found in the Nikon D200. Where the Multi-CAM 1000 is limited to only 11 AF sensors, the Multi-CAM 3500DX has 51. In *Figure 1* you can see what the new AF module looks like:

As we proceed through this chapter I'm going to call the Multi-CAM 3500DX Autofocus Module by the simpler name of "AF Module."

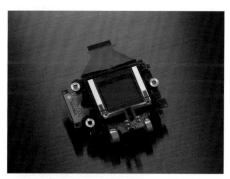

Figure 1 - Picture of Multi-CAM 3500DX sensor (Nikon Photo)

The AF Module has three *AF-Area Modes*:

1. Single-point AF
2. Dynamic-area AF
3. Auto-area AF

It also has three *Focus Modes*:

1. Single-servo, or "S" mode
2. Continuous-servo, or "C" mode (CL and CH)
3. Manual, or "M" mode

What's the difference? Basically, think of the AF-Area Modes as where the AF Module focuses, and the Focus Modes as how it focuses.

In addition, the D300 allows you to control how fast and how often a picture is taken. We'll look at how the shutter frame-rate (was called "motor-drive") works in relation to the AF system.

With the controls built into the D300's body, you'll be able to select whether the AF Module uses one or many of the 51 AF sensors to find your subject. You'll also select whether the camera grabs the focus and "locks" on a static subject, or whether it continuously seeks new focus if your subject is moving, and how fast in frames-per-second (FPS) it takes to capture the images.

Of course, if you want to, you can turn AF off completely, and simply use manual focus. This comes in handy when you decide to use older "non-CPU" Nikkor manual-focus lenses, such as the excellent AI/AI-S prime and zoom lenses of yesteryear and the few primes that are available new.

In fact, one of the important features of the near-professional D300 is that the camera will happily use older lenses. Many of us have our old favorites, such as the Nikkor 105mm f/2.5 portrait lens, or the 35mm f/2. We can use AF/AF-S lenses, or virtually any of the F-Mount AI/AI-S lenses, with a few limitations.

Tied in closely with the AF system is the "Release Mode." This determines how the camera takes the picture: one at a time, or in continuous bursts. You can look through the viewfinder to compose, or use the brand-new Live View mode (LV) which allows you to use the large monitor LCD on the back of the D300, instead of the viewfinder, to compose the image.

Setting Your Lens to Manual Focus

If you'd like, you can use the A-M switch found on most AF Nikkors to set the lens to Manual focus, and override the AF system completely. If the AF Nikkor lens supports autofocus with manual priority (M/A), you can use the AF Module to obtain primary focus, and then fine-tune it manually.

The AF Module supports 10 custom settings, *a1-a10*, on the *Custom Settings Menu*. We'll examine each of those custom settings in Chapter 6.

Let's consider the various features of the Multi-CAM 3500DX AF Module in detail.

Understanding the Focus Modes, AF-Area Modes, and Release Modes

The D300 has distinct modes for how and when to focus. We'll examine each of those modes as a starting point in our understanding of autofocus with the Multi-CAM 3500DX AF Module. We'll tie together information about the *Focus modes*, *AF-area modes*, and *Release modes* since they work together to acquire and maintain good focus on your subject.

In fact, this chapter encompasses information found in the User's Manual chapters on **Focus** and **Release Mode** (D300 English "En" User's Manual pages 61 to 94). It goes deeper than merely looking at the AF Module alone, since other related camera functions such as the Release modes directly affect how the AF system performs.

In *Figure 2* are four pictures of the controls we'll use in combination to change how the camera focuses and captures images.

Notice in the last picture in Figure 2 how the Multi Selector has a locking ring around it. At the top left of the ring you'll see a dot and an L. Move the switch to the dot setting, which unlocks the internal AF "sensor point in use." Otherwise, you won't be able to move the AF sensor point around the viewfinder within the 51 available points.

If you want to use the D300 as a point and shoot camera, ensure the AF sensor rectangle is centered in the viewfinder, set the lock on L, and the center AF focus is all the camera will use in *Single-point AF mode*. I leave mine unlocked all the time but then I check as I'm focusing to make sure I am using the AF sensor I want to use. I can move a single AF sensor, or a group of sensors, around the array of 51 available sensors with the Multi Selector.

Be aware that 15 of the 51 AF sensors on the D300 are cross-type sensors, which means that they will initiate focus in either a horizontal or a vertical direction. The center three columns by five rows of AF sensors are cross-type. All sensors outside of the three center columns of sensors are only sensitive in a horizontal direction. *Figure 3* has the sensors that are cross-type colored red:

Figure 3 – Central cross-type sensors

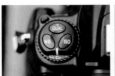

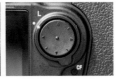

Figure 2 – Focus Mode Selector switch; Release Mode dial and lock release; AF-area Mode Selector; and Multi Selector

The D300's Improved Sensor

This is different and improved from the sensors on the D200 camera, on which only its single center sensor is a cross-type sensor. In the D300, the actual underlying AF sensors seem to be well represented by the little rectangles in the viewfinder, although a little less so, as I used sensors closer to the edges on my D300. On older Nikon cameras, the AF sensor was actually considerably wider than the brackets shown in the viewfinder.

Focus Modes in Detail

The *Focus Modes* allow you to control how the autofocus works with static and moving subjects. They allow your camera to "lock" focus on a subject that is not moving, or moving very slowly. They also allow your camera to "follow" focus on an actively moving subject. Let's consider the two servo-based *Focus Modes* to see when and how you might use them best.

Single-servo AF Mode (S)

Subject is not moving: When you press the shutter release button half way down, the AF Module quickly locks the focus on your subject, and waits for you to fire the shutter. If you don't release shutter button pressure and refocus when your subject starts moving, the focus will be out of date and useless. Once you have focus lock, take the picture quickly. This is perfect for non-moving subjects, or in some cases even very slowly moving subjects.

 Subject is regularly moving: This will require a little more work on your part. Since the AF system locks the focus on your subject, if it moves even slightly, the focus is no longer good. You'll have to lift your finger off of the shutter release and reapply pressure half way down to refocus. If the subject continues moving you'll need to press the shutter release button half way down, over and over, to keep the focus accurate. If your subject never stops moving, is moving

erratically, or only stops briefly, *Single-servo AF (S)* is probably not the best mode to use. In this case, *Continuous-servo AF (C)* is better, since it never locks focus and you can follow movement better.

Continuous-servo AF Mode (C)

Subject is not moving: When the subject is standing still *Continuous-servo AF* acts a lot like *Single-servo AF*, with the exception that the focus never locks. If you have camera movement, you may hear your lens chattering a little as the autofocus motor makes small adjustments in the focus position. Since it never locks in this mode, you'll need to be careful that you don't accidentally move the AF sensor off of the subject because it may focus on something in the background instead.

 Subject is moving across the viewfinder: If your subject moves from left to right, right to left, or up and down in the viewfinder, you will need to keep your AF sensor on the subject if you are using *Single-point AF* area mode. If you are using *Dynamic-area AF* or *Auto-area AF*, your camera will have the ability to track the subject across a few, or all, of the 51 AF sensors. We'll cover this in more detail in the upcoming **AF-Area Modes in Detail** section.

 Subject is moving toward or away from the camera: If your subject is coming toward you then another automatic function of the camera kicks in. It is called *Predictive Focus Tracking*, and it figures out how far the subject will move before the shutter fires. Once you've pressed the shutter button all the way down, *Predictive Focus Tracking* moves the lens elements slightly to correspond to where the subject should be when the shutter fires a few milliseconds later. In other words, if the subject is moving towards you it focuses slightly in front of your subject so that the camera has time to move the mirror and get the shutter blades out of the way. It takes 45 milliseconds for the camera to respond to pressing the shutter release.

Predictive Focus Tracking

Let's say you were playing a ball game and you threw the ball to a running player. You would have to throw the ball slightly in front of the receiving player so that the ball and the player arrive in the same place at the same time. *Predictive Focus Tracking* does something similar for you. It saves you from trying to focus your camera in front of your subject and waiting 45 milliseconds for it to arrive. That would be a bit hard to time!

Example of Use

If you are shooting an airshow, for instance, in 45 milliseconds a fast moving airplane can move enough to slightly change the focus area by the time the shutter opens. If you press the shutter in one smooth motion all the way to shutter release, first autofocus occurs, then the mirror moves up and the shutter starts opening. That takes about 45 milliseconds in the D300. In the time it takes for the camera to respond to your shutter release press, the airplane has moved slightly, which just barely throws the autofocus off. The camera is predicting where the airplane will be when the image is actually exposed and adjusts the focus accordingly.

Effects of Lens Movement

Lens movement (especially with long lenses) can be interpreted by the camera as subject movement. *Predictive Focus Tracking*, in that case, is tracking your camera movement while simultaneously trying to track your subject. Attempting to handhold a long lens will drive your camera crazy. Use a vibration reduction (*VR*) lens or a tripod for best results. Nikon says that there are special algorithms in *Predictive Focus Tracking* that notice sideways or up and down movement and shuts it down. So, *Predictive Focus Tracking* is not activated by the D300 for sideways or up and down subject movement, or panning.

AF-Area Modes in Detail

The AF-area modes are designed to give you control over how many AF sensors are in use at one time, and different ways to track subject movement.

Figure 4 shows the AF-area mode selector in the *Single-point AF* position.

Single-point AF

This mode uses a single AF sensor out of the array of 51 sensors to acquire a good focus. As mentioned before, you can control which sensor by selecting it with the Multi Selector. In *Figure 5* notice how the center AF sensor point (of the 51 sensor points) is the one that provides focus information.

If I have two people standing next to each other, but with a gap in the middle, I'll do one of two things.

One, I could get the focus first by pointing the center sensor at the face of one of my subjects, pressing the shutter release button half

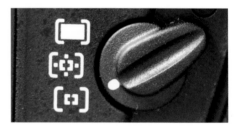

Figure 4 – AF-area Mode Selector Switch with Single-point AF

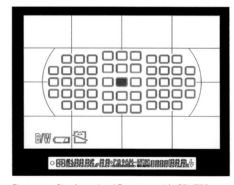

Figure 5 – Single-point AF sensor with CENTER sensor selected

way to get a focus, then holding it down while recomposing the image. When I have recomposed the shot, I finish pressing the shutter release the rest of the way and take the picture.

Single-Point AF Example of Use

If a subject is not moving, like a tree, or a standing person, then *Single-point AF* and *Single Frame Release* will allow you to acquire focus. Once the focus is acquired, the AF Module will "Lock" focus on the subject, and it will not change. If the subject moves, your focus will be out of date, and you'll need to recompose while releasing then pressing the shutter release button half way again. Often, if the subject is moving very slowly or sporadically, I'll not even use *CL* Release Mode, but will leave it in *S* Release Mode. I'll press the shutter release button half way to acquire focus when the subject moves and tap it again as needed. When I'm ready, I simply press the shutter release the rest of the way down and I've got the shot!

Note on Priority Modes

Any time you switch your D300 out of Single Frame "S" release mode, you must be aware of how custom settings a1 and a2 are configured. These two custom settings are for *Focus Priority* or *Release Priority*. These are not the same thing as the Release modes, so don't get confused. It is critical that you understand these two release "priorities" before you start using your D300 on critical shoots, or some of your images may not be in focus at all. I won't cover that information in this *Single-area AF* section, but in Chapter 6 we'll look at them in detail. Please, be very sure that you understand what *Custom settings a1* and *a2* do!

> ### Main Point
> Any time I'm shooting a static or slowly moving simple subject, I'll use *Single-point AF* along with *S* or *CL* release modes. (See pages 64 and 74 of your D300 User's Manual.)

Two, I can compose the picture first by centering it however I like, then use the Multi Selector to move the single AF sensor until it rests on the face of one of my subjects. With the sensor repositioned, I press the shutter release button half way down to get good focus, and the rest of the way down to take the picture.

Either of these methods will solve the age-old autofocus problem of having a perfectly focused background, with out of focus subjects because the center AF sensor was looking at the background between them.

Many of us will use *Single-point AF* mode most of the time. It works particularly well for static or slowly moving subjects. When I'm out shooting beautiful nature images or at a party snapshooting pictures of my friends, I'll use *Single-point AF*, along with *Single Frame (S) Release* mode, almost exclusively. If I'm shooting a wedding, where the bride and groom are walking slowly up the aisle, *Single-point AF* and *Continuous low speed (CL) Release* mode seem to work well for me.

Now, we move on to *Dynamic-area AF*, and see what benefits it brings us.

Dynamic-area AF

This mode is best used when your subject is moving. Instead of using a single AF sensor alone for autofocus, several sensors surrounding the one you have selected with your thumb switch are also active. In *Figure 6* is a picture of the *AF-area Mode Selector Switch* with *Dynamic-area AF* selected.

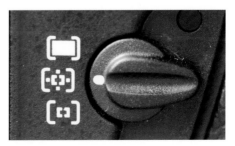

Figure 6 – AF-area Mode Selector Switch in Dynamic-area

You can select the three different sensors patterns in *Custom Setting a3*. The three primary patterns are represented in *Figure 7*. The first image shows 9 points or AF sensors in use.

The second shows 21 points, and the third, all 51 points.

See *Figure 8* for the *Custom setting* screens used to set the patterns.

You can, of course, move the first two patterns (9 and 21 points) around the viewfinder with your Multi Selector. Unfortunately, the camera does not show you more than the center AF sensor of the pattern, even though you have *9, 21, or 51 points* selected. The sensor you can see in the viewfinder is providing the primary autofocus, however the surrounding sensors (in the pattern you've selected in *Custom Setting a3*) are also active. If the subject moves and the primary AF sensor loses its focus, one of the surrounding sensors will grab the focus quickly.

If the subject is moving slowly or predictably, then you can use a smaller pattern, such as the *9 point* selection in *Custom setting a3*. If the subject's movement is more erratic or unpredictable, then you might want to increase the number of AF sensors involved. If 9 won't do it, try 21, and finally even 51 for subjects that are very unpredictable and move quickly.

Can you see how flexible the *Dynamic-area AF* mode is, especially when adjusting the patterns in *Custom Setting a3*? If your subject will only move a short distance (or slowly) you can simply select a pattern of 9 points. Maybe you're doing some macro shots of a bee on a flower, and she is moving around the flower. Or, you might be photographing a tennis game, and use 21 points to allow for more rapid side-to-side movement without losing the focus. You'll have to decide which pattern best fits your needs for the current shooting situation.

> **Main Point**
>
> Using *Dynamic-area AF*, and *Custom setting a3*, you can more accurately track and photograph all sorts, sizes, and speeds of moving subjects.

Figure 7 – Three Dynamic Sensor patterns (left to right) - 9, 21, 51

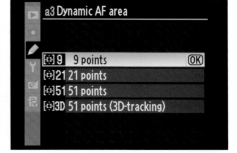

Figure 8 – Custom setting a3 - Dynamic Sensor patterns screens

Capture a Bird in Flight

Let's imagine that you are photographing a bird perched in a tree, but you want some shots of it in flight. You are patiently waiting for it to fly. You have *Dynamic-area AF* selected with all 51 points active, so that autofocus never fully locks and will track the bird instantly when it starts flying. You've already established focus with the sensor you selected using the Multi Selector, and are holding the shutter release half way down to maintain focus. You've also previously set the *Release Mode* to *CH (Continuous High)* so that you can fire off rapid bursts of images (up to 6 per second). Suddenly, and faster than you can react, the bird takes to flight. By the time you can get the camera moving, the bird has moved to the left in the viewfinder, and the focus tracking system has reacted by instantly switching away from the primary sensor you established focus with, and is now using other AF sensors in the pattern of 51 to maintain focus on the bird. You press the shutter release all the way down, and the images start pouring into your CF card. You are panning with the bird, firing bursts, until it moves out of range. You've got the shot!

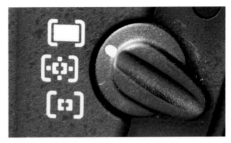

Figure 9 – AF-area Mode Selector Switch in Auto-area

what the subject is, and selects the AF sensors it thinks work best. In *Figure 9* is a picture of the AF-area mode selector switch with *Auto-area AF* selected.

If you are using *Single-servo AF (S)* you'll have an idea what is going to be in focus, because the AF sensors in use will flash on the screen in red, and then turn black for a period of one second. If, however, you are using *Continuous-servo AF (C)* nothing will appear on the viewfinder screen to give you a clue of what is going to be in focus. In *Continuous-servo AF (C)*, your camera is operating like a very expensive Nikon Coolpix point & shoot!

According to Nikon, if you are using a D or G lens, there is a bit of "human recognition technology" built into this mode, similar to the Coolpix. Since most of us will only be using *Auto-area AF* when we want to shoot for fun, a human subject that is closest to the camera is the most likely subject anyway. Your D300, using *Continuous-servo AF (C)*, can usually detect a human and help you avoid shots with perfectly focused backgrounds and blurry human subjects.

We've covered the Focus and AF-Area modes pretty well, so now we move on to the Release modes.

We'll talk more about the 9, 21, and 51 points later in this chapter, and even discuss another pattern called *51 points (3D-Tracking)*, which allows your D300 to pay attention to the color of the subject to improve tracking accuracy with some subjects.

We'll also examine *Custom Setting a4* later in the chapter. This setting allows you to enable "Focus Tracking with Lock-On," which affects what happens if something briefly gets between your camera and subject while you're following the subject with your D300.

Auto-area AF

This mode turns the D300 into an expensive point & shoot camera. Use this mode when you simply have no time to think, but would still like to get great images. The AF Module decides

Requirements for Fast Frame Rates

All of the settings for fast frame rates (high FPS) are based on the assumption that you are shooting at least 1/250 of a second shutter speed, have a fully charged battery, and some buffer space left in your camera's memory.

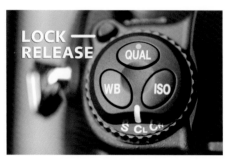

Figure 10 – Release mode dial on CL with its Lock Release button at the upper left

Release Modes in Detail

The D300 has several Release modes, which decide how many images can be taken, and how fast. In *Figure 10*, we see the *Release mode* dial with its lock button (press the lock button, turn the dial).

Here is a look at each release mode in more detail.

D300 Release Modes:
• S – Single Frame
• CL – Continuous low speed
• CH – Continuous high speed
• LV – Live View
• Self-timer
• MUP – Mirror Up

In the good-old-film-days, some of the release modes would have been called "Motor-Drive" settings, since those modes are concerned with how fast the camera is allowed to take pictures.

We've already talked about these modes to some degree in the consideration of the AF-Area modes.

Single frame (S) mode

This is the simplest frame rate, since it takes a single picture each time you depress the shutter release fully. No speed here. This is for shooting a few frames at a time. Nature shooters will often use this mode since they are more concerned with correct depth-of-field, and excellent composition.

Continuous low speed (CL) mode

This mode allows you to select an image taking between 1 frame per second and 6 frames per second (FPS). If you have an MB-D10 battery pack mounted on your D300, you can also select 7 FPS. The camera cannot shoot over 6 FPS without the MB-D10 battery pack, although it will allow you to select 7 FPS. The default frame rate from the factory is 3 FPS, which seems about right for most of us. If you want more or less speed, simply adjust *Custom setting d4* (see D300 User's Manual page 282) and select your favorite frame speed.

Continuous high speed (CH) mode

This high speed mode is designed for when you want to go fast always! The camera will attempt to capture 6 frames per second every time you hold the shutter release button down. The manual states "up to" 6 FPS as the default without the MB-D10 battery pack mounted, and 8 FPS when you do have the battery pack on your camera. So, if you're a high FPS junkie, buy the battery pack!

Live View (LV) mode

This is a brand new mode with the release of the D3 and D300 cameras. Normally, one would not use the Monitor LCD to compose an image, since this is not as stable as holding the camera close to your body, and could result in shaky images.

However, in some instances a live view through the monitor is quite useful. For instance, what if you want to take an image of a small flower growing very close to the ground? You could just lie down on the ground and get your clothes dirty, or you can use LV mode instead. LV mode allows you to see what your camera's lens sees, without using the viewfinder.

Any time you need to take pictures high or low, or even on a tripod, the D300 will happily give you that power with its new LV mode. Let's look at some camera screenshots for setting Live View on your camera. First, you'll use your

camera's Release Mode lock button and dial (top left when viewed from the rear) to set the LV mode. It's to the right of the CL and CH modes.

Then, you'll need to set the *Shooting Menu's Live View* selection to *Hand-held* or *Tripod* (defaults to *Hand-held*). Finally, you'll set the *Release Mode* for *Single frame*, *Continuous low-speed*, or *Continuous high-speed* using the selection screens. You normally would use the Release Mode dial to do that, but since it is already set to LV mode, you'll have to use the shooting menus instead.

Figure 11 shows the Release Mode dial and the screens involved in the process.

Here are the steps to use the Live View mode after you've set the LV setting on the Release Mode dial and configured the selection screens:

LV Hand-held Mode (uses Phase-Detection AF instead of normal AF):

1. Point your camera toward your subject.
2. Press the shutter release half way down to activate Phase-Detection AF. The monitor

will not come on yet. Give it just a moment to autofocus. This saves time later!

3. Raise the mirror by fully pressing the shutter release button.
4. The Monitor LCD now comes on, so you can compose the picture.
5. Press the shutter release fully again. The mirror will drop, Phase Detection AF will activate, and the shutter will fire. If you don't fully press the shutter release, but go only half way, the mirror will drop and Phase-Detection AF will activate, but no picture will be taken, which is a good way to refocus if your subject has moved. (This can take a second or so in lower light levels, since Phase-Detection AF is not as fast as normal AF)
6. Repeat as necessary. Be sure to set the camera back to normal viewfinder mode using the *Release Mode* lock and dial when you are done with Live View.

LV Tripod Mode (uses Contrast-Detection AF instead of normal AF):

1. Frame your image in the viewfinder and press the AF-ON button to initiate autofocus. The shutter release will *not* cause AF to happen in *Tripod* mode. You must use the AF-ON button.
2. Press the shutter release button fully to raise the mirror.

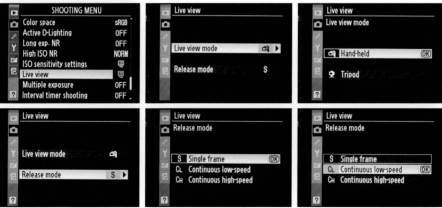

Figure 11 – Release mode dial and Live View settings

3. The monitor now comes on, so you can compose the picture.

4. Use the normal zoom button to enlarge the image enough that you can see how well the focus looks. (The zoom button looks like a magnifying glass with a plus sign in it. It's right above the OK button, on the lower left of the LCD monitor.)

5. Press the AF-ON button to top off the focus. This can take some time (especially in low light) since it is using contrast detection to find the best focus. You will see the image on the monitor focus before and past correct focus, and then finally settle on the correct focus. Be patient!

6. Without moving the camera, press the shutter release button fully to take the image. (The mirror will go up and down twice to take the picture. It sounds entirely weird but it works!). The D300 really should be on a tripod to make the *Tripod* mode work successfully.

In *Hand-held* mode, I've learned to lightly press the shutter release half way down so that AF can function while the mirror is briefly down. Once I feel sure that the camera is fully focused, I'll take the picture. The monitor is nice and big, so you can see focus detail pretty well. So far, it seems to be fine and actually usable. Hats off to Nikon on this one. Pretty cool!

Self-Timer Mode – The factory default timeout on the self-timer is 10 seconds. You can configure *Custom setting c3* to set 2, 5, 10, or

Consider it a Tripod "Only" Mode

Don't look at the Live View mode as a replacement for a Coolpix shooter. It has speed limitations that makes the best of the Coolpix cameras seem like speed demons in comparison. In *Hand-held LV* mode, it's not too bad. However, *Tripod* mode should really be considered a tripod-only mode, or you probably won't get pictures in focus. Contrast-Detection AF is painfully slow, but gets the job done, - eventually.

20 seconds. (See page 280 in your D300 User's Manual.)

If you like to hear that little "beep beep beep" when it is counting down the seconds to firing the shutter, you can control that sound with *Custom Setting d1*, by selecting *High*, *Low*, or *Off*. If either a *High* or *Low* beep is selected, a small musical note will appear in the top right of the LCD Control Panel on the camera's top. (See page 281 in your D300 User's Manual.)

Here are the three steps to use the self-timer after it has been configured (or left on factory defaults):

1. Use the Release Mode lock and dial to select *Self-timer* mode. That's the little symbol between *LV* mode and *MUP* mode.

2. Frame the photograph and focus the camera. If *Focus Priority* is selected, you will not be able to start the self-timer unless the little round green focus light is on in the viewfinder.

3. Press the shutter release button all the way down and run like the wind for your position in the group. (Or, if you are using the self-timer as a cheap cable release, just stand there looking cool, instead.) The AF-Assist light will blink once per second, and the beeping will start too. The last two seconds arrive and the AF-Assist light stops blinking, while the beeping doubles in speed. You are out of time once the beep gets fast! The image is taken about the time the beeping stops.

Mirror Up (MUP) Mode – This mode is very simple and very effective. I use this constantly when I am doing nature photography. Instead of having to find a lever to press, like on the older film cameras, all you have to do to use mirror up mode are follow these simple steps:

1. Use the Release Mode lock and dial to select *MUP* mode. It's past the *CL*, *CH*, *LV*, and Self-timer settings on the *Release Mode* dial.

2. Frame your picture, focus, and press the shutter release the rest of the way down to raise the mirror.

3. Press the shutter release again fully to take the picture.

For a complete consideration of *Custom Settings a1 to a10*, please see **Chapter 6 – Custom Setting Menus.**

It is very important that you read the information in Chapter 6 concerning *Custom Settings a1* and *a2*, especially the section called "Special Section on the Usage of *a1* and *a2*". If you do not read and understand this special section, you may get quite a few out-of-focus images as a result.

Tips on Stopping the Self-Timer

If you want to stop the self-timer, all you have to do is raise the flash. If the flash is already raised, just lower it and raise it again. Or, you could just turn the camera off. (Of course, that's like turning off your home computer while the operating system is busy with some task, and will probably result in your compact flash card bursting into flames, your lens elements unseating, or some other ugly thing happening. I think I'll just raise, or lower and raise, the flash instead!)

Don't Touch That Shutter Release!

Please buy yourself an electronic shutter release cable so that you're not using your finger to press the shutter release when on a tripod and in *MUP* mode. Touching the camera seems a bit silly after going to all that trouble to stabilize the camera and raise the mirror. A finger press could shake the entire tripod! If you do not have an electronic cable release, simply wait for 30 seconds after raising the mirror and the camera will fire on its own. It has a built-in 30-second delay, after you've raised the mirror, then the shutter will fire. This could be used as a slow but high-quality self-timer.

My Conclusions

I've followed the development of the Nikon autofocus systems since back in the late 1980's. My first camera with autofocus was the Nikon F4 professional film SLR. Down through the last 20 years I've experienced each new level of autofocus released by Nikon. It's gotten better and better with each new generation!

In the digital bodies, the first generation D100 set new standards followed by the second generation D200. Now the third generation has arrived, and my reaction has been, "Wow!"

This is a powerful leap forward. Autofocus with the D300 is a real pleasure. Nikon has really learned how to make excellent technology. The D300 has a more powerful AF system than any camera before it, and yet is somewhat simplified in its operation, in comparison.

The system can still come across as complex, but if you spend some time with this chapter, you should come away with a much greater understanding of the D300's AF Module. You'll better understand how you can adapt your camera to work best for your style of photography.

Enjoy your D300's excellent Multi-CAM 3500DX autofocus system!

White Balance

Back in the "good old days" we'd buy special rolls of film or filters to meet the challenges of color casts that came from indoor lighting, overcast days, or special situations.

The D300's method for balancing the camera to the available light comes with the White Balance (WB) controls.

How Does White Balance (WB) Work?

Normally the WB is used to adjust the camera so that whites are truly white and other colors are accurate under whatever light source you are shooting. You can also use the White Balance controls to deliberately introduce color casts into your image for interesting special effects.

Camera WB color temperatures are exactly backwards from the Kelvin scale we learned in school for star temperatures. Remember that a red giant star is "cool" while a blue/white star is "hot." The WB color temperatures are backwards because the WB system is adding color to make up for a deficit of color in the original light of the subject.

For instance, under a fluorescent light, there is a deficit of blue, which makes the image appear greenish-yellow. By adding blue, the image is balanced to a more normal appearance.

Another example might be shooting on a cloudy, overcast day. The ambient light could cause the image to look bluish if left unadjusted.

The WB control in your camera sees the "cool" color temperature and adds some red to "warm" the colors a bit. Normal camera WB on a cloudy, overcast day might be about 6000K.

Just remember that we use the real Kelvin temperature range in reverse, and that warm colors are considered reddish while blue colors are cool. Even though this is backwards from what we were taught in school, it fits our situation better. Blue seems cool while red seems warm to photographers! Just don't let your astronomer friends convince you otherwise.

> **Main Point**
>
> Understanding WB in a fundamental way is simply realizing that light has a range of colors that go from cool to warm. We can adjust our cameras to use the available light in an accurate and neutral "balanced" way that compensates for the actual light source, or allows a color cast to enter the image by unbalancing the settings.

We will discuss this from the standpoint of the D300's camera controls and how they deal with WB.

Color Temperature

The D300 WB range can vary from a very cool 2500K to a very warm 10000K. (See pages 127-146 in your D300 User's Manual for more details.)

In *Figure 1* is the same picture adjusted in Photoshop to three WB settings manually with the use of Photo Filters. Notice how the image in the center is about right while the same shots to the left and right are bluer (cooler) or warmer (more of an orange cast).

As mentioned before, the same adjustments we made with film and filters can now

Figure 1 – Same image with different WB settings

be achieved with the hard coded white balance settings built-in to the D300.

To achieve the same effect as daylight film and a warming filter, simply select the "Cloudy" white balance setting while shooting in normal daylight. This sets the D300 to balance at about 6000K which makes nice warm-looking images. If you want to really warm the image up, set the controls to "Shade," which sets the camera to 8000K.

On the other hand, if you want to make the image appear cool or bluish, try using the Fluorescent (4200K) or Incandescent (3000K) settings in normal daylight.

Remember, the color temperature shifts from "cool" values to "warm" values. The D300 can record your images with any color temperature from 2500K (very cool or bluish) to 10000K (very warm or reddish), and any major value in between. There's no need to carry different film emulsions or filters to deal with light color range. The D300 has very easy to use color temperature controls, and a full range of color temperatures available.

Following are two separate methods of setting the WB on the D300:

1. Manual WB using the WB button and selecting options.
2. Manual WB using the Monitor LCD's *Shooting Menu* and selecting options.

We'll consider each of these methods since you may prefer to use different methods according to the time you have to shoot and the color accuracy you want. Most critical photographers will use method number two; the PRE measurement method.

Method 1 - Manual White Balance Using the WB Button

Sometimes we might simply want to control the WB in a totally manual way. This method and the next are basically the same thing, only one is set using a button and dial, and the other by menu changes.

Each of these methods will allow you to set a particular WB temperature. If you want your image to appear cool, medium, or warm, you can set the appropriate color temperature and take the picture; then look at the image on the Monitor LCD. In *Figure 2*, we see the external camera controls used to adjust WB.

Manually Selecting a Color Temperature Between 2,500 and 10,000K

The "*K*" or Choose Color Temp selection is a flexible one which allows you to select a WB value manually between 2,500 and 10,000 K. Once you have selected the K symbol by holding down the *WB* button and rotating the Main command dial; you rotate the sub-command dial to select the actual WB temperature you desire.

Measuring Actual Ambient Light and Using "PRE" (PrE)

This method allows you to measure ambient light values and set the camera's WB. It's not hard to learn and is very accurate since it's an actual through-the-lens measurement of the Kelvin temperature of the source light. (See pages 136-141 of the D300 User's Manual.) You'll need a white or gray card to accomplish this measurement. *Figure 3* shows the popular WhiBal pocket card, which is a product of PictureFlow LLC and is available exclusively from RawWorkflow.com.

Figure 2-White balance external controls. White Balance button (top); Main command dial (rear); Sub-Command dial (front)

WB Button

Here is how to manually choose a WB color temperature value using the WB button, the *Main command* dial, and the Control Panel LCD:

1. Press and hold the WB button on the top left of your D300 (see *Figure 2*).
2. Rotate the *Main command* dial. Each click of the dial will change the display to one of the symbols in the chart below. They'll appear in sequence on the Control Panel LCD. (See pages 128-130 of the D300 User's Manual.) These symbols, options, and their Kelvin values are as follows:

 Auto White Balance, 3500-8000K.

 Incandescent, 3000K.

 Fluorescent, 4200K.

 Direct Sunlight, 5200K.

 Flash, 5400K.

 Cloudy, 6000K.

 Shade, 8000K.

 K, Choose your own color temp from 2500 to 10000K.

 PRE, Use to measure WB for the actual ambient light. If no measurement is taken, the value used is whatever was last stored in camera memory location *d-0*.

Figure 3 – The WhiBal™ pocket card in its case

How to select the PrE white balance measurement method:

1. Press and hold the WB button.
2. Rotate the *Main command* dial until PrE shows in the lower right of the Control Panel LCD. You'll also see *d-0* in the top left corner of the Control Panel LCD.
3. Release the WB button.
4. Press and hold the WB button again until the PrE starts flashing.
5. Point the camera at a white or neutral gray card in the light source in which you will be taking pictures. It does not have to focus on the card; it can just be pointed at it so that it fills the frame.
6. Press the shutter release fully as if you were photographing the white card. It will fire the shutter, but nothing will appear on the Monitor LCD.
7. Check the Control Panel LCD on top and see if *GOOD* is flashing. If you see *No Gd* flashing (instead of *GOOD*) then the operation was NOT successful. Your available light may not be bright enough to take an accurate reading.

The PrE measurement is very sensitive, since it is using the light coming through the lens to set the WB. Unless you are measuring in an extremely low light level it will virtually always be successful.

In step two above I mention "*d-0*" in the top left corner of the Control Panel LCD during a WB measurement. This *d-0* is where the current WB value is stored. The other memory locations *d-1* to *d-4* are four locations that you can use to store WB values you regularly use. Later you can copy a value stored in *d-1* to *d-4* back into *d-0*.

Storing White Balance Values for Future Use

If you have previously used the manual "measured" PRE method to set the WB, you will have a value already in WB memory location *d-0*. You can keep up to 5 WB values stored in your D300. In *d-0* you'll find the current "PRE" WB, and in *d-1* through *d-4* you'll find any stored WB values. They appear as tiny images, as shown in *Figure 4*.

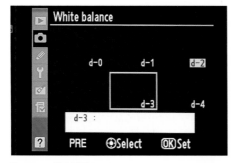

Figure 4 – The PRE screen

If you shoot under a certain light source on a frequent basis, such as in a studio, you may want to store one or more of your PRE set white balance values in one of the four permanent storage areas in your camera (*d-1 to d-4*).

I tried to do a white balance measurement directly into *d-1* to *d-4* by selecting one of the memory locations before doing the light measurement. However, my values did not show up in *d-1* to *d-4*, but instead overwrote the value in *d-0* each time. It is only possible to *copy* a value from *d-0* into one of the other four storage locations. I suppose Nikon was concerned that one might accidentally overwrite a carefully prepared white balance setting, so they added a copy step between the measurement and long-term storage.

In effect, you may have up to five white balance values stored in your camera. One is the current temporary setting, and the other four are in memory for longer term reuse. In *Figure 5*

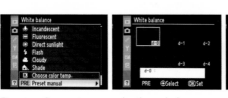

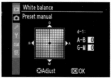

Figure 5 – Screens to access d-0 through d-4

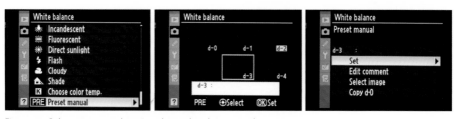

Figure 6 – Select a memory location d-1 to d-4, then copy d-0 to it

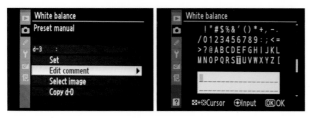

Figure 7 – Renaming a memory location by using Edit Comment

are the steps and shooting menus used to copy the current white balance value in memory location *d-0* to one of the other four areas *(d-1 to d-4)*. You'll see a visual representation—a tiny picture—of the stored WB values. If there is nothing stored in *d-1* through *d-4*, there will only be a blank spot above the number.

Saving a Current WB Reading to Memory Locations *d-1* to *d-4*:

1. Use **Method 1** to obtain a Good PRE white balance reading. It will automatically be placed in memory location *d-0*.
2. Use the screens shown in *Figure 5* to find the current *d-0* value.
3. Select a blank memory location *(d-1 to d-4)*, or one that you want to overwrite, and press the Multi Selector in the middle, like a button. *(Figure 6)*.
4. Select the menu selection *Copy d-0*, and press the *OK* button. You'll then see that *d-0* has written a copy of itself into the memory location you selected.
5. **Optional:** As shown in *Figure 7*, rename the memory location that you just stored by selecting it with the Multi Selector's center button, and then selecting *Edit comment* from the menu. Change the name of the memory location to something that will remind you of its use, if you'd like.

When you have the character-selection panel open (see *Figure 7*), use the Multi Selector to navigate between letters and numbers; then press the center of the Multi Selector to add the character to the name. To scroll through

characters already in the new name, hold the *Checkered Thumbnail* button on the left of the Monitor LCD while navigating to the left or right with the Multi Selector. Press the *Delete* button (garbage can on top left of camera) to delete the current character. Press the *OK* button to save the memory location name.

Using the Values Stored in Memory Locations *d-0* to *d-4*

Once you've written a WB value to one of the memory locations *d-1* to *d-4*, it will remain there for future use as needed. You can access any of the saved WB values by selecting PRE with the WB button, then rotating the front sub-command dial until you find the one you want *(d-0 to d-4)*. Also, you can use the menus to directly select the named memory location. (see *Figure 5*).

Storing and Selecting the White Balance from a Previously Captured Image

It is also possible to select a white balance value from an image you have already successfully taken. This image's value can be applied to the image you are about to take, or the value can be copied to *d-1* through *d-4* (using the method described previously) for later use.

Here are the steps and shooting screens to recover the white balance from an image already taken and stored on your Compact Flash (CF) memory card *(Figure 8)*:

1. Use the shooting menu screens shown in *Figure 5* to get to the *d-0* through *d-4* memory location screen.

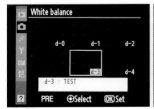

Figure 8 – Screens to recover a white balance setting from an image

2. Use the Multi Selector to select the memory location you want to set with the value from an image. You must select *d-1* through *d-4* only. You can't use *d-0* for this operation. Press the center of the multi selector to select the memory location you want to replace.

3. As shown in *Figure 8*, image 2, scroll down and choose *Select image*. It will be grayed-out if there are no images on your current CF card.

4. Scroll to the right on *Select image* and you'll see the Image Selection screen, as shown in *Figure 8*, image 3.

5. Navigate through the available images until you find the one you want to use for white balance information.

6. Press the center of the Multi Selector and a small picture of the image will show under the selected white balance memory location (*d-1* to *d-4*).

Method 2 - **Manual White Balance Using the Monitor LCD's Shooting Menu**

This method is similar to *Method 1*, but it uses camera *Shooting Menu* screens to select the Kelvin range. Instead of using the WB button and *Sub-command* dial, you'll open up your menus and set the color temperature by selecting from them.

In *Figure 9* are the steps to set the WB selection using your D300's *Shooting Menu*.

Normally you will use only the first two screens to set one of the "preset" WB values

such as *Cloudy*, *Shade*, or *Direct sunlight*, and then you'll just press the *OK* button for the final screen, without changing anything. *Figure 9* uses *Direct sunlight* as an example.

Note that the *Fluorescent* selection provides for choosing one of seven different light sources, covering a wide spectrum.

If you choose to "fine tune" any of the color temperature settings after you have selected one of the preset WB values, the last menu screen in *Figure 9* allows you to do so by "mired" clicks. Each scrolling press of the Multi Selector is equal to 5 mired each in the four color directions. Up is Green (G), down is Magenta (M), left is Blue (B), right is Amber (A).

If you aren't familiar with adjusting the preset's default color temperature, or don't want to change it (most won't), then simply press the *OK* button without moving the little square from the center. If you've accidentally moved it, simply move it back with the Multi Selector until it's in the middle again, then press *OK*. That will select the preset WB value you wanted to use, without modifying its default value. (Example default value is Flash at 5400K.)

Customizing Your White Balance

If you feel that one of the D300's preset values is not exactly what you would like it to be, you can experiment with the color temperature values for that preset by adjusting it along the horizontal or vertical color directions. (See pages 131-133 in your D300 User's Manual for more information.)

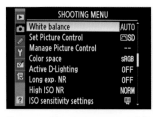
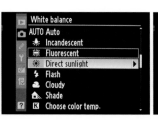
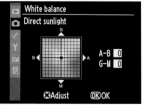

Figure 9 – Menu screens to set WB via camera menus

In review, the steps to set the preset you want to use are (see *Figure 9*):

1. Select *White balance* from the *Shooting Menu*, and then scroll right to the next screen.
2. Select one of the preset values, such as *Flash*, or *Cloudy*, and then scroll right to the next screen.
3. Press OK immediately, without moving the little square from its center position.

That is all there is to selecting a preset from within the menu system. The only difference by doing it this way is that you can fine tune the color temperature values in the third screen of *Figure 9*. I normally do not use *Method 2*, since *Method 1* allows me to select a preset WB value without accidentally modifying the settings of its default color temperature, and doesn't require me to use the menus.

I find that *Method 1* is much faster, since I am using external camera controls, and it takes only seconds to set the values, or even do a PRE reading of ambient light.

White Balance Bracketing

You can also do WB Bracketing in a way similar to Flash or Exposure Bracketing. If you want to use bracketing, you must change *Custom setting e5* from "AE & Flash" to "WB Bracketing." This means that flash or exposure bracketing will not work during the time that *e5* is set to WB Bracketing.

Personally, I prefer to use RAW mode and make minor or major adjustments in the computer postprocessing stage of the image's preparation. However, you may want to use WB bracketing, so let's consider it.

WB bracketing works similarly to exposure bracketing (see User's Manual pages 123-126). *WB bracketing does not work when your camera is in RAW mode!*

In *Figure 10* we see the controls and menus used to set up WB bracketing:

Here are the steps to set up WB Bracketing:

1. Set *Custom Setting e5* to *WB bracketing* (see *Figure 10*, and User's Manual pg.123).
2. As shown in *Figure 10*, choose the number of shots in the bracket by pressing and holding the function (*Fn*) button on the right front of the D300, and turning the *Main command* dial to select the number of shots in the bracket. (Look for the WB-BKT symbols to appear on the Control Panel LCD, along with lines below the +/- scale to show the number of shots you've selected, up to nine shots total.)
3. Select the WB Color Temperature Increment by pressing and holding the function (Fn) button and rotating the *Sub-command* dial. Choose 1, 2, or 3. (1=5 mired, 2=10 mired, 3=15 mired.) The D300 will expose the sequence of shots over and under according to what you've selected in Step # 2 above. You can only adjust the bracket along the Blue (B) to Amber (A) values (cool to warm). The shots to the + side are toward Blue, and to the negative side toward Amber.
4. Take the WB bracketed picture series. Be sure to set your D300 back to normal bracketing in *Custom setting e5*, when you're done.

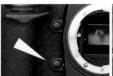 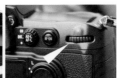

Figure 10 –Fn button, Main command dial, Sub-command dial, and Custom setting e5 screen

AUTO White Balance

Auto WB works pretty well in the D300. As the camera's RGB meter senses colors, it does its best to balance to any white or mid-range grays it can find in the image. However, the color will vary a little on each shot. If you shoot only in Auto WB mode, your camera considers each image a new WB problem and solves it without reference to the last image taken. Therefore, you may see a variance in the color balance of each image with Auto WB.

The Auto WB setting also has the fine-tuning screen mentioned in *Method 2* above. When you select *AUTO* in the *Shooting Menu*, you can toggle to the next screen and fine-tune the colors. I don't see how that is particularly useful since each image is likely to have slightly different color temperatures to deal with, which would mean the fine-tuning would have little value for

more than an image or two. If you were shooting in the exact same light for a period of time, I suppose the fine-tuning would be useful; however, wouldn't it make more sense to do a PRE reading of the light for exact WB? This choice will depend on your shooting style and personal preferences.

Should I Worry About White Balance if I Shoot in RAW Mode?

The quick answer is no, but it may not be the best answer. When you take a picture using RAW mode (creating .NEF files) the sensor image data has no WB, sharpening, or color saturation information applied. Instead, the information about your camera settings is stored as "markers" along with the RAW black & white sensor data. Color information is only applied permanently to the image when you postprocess and save the image in another format, like JPG, TIF, or EPS.

When you open the image in Nikon Capture, or another RAW conversion program, the camera settings are applied to the sensor data in a temporary way so that you can view the image on your computer screen. If you don't like the color balance or any other setting you used in-camera, you simply change it in the conversion software, and the image looks as if you used the new settings originally when you took the picture.

Does that mean I am not concerned about my WB settings, since I shoot RAW most of the time? No. The human brain can quickly adjust to an image's colors and perceive them as normal, even when they are not. That is one of the dangers of not using correct WB. Since an unbalanced image on-screen is not compared to another correctly balanced image side-by-side, there is a danger that your brain may accept the slightly incorrect camera settings as normal, and your image will be saved with a color cast.

As a rule of thumb, if you use your WB correctly at all times you'll consistently produce better images. You'll do less post-processing

My Opinion About Auto WB

If you are concerned with a series of images having the same color settings so that they look similar and require no extra postprocessing, it is best to actually adjust the WB to one of the preset or measured values. Then, each image taken will have the same color balance. Auto WB takes control of the image away from you! The D300 is very good at Auto WB, but I still shoot at a pre-defined WB setting most of the time. Call me old fashioned!

If I'm at a party, shooting images of friends for small snapshot prints, I'll often put my camera in Auto WB and Program "P" exposure mode. Then, I'll just take lots of pictures without worrying about a thing. However, if I'm shooting for commercial reasons, or am concerned with maximum image quality, I use a gray or white card and balance my camera to the available light. I only rebalance if the light source changes. Use Auto WB for when you are not overly concerned about absolutely correct WB. It'll be close enough for average use, and will return great images most of the time.

if the WB is correct in the first place. As RAW shooters we already have a lot of postprocessing work to do on our images. Why add WB corrections to the work flow? It's just more work, if you ask me!

Additionally, you might decide to switch to JPEG mode in the middle of a shoot, and if you are not accustomed to using your WB controls, you will be in trouble. When you shoot JPEGs, your camera will apply the WB information directly to the image, and save it on your card… permanently. Be safe … always use good WB technique!

White Balance Tips and Tricks

Tips for using a white/gray card: When measuring WB with a gray or white card keep in mind that your camera does not need to focus on the card. In PRE mode, it will not focus anyway, since it is only trying to read light values, not take a picture. The important thing is to put your lens close enough to the card to prevent it from seeing anything other than the card. Three or four inches (about 75mm-100mm) away from the card is about right for most lenses.

Also, be careful that the source light is not casting a shadow from the lens onto the card in a way that lets your lens see some of the shadow. This will make the measurement less accurate. Also, be sure that your source light does not make a glare on the card, which is a little harder to do since the card has a matte surface, but it still can be done. You may want to hold the card at a slight angle to the source light if it is particularly bright and might cause glare.

Finally, when the light is dim, use the white side of the card since it has more reflectivity. This may prevent a *No Gd* reading in low light. The gray card may be more accurate for color

balancing, but might be a little dark for a good measurement in dim light. If you are shooting in normal light, the gray card is best for balancing. You might want to experiment in normal light with your camera and see which you prefer.

My Conclusions

Pages 127-146 of your D300's User's Manual have extensive WB information. With the simple tips above, and a little study of the manual, you can become a D300 WB expert. Learn to use the color temperature features of your camera to make superior images.

You'll be able to capture very accurate colors, or make pictures with color casts reflecting how you feel about the image. Practice a bit, and you'll find it easy to remember how to set your WB in the field.

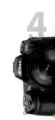

Shooting Menu Banks

Using the four *Shooting Menu* banks, your D300 can change from a pro camera to a snapshooter with just a few presses of the buttons.

This camera can shoot RAW files, using ISO 200, in Adobe RGB *Color space*, with the *Fn* button assigned to *Spot metering* for serious professional shooting, and then can quickly change to good-quality JPEGS, at ISO 400, in sRGB *Color space*, and with high image sharpening, for that party where you don't want to think about anything but having a good time. These are only two variations of the many available combinations of "bank" settings you can use.

The D300 has four *Shooting Menu* banks (and four *Custom Setting* banks) that are covered in the next chapter. You can easily set the functionality of these banks, name them, and use them to quickly change the way your D300 behaves.

Why not get your D300 now, and let's examine how to set the *Shooting Menu* banks. When you're done with this chapter, you'll be able to configure your D300 to be your own personal, multi-function camera.

The *Shooting Menu* banks allow you to set up functions such as file naming, image quality modes (RAW, JPEG, etc.), white balance, ISO, sharpening, and color space. You have a total of 18 separate menu items to configure in the *Shooting Menu*. Each bank can be configured with different settings and you can switch between the banks.

There are four default bank names—Banks A, B, C, and D. You can rename any of these. In this chapter, we'll assume that your camera banks have not yet been adjusted, and that you are not entirely familiar with the process. Let's

learn how to rename Bank A to a more useful name, and set its individual features. When you've done this once, you'll be ready to set your camera up for special uses and switch between them quickly.

Setting Up Shooting Menu Bank "A"

Press the *MENU* button on the back of your D300, and use the Multi Selector to scroll to the left, then up or down until you find the *Shooting Menu* icon (looks like a small camera on the left of the menus). Now, use the Multi Selector to scroll to the right (which will select *Shooting Menu*), then scroll down to find the *Shooting menu bank* item.

Notice in the first screen of *Figure 1* that there's a selection called *Shooting menu bank* with an "A" after it (unless it has been previously changed to a different bank, in which case it might be any letter A through D). This means that your D300 is using *Shooting menu bank A*. If any letter other than A is showing, you are in a different *Shooting menu bank*.

Let's set the D300's *Shooting menu bank* to A, and add a bank name, so that you'll be able to see at a glance what this particular bank is set up to accomplish. Scroll the Multi Selector to the right once. The screen will change to look like screen two of *Figure 1*.

Assuming that you have not yet renamed any of your *Shooting menu banks*, you'll see the four default *Shooting menu banks* called A, B, C, D, and a selection called "ABC Rename". Scroll down to *ABC Rename* and then scroll to the right. Your screen will now look like the third screen in *Figure 1*. This is the bank "rename" screen.

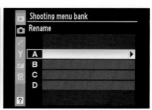

Figure 1 – First three screens used to select or rename a bank

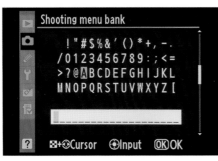

Figure 2 – Screen with characters for creating a name

The factory default for an unnamed bank is simply a blank field. In other words, if you haven't yet named your banks, you'll simply see the big letter A, B, C, or D, followed by a blank field.

We'll rename our bank, by selecting the top bank A, and then scrolling to the right. The screen will now look like the menu screen in *Figure 2*.

You'll see a series of symbols, numbers, and letters on top, with a line of dashes at the bottom. The dashes are where we will put our text to rename the bank. In the upper left corner of the character area is a blank spot which represents a blank for insertion in the line of text. This space is good for separating words. If you scroll down past the uppercase letters, you'll find some lowercase letters too. I use "NEF Uncompressed" as the name for my Bank A.

Below are a series of steps to use while creating the new bank name. Refer to *Figure 2A* for the camera controls to use in renaming:

Figure 2A – Camera controls for renaming banks: Multi Selector, Checkered Thumbnail button, Delete button, and OK button

Steps to input new characters:

1. Use the Multi Selector to scroll through the numbers and letters to find the characters you want to use. Scroll down for lowercase letters.
2. Press the center of the Multi Selector to select a character. Keep selecting new characters until you have the entire new bank name in place.
3. If you make a mistake, hold down the *Checkered Thumbnail* button while using the Multi Selector to move to the position of the error. Push the garbage can "Delete" button on the top left of the back of the D300. The unwanted character will disappear.
4. Press the *OK* button to save the new name. Congratulations! You have named Bank A to a more meaningful name so that you can identify it quickly.

Now, scroll the Multi Selector to the left until the *Shooting Menu* appears, or just press the *MENU* button to return to the start.

Setting up Your Menu Bank

We are using Bank A and now must set up the camera functionality for this bank. Using the Multi Selector, scroll down and set each individual line item available under the *Shooting Menu*. They will each be saved as part of Bank A that we just renamed. Be sure to set, at least, the following:

- Image quality
- JPEG compression (if you are using JPEG mode)
- RAW compression (if you are using RAW mode)
- White balance
- ISO sensitivity
- Image sharpening
- Color space

The items above are a subset of 18 items that can be set for each bank. These form the basis for how your D300 functions when you are using a particular bank. The ones I listed above are the ones I personally consider most important. However, you should look at the complete list and consider which are most important to you.

Shooting Menu Banks

The *Shooting Menu* items *Multiple exposure* and *Interval timer shooting* affect all four *Shooting menu banks* at once. So, if you change either of these settings, they will affect all four banks (A-D) simultaneously. The other 16 settings affect only the bank your camera is currently using.

Each bank can be completely configured with these items having different settings. Your D300 can act like four different cameras, since you can select four different banks, each having different settings.

When you have finished modifying the items that affect what type of shooting you will do with any bank, your D300 now has a certain "personality" for that bank. This facility gives you a very flexible camera.

On pages 254-263 of the D300 User's Manual, you will find extensive information on each of the 18 *Shooting Menu* items. We will briefly consider what each of these items does, so that you can decide how to set your *Shooting menu bank* A. You can, of course, configure each of these same items in a completely different way using *Shooting menu banks* B through D, and give each a different name to identify the special configuration.

Shooting Menu's 18 Item Review

Now, let's move on to the 18 configurable items in the *Shooting Menu*, and discuss each one of them. Pay careful attention to the items that are essential to your style of shooting.

Reset shooting menu

(User's Manual page 257)
Be careful with this selection. It does what it sounds like, and resets the *Shooting menu* for the currently selected bank back to factory default settings. Page 398 of the User's Manual shows the default settings, in case you are interested.

This is a rather simple process. As seen in screen three of *Figure 3*, simply scroll to *Yes* or *No* and press the *OK* button, or scroll to the right. That's about it. If you select *Yes*, the *Shooting menu bank* you're currently using will be reset to factory defaults.

Active folder *(User's Manual pages 258-259)*

(Figure 4) The D300 defaults to creating a folder on your Compact Flash (CF) card with a name of

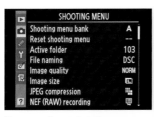
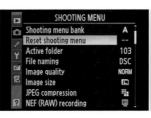

Figure 3 – Reset shooting menu screens

Figure 4 – Active folder screens

"100ND300". This folder can contain up to 999 images. If you want to store images in separate folders on the current CF card, you might want to create a new folder, such as 200ND300, or 300ND300.

Each of these folders can hold 999 images and, using *Active folder*, you can select any one of these folders as the default folder. This is a way to isolate certain types of images on a photographic outing. Maybe you'll put landscapes in folder number 300ND300, and people shots in 400ND300. Whenever the D300 senses that the current folder contains 999 images, a new folder is created and named by incrementing the value in the first 3 digits of the current folder's name by one. Therefore, when manually creating folder names, you may want to leave room for the D300's dynamic folder creation and automatic naming.

As shown in *Figure 4*, to create a new folder, scroll to the right when *Active folder* is selected. Now select *New folder number* by scrolling to the right. You'll now see a screen that allows you to create a new folder with a number between 100 and 999. Choose a number using the Multi Selector, then press the *OK* button when you are done.

You cannot create a folder numbered 000 (I tried), or any other number less than 100. Remember that the three digit number you select will have "ND300" appended to it, and will finally look something like "101ND300" when you have finished.

Once you have created a new folder, you can select it for receiving images, or, in other words, make it the current folder. Refer to image one in *Figure 5*, and scroll down to *Select folder*, then scroll right. You'll see the available folders displayed in a list that looks like:

100ND300

101ND300

Simply select the folder you want to use, and press the *OK* button. All images will now be saved to this folder until you change it to another. You can tell at a glance which folder is active by looking at screen one in *Figure 4*. To the right of the words *Active folder*, you'll see the first three characters of the current folder. Folder number 101ND300 will display as *Active folder 101*.

If you are in folder 999ND300 and the camera records the 999th image (or, if it records

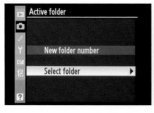 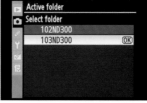

Figure 5 – Select folder screens

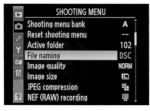 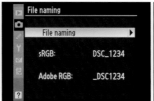 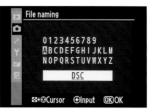

Figure 6 – File naming screens

image number 9999), the shutter release will be disabled until you change to a different folder.

File naming
(User's Manual page 260)
This feature allows you to change the first three letters of the image name for each of the images created by your camera. The camera defaults to using the following file naming for your images. *(Figure 6).*

sRGB *Color space:* **DSC_1234**
Adobe RGB *Color space:* **_DSC1234**

According to which color space you are using, the D300 adds an underscore character to the end of the three DSC characters in sRGB, or to the beginning in Adobe RGB, as shown above.

I use this feature on my Nikon D300 in a special way. Since the D300 can count its images in a *File number sequence* that continues from 0001 to 9999 *(see Custom setting d6)*, I use *File naming* to help me classify my images in sequence. Here's how I do it.

When I first got my D300, I changed the three default characters from DSC to 1DY. The "1" is purely arbitrary, and "DY" are the initials of my name (you could certainly replace the "DSC" characters with your three initials), thereby helping me protect the copyright of my image in case it is ever stolen and misused. This allows me to use filenames 1DY0001 through 1DY9999 in the current folder, as long as there are no more than a total of 999 files in the folder

Since the camera's *File number sequence* counter rolls back over to 0001 when you exceed 9999 images, you need a way to keep from accidentally overwriting images from the first set of 9999 images you took. Fortunately, the D300 will create a new folder when the image number in the current folder is "9999" (or even when there are 999 images in the current folder).

If Nikon ever gives us just one extra digit in our image counting, this would be a moot point, since we could count in sequences of just under 100,000 images, instead of 10,000 images. I

File Number Sequence

If *Custom setting d6* is set to *Off*, the D300 will start the *File number sequence* back over at 0001 each time you format your CF card. I verified that *Custom setting d6* was set to *On* as soon as I got my D300, so that it would remember the sequence. I want to know exactly how many images I've shot with this camera!

suppose that many of us will have traded on up to the next Nikon DSLR before we reach enough images that this really becomes a constraint. On my Nikon D2X, which I've used for nearly four years, I am now about to break 30,000 images.

This is merely the way I'm utilizing this useful feature in the D300. If you don't want to add your initials, you could use the three characters to classify your image names in all sorts of creative ways.

To rename your three characters from DSC to a sequence of your choosing, please refer to *Figure 6*. From the second screen of *Figure 6*, scroll to the right until you see the third screen. This works just like the method for naming the *Shooting menu banks* discussed in **Setting Up Shooting Menu Bank "A"** above (*Figure 2*), except that you only have uppercase characters and numbers from which to select.

Steps to input new characters:

1. Use the Multi Selector to scroll through the numbers and letters to find the characters you want to use.
2. Press the center of the Multi Selector to select a character.
3. To correct an error, hold down the *Checkered Thumbnail* button and use the Multi Selector to scroll. Use the garbage can *Delete* button to delete a character.
4. Press the *OK* button to save.

Now you've customized your camera so that the image names it creates reflects your personal needs.

Image quality, Image size, JPEG compression, and NEF (RAW) recording
(User's Manual pages 55-60)

This section outlines four items in the *Shooting Menu*. All four of these are related to how *Image quality* is set, so must be discussed as a unit.

There are three camera controls we'll use to adjust the image quality parameter: the *QUAL* button, *Main command* dial, and Control Panel LCD. *(Figure 7).*

The D300 supports the following image types:

1. NEF (RAW) Uncompressed or Compressed (2 types)
2. TIFF (RGB)
3. JPEG Fine, Normal, and Basic
4. Combination of NEF and JPEG at the same time (2 images at once).

Let's look at each of these formats and see which you might want to use regularly. Following this section is a special supplement called **" Notes on the Image Formats: RAW, TIFF, and JPEG."** That special section will go beyond just how to turn the different formats on and off, and discusses why you might want to use one particular format over another. *(Figure 8)*

NEF (RAW) Format

This format stores raw image data directly to the camera's CF memory card. You must use conversion software, such as Nikon ViewNX or Capture NX, or a photo editing product such as Photoshop CS3, to later change your Nikon Electronic Format (NEF) format RAW file into a format like TIFF or JPEG. You may not be able to view NEF files directly on your computer

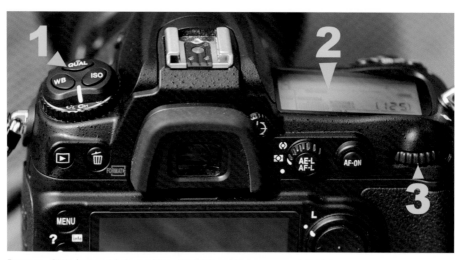

Figure 7 – QUAL button (1), Control Panel LCD (2) and Main command dial (3)

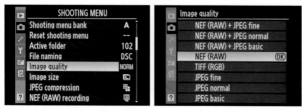

Figure 8 – Two Shooting Menu screens for setting Image Quality

unless you have the conversion software installed. (Be aware that some older versions of these software products may not have been updated to support the NEF file format used in the D300.)

Some operating systems provide downloadable "patches" that let you at least view NEF files as small thumbnails. Before you go out shooting in NEF's RAW format I recommend that you install your conversion software of choice, so that you'll be able to view and adjust these images.

There are three NEF formats available:

1. **NEF (RAW) Lossless Compressed** (20-40% size reduction)
2. **NEF (RAW) Uncompressed**
3. **NEF (RAW) Compressed** (40-55% size reduction)

NEF (RAW) Lossless Compressed - The factory default for NEF (RAW) format is *NEF (RAW) Lossless Compressed*. According to Nikon, this compression will not affect image quality since it is a "reversible" compression algorithm. Since this lowers the stored file size by 20-40% with no data loss it's a good one to consider.

To set your camera to *NEF (RAW) Lossless Compressed*, do the following:

1. Select *Image quality* from the *Shooting Menu* (*Figure 8*).
2. Select *NEF (RAW)* from the list of formats (*Figure 8*).

Once you have selected *NEF (RAW) recording*, you'll need to complete the following steps, referring to *Figure 9*:

1. Scroll down to *NEF (RAW) recording* and then scroll right.
2. Select *Type* and scroll right.

3. Select *Lossless compressed* and press the *OK* button.

Your D300 is now in *NEF (RAW)* mode and is using lossless compression to save a lot of CF card and computer hard drive storage space. If you do not complete the steps shown in *Figure 9*, your camera will probably still be using lossless compression, since that is the factory default for NEF (RAW).

NEF (RAW) Compressed – Before the newest generation of cameras, including the D300, this mode was known as "visually lossless." Compression is applied to the image, which reduces it by 40-55%, depending on the detail in the image. There is a small amount of data loss involved in this compression method. Most people won't be able to see the loss, since it doesn't affect the image visually. I have never really seen any loss in my images. However, I've read that some have noticed slightly less highlight detail, so there may be a small amount of dynamic range loss toward the highlights.

Nikon says that this is a "non-reversible" compression, so once you've captured an image using this mode, it is permanently compressed, and any small amount of compression data loss is permanent. If this concerns you, then use the *Lossless compressed* method discussed above. It won't compress the image quite as much, at 20-40%, but is guaranteed by Nikon to be a reversible compression that in no way affects the image.

NEF (RAW) Uncompressed – When I'm out shooting nature images, I use this mode exclusively. No compression is applied to the image. This mode provides the absolutely best image your camera can capture. The only drawback to this mode is that your images will be quite large

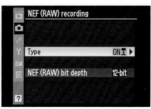
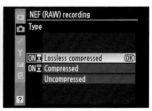

Figure 9 – Shooting Menu screens for setting NEF (RAW) recording compression

to store. In 14-bit color-depth, each image will be in the 25 megabyte range (which is about 20 megabytes if you're using 12-bit color-depth), so it will take larger storage media to contain your images in quantity.

Your CF Card's Storage Capacity

Why does my CF card's remaining image capacity seem to stay the same in NEF *Compressed* modes as it is in *Uncompressed* mode? Shouldn't it show lots more capacity in *compressed* modes since they make the image smaller by 20-55%? Good questions! The reason your D300 does not show any increased image capacity in the Control Panel LCD in compressed modes, is because the D300 has no idea how well it will be able to compress a particular image. Images with large amounts of blank space (such as a sky) will compress much more efficiently than an image of a forest with lots of little leaves. The D300 shows a certain amount of image storage capacity in NEF (RAW) modes like the 320 images you can expect with an 8-gigabte CF card. What you'll find is that, in the compressed modes, the D300 does not decrease the image capacity by one for each picture taken, like it does in uncompressed mode. This means that the D300 will only decrease the number of available images every two or three shots, according to how well it could compress the images. When the card is filled up, it might have more than twice as many images stored as it initially reported that it could hold. Basically, your D300 deliberately under-reports storage capacity when you are shooting in either of the NEF (RAW) compressed modes.

An 8-gigabyte CF card will hold about 320 images in this mode, so your D300 is not overly limited in image capacity while shooting. With hard drive prices dropping quickly, and even terabyte-sized hard drives becoming quite affordable, using the *Uncompressed* mode is not such a concern, anymore. I use this mode, and shoot at 14-bit color-depth, when I am very serious about my images, such as when I am out shooting premium stock. Maximum quality!

NEF (RAW) Bit Depth – When shooting in NEF(RAW), the D300 has a special feature for those of us concerned about storing the maximum amount of color information.

The D300 has the ability to select the bit depth, or number of colors per channel, stored

14-Bit Color-Depth and Frame Rates

If you choose 14-bits, be aware that your camera's file sizes will be larger than they would have been in 12-bits—1.3 times larger for uncompressed RAW images, and a bit less for compressed RAW images. Lots more color information is being stored, after all. There is a drawback to this 14-bit mode that some may find quite objectionable. The maximum frame advance rate in *CH* (Continuous high) drops from the normal 6 frames per second to only 2.5 frames per second. It simply takes more time to move all that extra color information. So, if you are a sports or action shooter, 14-bits may not be for you. However, if you are a nature shooter and don't need high-speed frame rates, 14-bit is best for the image.

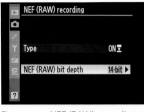 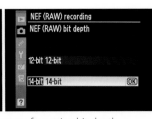 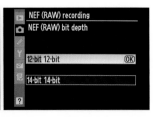

Figure 10 – NEF (RAW) recording screens for setting bit-depth

in an image. The default is 12-bits, or 4096 colors per RGB channel. Or, you can switch it (as shown in *Figure 10*) to 14-bits, or 16384 colors per RGB channel. This is further explained in the short tutorial on "channels and bits" following this section.

As mentioned above and seen in *Figure 10*, the D300 has the following two bit-depths available:

- *12-bit*
- *14-bit*

Referring to *Figure 10*, select one of the bit depth settings. I always use 14-bits, because I want all the color my camera can capture, for the best pictures later. If you'll read my bit-depth tutorial in the next section, you'll understand why I feel that way.

Bit-Depth Tutorial

What does all the 8-bit, 12-bit, and 14-bit talk mean? In NEF(RAW), why would I change my camera to 14-bit depth instead of the default of 12-bits?

Here is a short tutorial on bit-depth and how it affects color storage in an image.

An image from your D300 is an RGB image. RGB stands for Red, Green, Blue (R=Red, G=Green, B=Blue). Each of the colors has its own "channel." There is a Red channel, a Green channel, and a Blue channel.

If you are shooting in 12-bit mode, your D300 will record up to 4096 colors for each channel. Therefore, there will be up to 4096 different Reds, 4096 different Greens, and 4096 different Blues. An extravaganza of color! In fact, almost 69,000,000,000 colors.

However, if you set your camera to 14-bit mode, instead of 4096 different colors per channel, the camera can now store 16384 different colors in each channel. Wow! That's quite a lot more color. Four times more for each color channel, to be exact, which totals almost 4,400,000,000,000 colors, or 64 times as many colors.

Is that important? Well, it can be, since the more color information you have available, the

better for the image. I always use the 14-bit mode, now that I have it available. Later that allows me to have smoother color changes, when a broad range of color is actually in the image. I like that!

Of course, once you save your image as a JPEG or TIFF, most of those colors are "compressed" or thrown away. Shooting in-camera as a TIFF or JPEG means that the D300 converts from a 12 or 14-bit RGB file, down to an 8-bit file. An 8-bit file can only hold 256 different colors per RGB channel. So, there's a big difference in the number of colors stored in the image going from a RAW file to an in-camera JPEG or TIFF. That's why I always shoot in RAW, so that later I can make full use of all those potential extra colors.

If you shoot in RAW, and later save your image as a 16-bit TIFF file, you can store all the colors you originally captured. The D300 will not create a 16-bit TIFF. It is limited to an 8-bit TIFF. However, if you shoot RAW, and in 14-bits, you can later save the file into the 16-bit TIFF and not lose any color information. 16-bit files can contain 65536 different colors in each of the RGB channels. Many people save their files as 16-bit TIFFs during post-processing of the RAW file. TIFF gives us a known and safe industry standard format that will fully contain all the image color information in a RAW file.

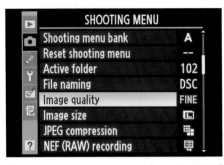
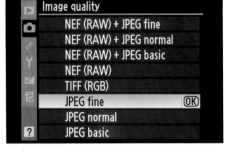

Figure 11 – Image quality screens for setting JPEG fine

JPEG Format

As shown in *Figure 11*, the D300 has three JPEG modes. Each of the modes affects the final quality of the image. Let's look at each mode in detail:

- *JPEG fine* (Compression approximately 1:4)
- *JPEG normal* (Compression approximately 1:8)
- *JPEG basic* (Compression approximately 1:16)

Each of the JPEG modes provides a certain level of "lossy" image compression. The human eye compensates for small color changes quite well, so the JPEG compression algorithm works efficiently enough for photos that are less than 'fine art'. A useful thing about JPEG is that one can vary the file size of the image, via compression, without significantly reducing quality.

JPEG fine (or Fine Quality JPEG) uses a 1:4 compression ratio, so there is a large difference in the file size, with it being as small as 25% of the original size. In this mode, a normal 20 megabyte D300 file can be compressed down to as little as 5 megabytes, without significant loss of image quality. If you decide to shoot in JPEG, this mode will give you the best quality JPEG your camera can produce. Where a *RAW Uncompressed* setting only allows 400 12-bit images on an 8-gigabyte CF card, the *JPEG fine* setting raises that to about 1100 files.

JPEG normal (or Normal Quality JPEG) uses a 1:8 compression ratio. This makes a 20 megabyte D300 image file as small as 2.5 megabytes. The image quality is still very acceptable in this mode, so if you are just shooting at a party for 4x6 image size, this mode will allow you to store a large number of images. An 8-gigabyte CF card will hold about 2200 JPEG normal image files.

JPEG basic (or Basic Quality JPEG) uses a 1:16 compression ratio, so the 20 megabyte D300 file stores as a 1.25 megabyte JPEG file. Remember, these are full size files so you can surely take a lot of pictures. If you are shooting for the Web, or just want to document an area well, this mode has sufficient quality. My D300 tells me it can store a whopping 4300 *JPEG basic* files on my 8-gigabyte CF card.

JPEG Compression Menu

There is one more menu that we need to discuss. Remember how the NEF (RAW) mode has an additional menu screen called *NEF (RAW) recording*, (*Figure 9*) that allows you to select the type of RAW compression you'd like to use?

Well, the JPEG mode has a similar menu called *JPEG Compression*, as shown in *Figure 12*.

There are two types of compression available with JPEGs. Here they are:

- *Size priority*
- *Optimal quality*

These two modes affect the final file size and image quality of the picture.

Figure 12 – Two Shooting Menu screens for setting the JPEG Compression, with second screen set to Optimal quality

Figure 13 – Image quality screens for setting TIFF

Size priority is designed to keep the images within a relatively consistent file size. It will sacrifice image quality to keep the image small. If you need to keep your images within a certain file size for storage purposes, then use this selection. If any one image is 5 megabytes in size, nearly all the images will be close to that size.

Optimal quality is not concerned with file size. It is going to protect the quality of the image, even if that means the file size will vary a great deal. If one image is 5 megabytes in file size, since it has lots of sky and is easily compressed, and another has trees and leaves that are not easy to compress, the latter's file size might be 10 megabytes. *Optimal quality* means just that!

Personally, I always use *Optimal quality* when I shoot JPEGs, since the whole JPEG concept is one of lossy image compression. Size priority just adds more potential "lossiness" (is that a word?), so I avoid it.

TIFF Format

The TIFF mode is probably one of the least used modes in the D300, since it drops storage capacity on an 8-gigabyte card to just a little over 200 images. Plus, it slows the image writing process to the CF card. *(Figure 13)*.

Personally, I would rather shoot in NEF (RAW) mode, since I can get almost double the number of images (at 12-bit color-depth) on my CF card, and they are 12 or 14-bits instead of the TIFF mode's 8-bits.

However, since the TIFF mode creates images that do not have to be post-processed later (but easily can be if desired) some people will use TIFF mode for initial shooting. TIFF is not a lossy compressed mode, although there is a conversion from 12 or 14-bit to 8-bit initially. The image loses 4 or 6 bits from each color channel during the conversion so there is color data loss, but it is not enough to make a big difference in the image. Use TIFF mode if you do not want the "lossy" compression of a JPEG, and you'd rather not adjust the images later in your computer.

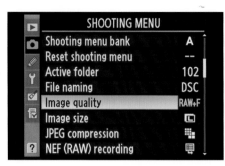
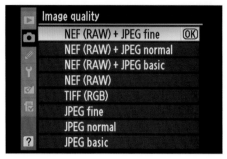

Figure 13A – Image quality screens for setting NEF + JPEG fine

Combined NEF and JPEG Shooting
(two images at once)

Some photographers use a clever storage mode whereby the D300 takes two images at the same time. It's called *NEF (RAW) + JPEG*. This gives you the best of both worlds in that you shoot a RAW file and a JPEG file each time you press the shutter button. In *NEF (RAW) + JPEG* fine, my camera's 8-gigabyte CF card storage drops

Storage Capacity for Combined Modes

Note the previous section under JPEG Compression Menu, and *Figure 12*. If you are using the NEF (RAW) + JPEG modes, please be aware that the JPEGs created by these "combined" modes all use *Size priority* as a default. User's Manual page 56 seems to imply that one cannot change this since it does not mention a way to do so. However, I have noted that even when I am using the NEF + JPEG modes, the number of files stored changes when I select *Size priority* and then change to *Optimal priority*. For instance, *NEF (RAW) + JPEG fine* stores 295 files on an 8-gigabyte card when using *JPEG compression* set to *Size priority*. Then, when I change to *Optimal quality*, the file storage drops to 261 files. So, it seems that *Size priority* is only a default value when you are using NEF + JPEG modes. The manual is unclear on this point, but testing bears this out.

to about 295 images since it is storing both an uncompressed 14-bit RAW and a high-quality JPEG file at the same time for each picture taken *(Figure 13A)*.

You can use the RAW file to store all the image data, and later to post-process it into a masterpiece, or you can just use the JPEG file immediately with no adjustment. Many people use this combination quite often. You can have a JPEG to give others immediately, and later work on the RAW file for special purposes. Here are the three available modes:

- *NEF (RAW) + JPEG fine*
- *NEF (RAW) + JPEG normal*
- *NEF (RAW) + JPEG basic*

There is no need to go into any amount of detail about these modes other than what we have already discussed. The NEF + JPEG modes have the same features as their individual modes. In other words, the NEF (RAW) file works just like a NEF (RAW) file if you were using the standalone NEF (RAW) mode. The JPEG in a NEF + JPEG mode works just like a standalone JPEG shot without a NEF (RAW) file.

If you need more information, just refer to the NEF (RAW) or JPEG information above this section.

Now, let's consider which of these formats might become your favorite, and the benefits each might bring to your photography.

Notes on the Image Formats: RAW, TIFF, and JPEG

NEF (RAW) Notes

There are innumerable discussions on Internet camera forums on the subject of "Which is the best image format?"As a primarily RAW-shooting photographer, I have strong opinions on that and will do my best not to be overbearing about it.

Yes, I am a NEF (RAW) photographer about 99% of the time. I think of a RAW, similar to the way I thought of my slides and negatives a few years ago: this is my original file that must be saved and protected. The only problems I can think of for the RAW format are the following:

1. You must post-process and convert every image you shoot into a TIFF or JPEG (or other viewable format).
2. There is no industry standard RAW image format, and Nikon can change the NEF (RAW) format each time they come out with a new camera.

Other than those drawbacks, I—and many others—shoot NEF (RAW) for maximum image quality.

It is important that you understand something very different about NEF (RAW) files. They are not really images ... yet. Basically, a RAW file is composed of sensor data and camera setting information markers. The RAW file is saved in a form that must be converted to another image type to be used in print or on the Web.

When you take a picture in RAW the camera records the sensor data and markers for how the camera's color, sharpening, etc. are set, but does not apply the camera setting information to the image. In your computer's post-processing software, the image will appear on screen using the settings you initially set in your D300. However, they are only applied in a temporary manner.

If you do not like the white balance you had selected at the time you took the picture, simply apply a new white balance, and the image will be just as if you had used the new white balance setting when you took the picture. If you had low sharpening set in-camera, and change it to normal sharpening in-computer, then the image will look just like it would have looked if you had used normal in-camera sharpening when you took the image.

This is quite powerful! Virtually no camera settings are applied to a RAW file in a permanent way. That means you can change the image to completely different settings, and the image will be as if you had used the new settings, when you first took the picture. This allows a lot of flexibility later. If you shot the image initially in what you might think of as "Color Mode I", and now want to use "Color Mode II", all you have to do is change the image to "Color Mode II", and it will be as if you used "Color Mode II" when you first took the picture. Complete flexibility!

NEF (RAW) is generally used by individuals concerned with maximum image quality and who have time to convert the image in the computer after taking it with the camera.

Here are the benefits of the NEF (RAW) format:

NEF (RAW) pros:

- Allows the manipulation of image data to achieve the **highest quality image available** from the camera.
- All original detail stays in the image for future processing needs.
- No conversions, sharpening, sizing, or color rebalancing will be performed by the camera. Your images are untouched and pure!
- Can convert to any of the other image formats by using your computer's much more powerful processor instead of the camera processor.
- You have *much* more control over the final look of the image, since *you* (not the camera) are making decisions as to the final appearance of the image.
- Supports 12-bit or 14-bit color-depth for maximum image data.

And, to be balanced, let's look at the negatives of the NEF (RAW) format.

NEF (RAW) Cons:

- Not compatible with publishing industry, except by conversion to another format.
- Requires post-processing by special proprietary software as provided by the camera manufacturer or third-party software programmers. (This is generally included with the camera.)
- Large file sizes, so you must have sufficient storage media. (Although, not as large as TIFF.)
- No accepted industry standard RAW mode. Each camera manufacturer has its own proprietary format. Adobe has recently introduced a new RAW format called DNG (Digital Negative) that might become an industry standard. We'll see!
- 12-bit or 14-bit color-depth is not really in use, since 8-bit is industry standard.

JPEG Notes

JPEG (.JPG) is used by individuals who want excellent image quality but have little time or interest in later post-processing or converting images to another format. They want to use the image immediately when it comes out of the camera, with no major adjustments. (The initials *JPEG* stand for "Joint Photographic Experts Group.")

The JPEG format applies whatever camera settings you have chosen to the image when it is taken. It comes out of the camera ready to use, as long as you have exposed it properly, and have all the other settings set in the best way for the image.

Since JPEG is a "lossy" format, one cannot modify and save it more than a time or two before ruining the image from compression losses. However, since there is no post-processing required later this format allows much quicker use of the image. A person shooting a large quantity of images who may not have the time, patience or software to convert RAW

images will usually use JPEG. This describes a large number of photographers.

While a nature photographer might want to use RAW, since he has more time for processing images and wringing the last drop of quality out of them, an event or news editorial photographer may not have the time or interest in processing images, so he'll use JPEG.

Here are the pros and cons of using JPEG mode:

JPEG Pros

- Maximum storage of images on camera card and later on computer hard drive storage.
- Fastest writes from camera memory buffer to memory card storage.
- Absolute compatibility with everything and everybody in imaging.
- Uses the industry standard 8-bit color-depth.
- High-quality first-use images.
- No special software needed to use the image right out of the camera. (No post-processing.)
- Immediate use on websites with minimal processing.
- Easy transfer across Internet and as e-mail attachments.

JPEG Cons

- JPEG is a "lossy" format, which means that it permanently throws away image data from compression algorithm losses as you select higher percentages of compression.
- You cannot use JPEG to manipulate an image more than once or twice before it degrades to an unusable state.
- Every time you modify and resave a JPEG image it loses more data.
- May not be as sharp out of the camera as TIFF or RAW modes due to initial camera compression.

TIFF Notes

Finally, let's consider the TIFF format. It is used by those who want to be able to work with their images over and over without throwing away data from compression, like JPEG does.

You can shoot in TIFF if you'd like since the D300 allows it and you'll get excellent 8-bit images. When you shoot TIFF the camera does not compress the image, but it does apply the camera settings to the image file immediately. Since the camera shoots natively in 12-bit or 14-bit, there is some initial data loss in using the TIFF format since some data is thrown away when converting down to 8-bit TIFF. The primary problem with TIFF files is that they are huge and will slow your camera down while it saves those large TIFF files.

Here are the pros and cons of the TIFF format:

TIFF Pros

- Very high image quality.
- Excellent compatibility with the publishing industry.
- Is considered a "lossless" format, since the image normally uses no compression, and loses no more data than the initial conversion from 12 or 14-bits to 8-bits in the camera's software.
- Can modify and resave the images an endless number of times without throwing away image data.
- Does not require software post-processing during or after download from camera, so the image is immediately usable.

TIFF Cons

- Very large files in camera memory, so your ability to take a lot of images requires very large CF storage cards.
- Must have large hard drives on your computer to store these larger images.
- In-camera image processing is slower, so you will be limited in the number of fast pictures you can take.
- Unless you have a high-speed Internet connection, don't even consider sending one of these monsters across the Internet. Even then, you may find you are constrained by your ISP's file-size limitations

Final Image Format Ramblings

Which format do I prefer? Why, RAW, of course! But, it does require a bit of a commitment to shoot in this format. The D300 is simply an image capturing device, and you are the image manipulator. You decide the final format, compression ratios, sizes, color balances, etc. In RAW mode, you have the absolute best image your camera can produce. It is not modified by the D300 and is ready for your personal touch. No camera processing allowed!

If you get nothing else from this chapter section, remember this: By letting your camera process the images in ANY way, it is modifying or throwing away image data. There is only a finite amount of data for each image that can be stored on your camera, and later on the computer. With JPEG or TIFF mode, your camera is optimizing the image according to the assumptions recorded in its memory. Data is being thrown away permanently in varying amounts.

If you want to keep ALL the image data that was recorded in the image, you must store your originals in RAW format. Otherwise you'll never again be able to access that original data to change how it looks. RAW format is the closest thing to a film negative or a transparency that your digital camera can make.

This is important if you would like to use the image later for modification. If you are a photographer who is concerned with maximum quality, you should probably shoot and store your images in RAW (or even TIFF) format. Later, when you have the urge to make another masterpiece out of the original RAW image file, you will have ALL of your original data intact for the highest quality.

If you are concerned that the RAW format may change too much over time to be readable by future generations then you might want to convert your images into TIFF or JPEG files. TIFF is best if you want to modify them later. I often save a TIFF version of my best files just in case RAW changes too much in the future. Why not do a little more research on this subject and decide which you like best.

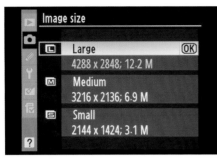

Figure 14 – Image Size screens

Image Size

(User's Manual page 60)

This menu selection only applies to images captured in TIFF or JPEG modes. If you are shooting with your D300 in NEF + JPEG modes, it only applies to the JPEG image in the pair. *(Figure 14)*.

This is relatively simple, since it just affects the megapixel (MP) size of the image. Here are the three settings under *Image size*:

- *Large* – 4288 x 2848 – 12.2 Megapixels
- *Medium* – 3216 x 2136 – 6.9 Megapixels
- *Small* – 2144 x 1424 – 3.1 Megapixels

I've been playing around with these settings for the fun of it. I'm personally not interested in using my 12.2MP D300 as a 6.9MP or 3.1MP camera, but you may have special uses for these settings.

If I set the D300's *Image Quality* to *JPEG basic*, *Image size* to *Small*, and *JPEG compression* to *Size priority*, my D300 will capture 15800 images on an 8-gigabyte card. The images are 3.1MP in size (2144 x 1424 = 3,053,056 or 3.1MP), and compressed to the maximum the D300 will create, but there's a large number of them.

If I were to set off today to walk completely around the Earth, and I had only one 8-gigabyte

CF card to take with me, well, my D300 will give me almost 16000 images on the one card, so I can at least document my trip very well.

White balance

(User's Manual pages 127-146)

We have devoted an entire chapter of this book to *White Balance*. Please turn to **Chapter 4 – White Balance** for detailed information on this important subject.

Set Picture Control

(User's Manual pages 148-155)

As shown in *Figure 15*, there are a series of Set Picture Control screen selections that modify how your D300 captures an image. They are:

- *SD* or Standard
- *NL* or Neutral
- *VI* or Vivid
- *MC* or Monochrome

Each of these settings has a different and variable combination of the following settings:

- Sharpening
- Contrast
- Brightness
- Saturation
- Hue
- Filter Effects (only applies to *MC* – Monochrome)
- Toning (only applies to *MC* – Monochrome)

You can select one of the controls (*SD*, *NL*, *VI*, or *MC*) and leave the settings as they are set at the factory or you can modify the settings (*Figure 15* screen 3) and completely change how the D300 captures the image. If you are shooting in RAW mode, the D300 does not apply these settings to the image, but stores these settings with the

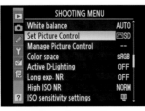 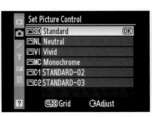 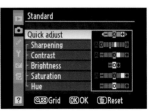

Figure 15 – Set Picture Control screens for setting SD, NL, VI, or MC

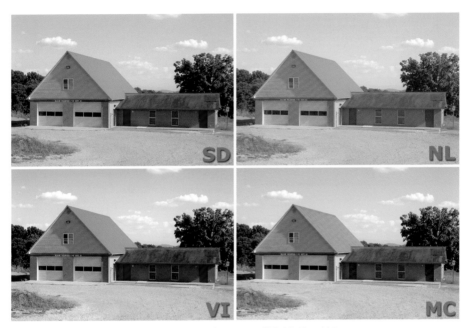

Figure 16 – Four images of the same subject with settings of SD, NL, VI, or MC

image so that you can later change them in-computer.

Let's examine each of the Picture Controls, and then we'll look at the settings.

Picture Controls

SD or Standard is Nikon's recommendation for getting "balanced" results. They recommend SD for most situations. Use this if you later want a balanced image and don't want to post-process it to get it there. It has what Nikon calls "Standard" image processing (*Figure 16*).

NL or Neutral is best for an image that will later be extensively post-processed in the computer. It too is a balanced image but has minimal camera processing so that you'll have room to do more with the image later in the computer.

VI or Vivid is for the Fuji Velvia lovers among us! This setting places emphasis on saturating primary colors for intense imagery. The contrast is higher for good highs and lows, and the sharpness is higher too. If you are shooting JPEGs and want to try and imitate a saturated

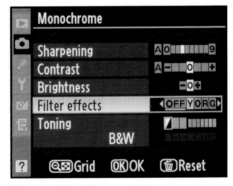

Figure 17 – Filter effects controls

transparency film like Velvia, this mode is for you!

MC or Monochrome allows the Black & White (B&W) lovers among us to shoot natively in toned B&W.

As shown in *Figure 17*, there are *Filter effects* available that simulate the effect of Yellow, Orange, Red, and Green filters on a monochrome image. Yellow, Orange, and Red changes the contrast of the sky in B&W images. Green is

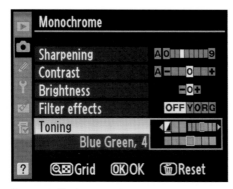

Figure 18 – Toning controls

often used in B&W portrait work to change the appearance of skin tones. You don't have to buy these filters because they are included in your D300! *(Figure 18)*

In addition to the basic *B&W Toning* selection, there are also nine variable *Toning* effects available, varying from *Sepia* and *Cyanotype* to *Red*, *Yellow*, *Green*, *Blue Green*, *Blue*, *Purple Blue*, and *Red Purple*. Each of the *Toning* effects are variable within themselves. You can adjust the saturation of the individual tones. You can shoot a basic B&W image, use filters to change how colors appear, or tone the image in experimental ways.

If you press the *Checkered Thumbnail* button while viewing one of these settings, the camera will show you a grid of settings that is for informational use only (as far as I can tell). You have to adjust the individual settings, such as *Sharpness*, *Contrast*, or *Saturation* in the controls shown in *Figure 15*. If you modify the settings, a small underline character will appear where the previous setting was originally.

Manage Picture Control
(User's Manual pages 156-159)
This section of your D300's *Shooting Menu* allows you to store Picture Control settings for future use. If you modify them under the Picture Control section (just before this one) you are simply creating a one-off setting. If you'd like to set up different combinations of picture controls that you can use later, the D300 is happy to oblige.

There are six screens involved in modifying a default Picture Control and storing the results for later usage. In *Figure 19*, we see the screens involved to modify and save a Picture Control setting.

1. Select *Manage Picture Control* from the *Shooting Menu*.
2. Highlight and select *Save/edit* by scrolling to the right.

Figure 19 – Manage Picture Control screens

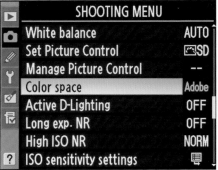
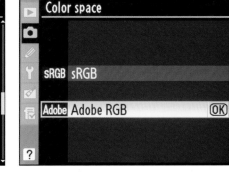

Figure 20 – Color space screens

3. Highlight and select a Picture Control that you want to use as a base for your new settings; scroll right.
4. Make your adjustments to the items such as *Sharpness*, *Contrast*, etc. and when you are done press the *OK* button.
5. Select one of the nine storage areas (named *C-1* through *C-9*) and scroll to the right.
6. You should now be on the *Rename* screen, which works just like the other screens you've used to rename things. See **Setting Up Shooting Menu Bank "A"** at the beginning of this chapter to see how to use the *Rename* controls.
7. Press the *OK* button when you have entered the name.

Your camera is now set to your "custom" Picture Control settings. You can create up to nine of these in *C-1* through *C-9*, and switch between them at will.

Color space

(User's Manual pages 169-170)
Color spaces are an interesting and important part of digital photography, and help your images fit into a much broader range of imaging devices. Software, printers, monitors, and other devices all recognize what color space is attached to your image, and use it (along with other color profiles) to help balance the image to the correct output colors for the device in use.

The two available color spaces have different "gamuts" or range of colors *(Figure 20)*.

The Nikon D300 camera uses these two *Color spaces*:

• *sRGB*
• *Adobe RGB*

Both of these color spaces have an equal number of available colors within them. The difference is that *Adobe RGB* has a wider color gamut. It's not that *Adobe RGB* has more colors than *sRGB*, they are just different colors from a wider selection in the total color range available to the camera.

To make it simple, let's imagine that there are only 1000 colors available to us. Let's say that *sRGB* uses colors 1 through 256. *Adobe RGB* would use colors from a broader selection in the range of 1000 colors. Instead of 1 through 256, *Adobe RGB* might use 1 through 128, then colors 250 to 255, and 300 to 305, and 415 to 420, and 550 to 560, and 895 to 900, and so on. They both use the same number of colors, but the colors come from different places in the color temperature spectrum. *Adobe RGB* uses colors from a broader selection of the total color range, therefore, it has a wider gamut.

I personally always use *Adobe RGB*, since I predominantly shoot nature with a wide range of color. I want as accurate color as my camera will give me.

There are some drawbacks to using *Adobe RGB* though. The *sRGB* color space is widely

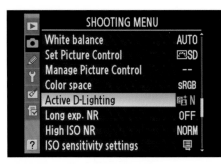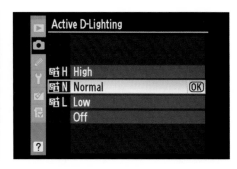

Figure 21 – Active D-Lighting screens

used in printing and display devices. If you try to print directly to some inkjet printers using the *Adobe RGB* color space, the colors may not be as brilliant as with *sRGB*. If you aren't going to modify your images out-of-camera and just take them directly to print, you may want to use *sRGB*. If you only shoot JPEGs, it might be better to stay with *sRGB* for everyday shooting.

If you are a RAW shooter, and regularly post-process your images, you should use *Adobe RGB*. You will then have that wider gamut of colors to work with and can optimize your images. Later, you can convert your carefully crafted images to print with a good color profile and get great results from inkjet printers and other printing devices.

So, a rough way to look at it is:
- JPEG shooters use *sRGB*
- RAW shooters use *Adobe RGB*

These are not hard and fast rules, but most people use the settings above, according to their style of shooting.

Active D-Lighting

(User's Manual pages 167-168)
Often the range of light around our image subject is broader than the D300's sensor can capture. Where the D300 might be able to capture 4 to 6 stops of light, the light out in the world on a bright summer day might equal 12 stops in range. The contrast is so high!

Since the D300 cannot grab the full range of light, and most people use the histogram to expose for the highlights, some of the image

detail will be lost in the shadows. The D300 allows you to "D-Light" the image and bring out additional shadow detail or (in other words) lower the image contrast *(Figure 21)*.

Active D-Lighting has these settings:
- *High*
- *Normal*
- *Low*
- *Off* (no *Active D-Lighting*)

If you are familiar with Nikon Capture NX you may already know how D-Lighting works, since you can use it to bring up "lost" shadow detail at the expense of adding noise in the darker areas recovered.

Active D-Lighting will bring out detail in areas of your image that are hidden in shadow due to excessive image contrast. *Figure 22* shows a series of four images with active D-Lighting set to its various levels.

You'll need to experiment with the *Active D-Lighting* settings to see which you like best. It has the effect of lowering contrast, and some people do not like low-contrast images. Also, any time you recover lost detail from shadows, there will be extra noise in the areas recovered. So watch the noise!

Long Exposure NR

(User's Manual page 262)
Nikon knows its sensors well. They feel that images taken at exposures longer than eight seconds may exhibit more noise than is acceptable for normal use. They provide two settings

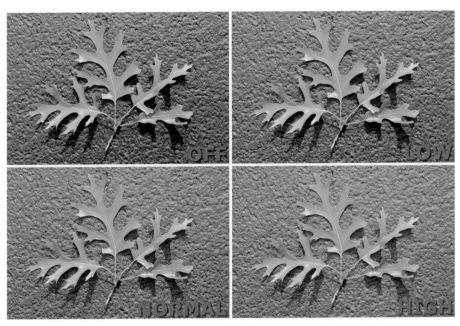

Figure 22 – Active D-Lighting images, showing effects of all four settings

Figure 23 – Long Exposure NR screens

for long exposure noise reduction, as shown in *Figure 23*.

The two choices are:
- *On*
- *Off*

On: When you select *On*, and your exposure goes over eight seconds, the D300 will take two exposures with the exact same time for each. The first exposure is the normal picture taking exposure. The second is a "black frame subtraction" exposure in which an image is made for the same length of time as the first one, but with the shutter

closed. The noise in the second "black frame" image is examined, and subtracted from the original image. It's really quite effective and beats having to blur the image to get rid of noise. I've taken images of around 30 seconds and had perfectly usable results. The only drawback is that the exposure time is doubled since two images are taken.

When the second "black frame" image is being taken, the words "Job nr" will blink in the Control Panel LCD, and in the viewfinder. During this second exposure (while *Job nr* is flashing) you cannot use the camera. If you turn

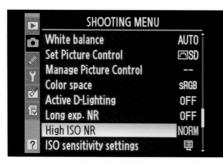 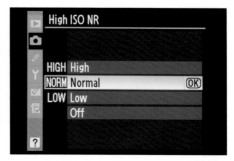

Figure 24 – High ISO NR screens

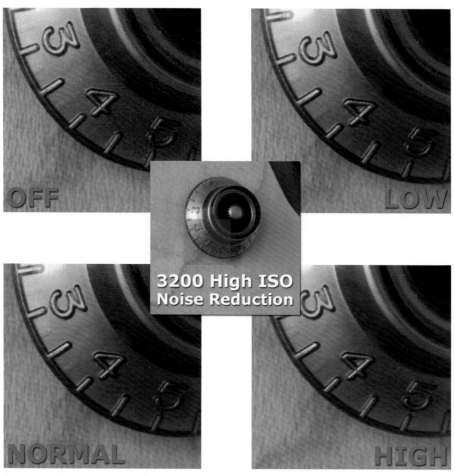

Figure 25 – ISO 3200 image at all four noise reduction settings

it off while *Job nr* is flashing then the camera still keeps the first image, but does not apply any noise reduction on it.

If *Long Exposure Noise Reduction* is *On*, the frame-advance rate may slow down, and the capacity of the in-camera memory buffer will drop.

Off: If you select *Off*, then, of course, you will have no noise reduction with long exposures above ISO 800, unless you exceed ISO 3200, as discussed in the next section.

High ISO Noise Reduction
(User's Manual page 263)
The D300 has better noise control than most cameras so it is able to shoot up to ISO 800 with little noise. However, no digital camera is completely without noise (that I know of) so it is a good idea to use some noise reduction above a certain level of exposure gain. With the D300 the ISO can go up to 800 without noise reduction. After that, you must choose to allow or disallow *High ISO Noise Reduction* (NR). *Figure 24* shows the selections:

- *High*
- *Normal* (factory default)
- *Low*
- *Off*

For any of the settings above (except *Off*) *High ISO Noise Reduction* will be performed starting at ISO 800. You'll need to shoot some high ISO exposures and decide for yourself whether you are comfortable with *High*, *Normal*, *Low*, or even *Off*. *Figure 25* is an image taken at a worst-case ISO 3200 with NR set to *Off*. I then retook

the same image at *High*, *Normal*, and *Low* settings:

Even if you turn *High ISO Noise Reduction* off, the D300 will still apply NR when you exceed ISO 3200. The official starting point for forced *High ISO Noise Reduction* is HI 0.3, which (if I understand correctly) is between ISO 3200 and ISO 6400, with HI 0.3 being 1/3 stop above ISO 3200. There are two other 1/3 stop levels above HI 0.3, namely HI 0.7, and HI 1, which should approximate ISO 6400.

It seems like a good idea to have High ISO Noise Reduction turned on, at least at the *Low* level. I leave mine on *Normal*.

ISO Sensitivity Settings
(User's Manual pages 96-99)
An ISO number, such as ISO 200 or ISO 3200 is an agreed-on sensitivity for the image capturing sensor. Virtually anywhere in the world, all camera ISO numbers will mean the same thing. With that fact established, camera bodies and lenses can be designed to take advantage of the ISO sensitivity ranges they will have to deal with. Standards are good!

In the D300, the ISO numbers are sensitivity equivalents. Consider ISO "sensitivity" as the digital equivalent of film speed. The higher the ISO sensitivity the less light needed for the exposure. A high ISO setting allows higher shutter speeds and smaller apertures.

In *Figure 26*, we see the external camera controls used to adjust ISO quickly. This is the easiest method to change the camera's ISO setting.

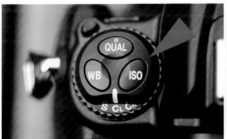
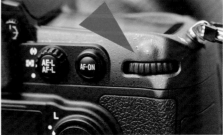

Figure 26 – ISO external controls: ISO button and Main command dial

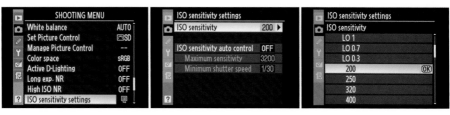

Figure 27 – ISO sensitivity settings screens

You can also use the *Shooting Menu's - ISO sensitivity settings* screens. *Figure 27* shows the screens used to change the camera's ISO.

Notice in screen three of *Figure 27* that you have a scrollable list of ISO values, starting from LO 1 (ISO 100) all the way to HI 1 (ISO 6400). The normal ISO range for the D300 is ISO 200 to ISO 3200. Select your needed ISO from the list of available ISOs.

The standard minimum *ISO sensitivity setting* for the D300 is ISO 200. You can adjust the camera in a range from ISO 100 through ISO 6400, in 1/3 steps.

The D300 is very flexible in the number of increments allowed while adjusting the ISO sensitivity. According to how you have *Custom Setting b1* set, the ISO numbers can be adjusted in 1/3, 1/2, or 1 EV steps.

Below is a chart that shows the ISO ranges for all the *Custom Setting b1* settings:

ISO Ranges for *Custom Setting B1*

1/3 EV Step ISO Range
(Custom Setting b1 factory default)

LO 1, LO 0.7, LO 0.3, 200, 250, 320, 400, 500, 640, 800, 1000, 1250, 1600, 2000, 2500, 3200, HI 0.3, HI 0.7, HI 1

1/2 EV Step ISO Range

LO 1, LO 0.5, 200, 280, 400, 560, 800, 1100, 1600, 2200, 3200, HI 0.5, HI 1

1 EV Step ISO Range

LO 1.0, 200, 400, 800, 1600, 3200, HI 1

Select your favorite ISO setting from the above values, either with the external camera controls, or with the *Shooting Menu's - ISO Sensitivity Settings* screens.

You can also simply let your camera decide which ISO it would like to use. Let's consider this often misunderstood feature in detail.

ISO Sensitivity Auto Control (ISO-AUTO)

You may have noticed in screen two of *Figure 27* that there is another setting available, the *ISO sensitivity auto control*, which defaults to *Off*. This was known on earlier Nikon cameras as ISO-Auto, and the term *ISO-AUTO* is used in the D300.

This setting is used to allow the camera to control the ISO according to the light levels sensed by the camera meter. In *Figure 28*, we see the *Shooting Menu* screens used to enable and configure *ISO-AUTO*.

Once you've turned ISO-AUTO on you should set two values, according to how you shoot:

• *Maximum sensitivity*
• *Minimum shutter speed*

Maximum sensitivity – This setting is a safeguard for you. If you would prefer that ISO-AUTO not exceed a certain ISO, simply select from the list shown in *Figure 29*.

You'll note that there are only five available settings ranging from ISO 400 through HI 1. Whichever one of these settings you choose will be the maximum ISO the camera will use to get a good exposure when the light drops.

Minimum shutter speed – Since shutter speed controls how sharp an image can be, due to camera shake and subject movement, you'll need some control over the minimum shutter

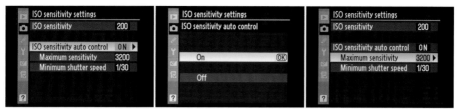

Figure 28 – Screens to set ISO-AUTO

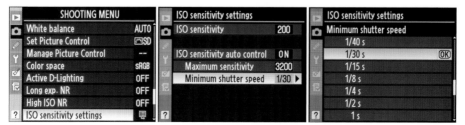

Figure 29 – Setting ISO-AUTO Maximum sensitivity

High ISO Noise Reduction

It might be a good idea to enable *High ISO Noise Reduction* as discussed a few pages back, when you enable ISO-AUTO. This is especially true if you leave the camera set to the default maximum ISO value of 3200. Otherwise, you may have excessive noise when the light drops.

speed allowed while ISO-AUTO is turned on. See *Figure 30* (screen 3) for a list of shutter speeds.

You can select a shutter speed from the list, and it will be set as the minimum shutter speed the camera will allow when the light gets darker.

When you have enabled ISO-AUTO the Control Panel LCD and viewfinder will show and blink the words "ISO-AUTO." The blinking is a reminder to turn it off when not needed, so that you don't get unnecessarily noisy images.

When and Why Should I Use ISO-AUTO?

How much automation do you need to produce consistently excellent images?

Normally you will set your camera to a particular ISO number, such as 200 or 400, and shoot

your images. As the light diminishes or you find yourself in the deep shade, you might increase the ISO number to allow handheld images to continue being made.

If you are in circumstances where you absolutely must get the shot, ISO-AUTO will work nicely. Here are a few scenarios:

Scenario # 1

Let's say you are a photojournalist and you're shooting flash pictures of an important news personality as he disembarks from his airplane, walks into the terminal, and drives away in his limousine. Under those circumstances you will have little time to check your ISO settings or shutter speeds and will be shooting in widely varying light conditions.

Figure 30 – Selecting ISO-AUTO Minimum shutter speed

Scenario # 2

You are a wedding photographer in a church that does not allow the use of flash. As you follow the bride and groom from the dark inner rooms of the church, out into the lobby, and finally up to the altar, your light conditions will be varying constantly. You have no time to deal with the fluctuations in light by changing your ISO since things are moving too quickly.

Scenario # 3

You are at a party and you want some pictures. You want to use flash but the pop-up Speedlight may not be powerful enough to reach across the room at low ISO settings. You really don't want to be bothered with camera configuration at this time but still want some well exposed images. Light will vary as you move around the room, talking and laughing, and snapping pictures.

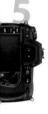

These scenarios are excellent environments for ISO-AUTO. The camera will use your normal settings (such as your normal ISO, shutter speed and aperture) *until* the light will not allow those settings to provide an accurate exposure. Only then will the camera raise or lower the ISO value to keep the camera functioning within the shutter/aperture parameters you have set.

Look at ISO-AUTO as a "failsafe" for times when you *must get the shot*, but have little time to deal with camera settings, or when you don't want to vary the shutter/aperture settings but still want to be assured of a well exposed image.

Unless you are a private detective shooting handheld telephoto images from your car, or are a photojournalist or sports photographer who *must get the shot every time* regardless of maximum quality, I personally would not recommend leaving your camera set to ISO-AUTO. Use it only when you really need to get the shot under any circumstances!

Of course, if you are unsure of how to use the "correct" ISO for the light level, don't be afraid to experiment with this mode. At the very worst all you might get are noisier than normal images.

Are There Any Drawbacks to Using ISO-AUTO?

Maybe, but it really depends on how widely varying the light conditions will be when you are shooting. Most of the time your camera will maintain normal ISO range settings in ISO-AUTO so your images will be their normal low-noise, sharp, masterpieces. However, at times the light may be so low that the ISO may exceed the "normal" range of ISO 200 through ISO 800, and will start getting into the noisier ranges above ISO 800.

Just be aware that ISO-AUTO can and will push your ISO into a range that causes noisier images when light levels drop. Use it with this understanding and you'll do fine. ISO 6400 is the maximum in ISO-AUTO, unless you have set the maximum to a lower number. Make sure you understand this, or you might get some noisy images.

ISO-AUTO is yet another feature in this powerful Nikon camera. Maybe not everyone needs this "failsafe" feature, but for those who do, it must be there. I will use it myself in circumstances where getting the shot is the most important thing, and where light levels may get too low for normal ISO image making.

Even if you think you might only use it from time-to-time, do learn how to use it for those times. Experiment with ISO-AUTO. It's fun and can be useful!

Live View

The *Live View* mode is covered in great detail in **Chapter Three – Multi-CAM 3500DX Autofocus**. Please refer to that chapter for information on setting and using *Live View*.

Multiple exposure

(*User's Manual pages 186-190*)
"Multiple exposure" is the process whereby you take more than one exposure on a single "frame" or picture. Most of us will only do "double exposures" which is two exposures on one frame. It requires you to figure the exposure values carefully for each exposure so that,

Figure 31 – Multiple exposure set up screens

in the end, all the combined exposures equal one normal exposure. In other words, if you are going to do a non-masked double exposure, your background will need two exposures at ½ the normal exposure value to equal one normal exposure.

The D300 allows us to figure our own exposure settings and do them manually, or gives us "Auto Gain" to help us with exposure calculations.

There are really only three steps to setting up a multiple exposure session. However, there are six *Shooting Menu* screens we'll use to do these three steps, which are as follows:

1. Select the *Number of shots* you want to take from the *Shooting Menu* screens.
2. Turn *Auto Gain* on or off according to how you want to control exposure.
3. Take the picture.

Let's consider each of the screens we see in *Figure 31*, and discover how to set up the *Multiple exposure* system.

Using *Figure 31* as a reference, do the following:

1. Select *Multiple exposure* from the *Shooting Menu* (screen 1).
2. Select *Number of shots* from screen 2, scroll right.
3. Select a number of shots on screen 3 (any number between 2-10).
4. Press the *OK* button to lock in the number of shots.
5. Select *Auto gain* from screen 4, scroll right.
6. Select *On* in screen 5.
7. Press the *OK* button to turn *Auto gain* on.
8. Select *Done* from screen 6 and press the *OK* button.
9. Shoot your images from a tripod.

Once you've selected a *Number of shots*, the camera remembers the value and comes back to it for the next session. To repeat another series of multiple exposures with the same settings you'll have to use screen 2 again (*Figure 31*) and select *Done*, then press the *OK* button. These steps prepare the camera to do the multiple exposures in the same way as last time, by remembering the previous *Number of shots* and other settings until you reset them (using screen 2).

If the D300's *Release mode* is set to either *CH* or *CL*, the shutter is triggered *Number of shots* in a single burst; otherwise, you will need to press the shutter release button for each of the *Number of shots* exposures.

Understanding Auto Gain

Auto Gain defaults to *On*, so you need to understand it well.

Auto Gain only applies if you want to make a number of exposures with the exact same exposure value for each. If you want to make two exposures, the camera will meter for a normal exposure and then divide the exposure in half for the two shots. For three shots, it will divide the exposure by 1/3 each, four shots by 1/4 each, eight shots by 1/8 each... and so forth.

In other words, it will take the normal exposure for a single shot and divide it by the number of shots, so that when you are done, you have the equivalent of a single good exposure.

Here is another way of looking at it: if I want a two-shot multiple-exposure I normally want the background to get ½ of the normal exposure in each shot, so that it will appear normal in the final image. *Auto Gain* does that automatically. If I need four shots, I only want the background to get ¼ of a normal exposure for each shot so that I'll have a normally exposed background when the four shots are taken.

The reason I mentioned this in such a repetitive fashion is that it took me a little while to wrap my brain around the confusing presentation of this issue in the User's Manual. Whoever heard of "gain" meaning dividing something into parts? What I think the manual writers were trying to say is that each shot "gains" a portion of the normal exposure, so that in the end the exposure is complete and correct. I hope this makes sense to you!

Auto Gain is, therefore, like an automatic normal exposure "divider-upper" for multiple exposures. It divides up the exposure into appropriate sections, so you won't have to fool with it.

When should you use *Auto Gain*? Only when you have no need for controlling exposure differently on each frame, but, instead, can use an exact division of similar exposures.

Auto Gain works fine if you're not using masks. When you use a mask, you want a full normal exposure for each of the uncovered (non-masked) sections of the image, so *Auto Gain* will not work for this. In this case, you should use *MANUAL* exposure with *Auto Gain* turned off instead.

Interval timer shooting
(User's Manual pages 191-197)
Interval timer shooting allows you to set up your D300 to shoot a series of images over time. Make sure you have a full battery (or are connected to a full-time power source) for images taken over long periods of time.

The first step in using *Interval timer shooting* is to make sure that your World Time (where you are located on the earth), and time & date are set correctly in the *Setup Menu* of your D300. The *Setup Menu* is two menus below the *Shooting Menu*. It is right below the *Custom Settings* menu. If you don't have your World Time set on the D300, your *Interval timer* screen will be grayed out and you won't be able to use it.

Figure 32 shows the *Shooting Menu* screens used to set *Interval Timer Shooting*.

The screens look a little daunting, so it might help you to understand that the bottom half of screen 2 in *Figure 32* is informational in nature. It shows the settings you will create with the top half of the screen.

There are four steps to setting your camera for *Interval timer shooting*. They are:
1. Choose a *Start time*.
2. Choose an *Interval*.
3. Choose the number of intervals.
4. Choose the number of shots per interval.
So, if I wanted to take a series of images starting at *Now* (starting time) and shoot for every 10 seconds (*Interval*), making 2 images per

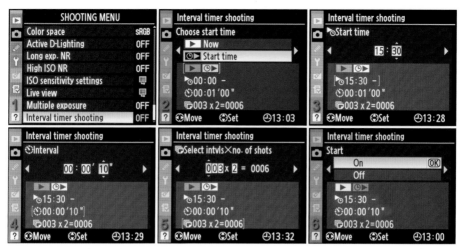

Figure 32 – Interval timer shooting setup screens

interval (number of shots), over a period of 30 seconds (number of intervals), I would set the following:

1. Under screen 2 of *Figure 32*, you could select *Now* under *Choose start time*, and the timer will start 3 seconds after you complete the rest of these five steps. If you would rather start at a future time, instead of *Now*, simply select "*Start time*" from screen 2, then scroll right. If you select *Now*, please skip step 2 below, and go directly to step 3.

2. You will now see a *Start time* screen (see screen 3 in *Figure 32*) with the time in military 24 hour format looking like this:

 00:00

 Since we want to set this for a future time to start the process, let's choose a time. If I wanted to start at 3:30 PM, I would insert the following in the fields:

 15:30

 This is in 24-hour "military" time instead of the normal 12-hour time with which we are more familiar.

3. You will now see the *Interval* screen with **"Hours : Minutes' Seconds"** in the following format:

 00 : 00' 00"

Since we want to start out with an *Interval* of 10 seconds, let's set the screen to look like this:

00 : 00' 10"

The first pair of digits represents the hours, the second pair represents minutes, and the last pair represents seconds. Since we have chosen an *Interval* of 10 seconds, the number in the third pair of digits should be "10" representing 10 seconds (see screen 4 in *Figure 32*). Scroll to the right.

4. Now we'll select the number of Intervals, using screen 5 in *Figure 32*.

 This screen will say: **"Select intvls X no. of shots"**. The formula below that heading is in the following format:

 Number of intervals x Number of shots = Total shots:

 000 x 0 = 0000

 Use the Multi Selector to set your D300 so that it looks like this instead:

 003 x 2 = 0006

This means that there will be 003 intervals of 10 seconds each (set in step 3 above) and that the camera will take 2 pictures in each interval for a total of 0006 pictures. In other words, 2 pictures will be taken every 10 seconds over a period of 30 seconds for a total of 6 images. Now scroll to the right to the next screen.

5. Using screen 6 of *Figure 32*, select *On* and press the *OK* button, and a **"! Timer Active"** message will appear briefly on your Monitor LCD. If you look at the Control Panel LCD, you will see the word *INTERVAL* flashing. This will keep flashing as long as the interval timer is in operation.

To pause or stop an interval from being timed and cease timer operations simply select the *Interval timer shooting* screen and scroll to the right. You can select *Pause* or *Off* from the next screen. It will also show you the *Starting Time, Current Time, Number of Intervals* and *Number of Shots* remaining (in case you don't want to pause or stop it, but just want to see how things are going).

During timed-interval operations, while the *INTERVAL* word is flashing on the Control Panel LCD, the number of intervals remaining will be displayed in the same spot the shutter speed is normally displayed on the Control Panel LCD, and the place that normally displays the aperture will instead display the number of shots remaining in the current interval (see page 194 of your User's Manual under the sub-heading During Shooting.)

The Eyepiece Cap

If you are shooting this timed interval in daylight hours, be sure to use the little eyepiece cap (DK-5) supplied with your D300. Otherwise, changes in the light from behind the camera could cause the exposure to be inaccurate.

Congratulations! You've fully configured *Shooting Menu* Bank A.

Now, set up another bank or all the shooting banks, and rename them by repeating the steps above in **Setting Up Shooting Menu Bank "A"**. Remember that you have four *Shooting Menu* banks, and we've only configured one of them.

My Conclusions

Using the D300's four *Shooting Menu* banks allows you a great deal of flexibility in how your camera operates. By selectively configuring each bank, you can essentially switch between four different cameras.

When you combine the use of the four *Shooting Menu* banks with the four *Custom Setting* banks (covered in the next chapter), you'll have an expanded number of ways to configure your camera for specific, personally defined purposes.

Custom Setting Banks

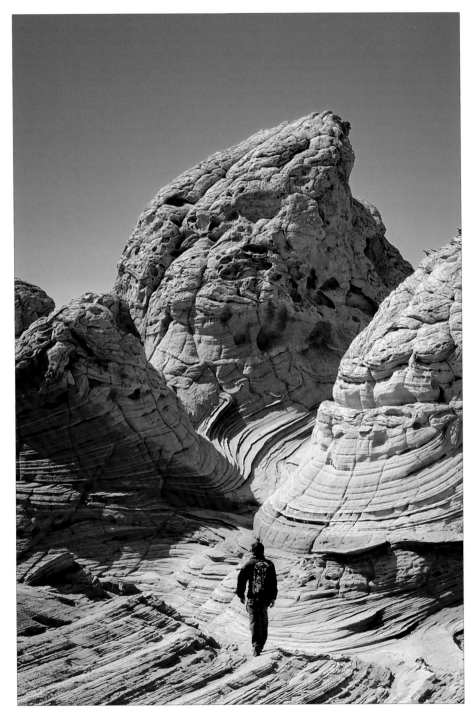

In Chapter 5, we carefully considered the configurability of the Nikon D300 and its *Shooting Menu* banks. Now we will continue with this process by going over the *Custom setting* banks in great detail.

Each of those settings can be configured in different ways. When combined with the *Shooting Menu*, the *Custom Setting Menu* allows you to configure your D300 in a variety of ways.

This chapter will help you develop a much better understanding of your favorite digital shooter. Without further ado, let's dive right into the settings and see what they each do.

Setting Up Custom Setting Bank "A"

First, we'll consider the process of renaming bank A on our D300 so that we'll know what style of shooting this bank is configured to support.

In the last chapter, we discussed how to rename a *Shooting Menu* bank to a name that describes its functionality. Changing the name of a *Custom setting* bank works exactly the same way. If you are familiar with the process, you can just name your bank and skip this first section.

Renaming Custom Setting Bank A
Press the *MENU* button on the back of your D300, and use the Multi Selector to scroll to the left, then up or down until you find the *Custom Setting Menu* (looks like a small pencil on the left of the Monitor LCD), then scroll to the *Custom setting bank* line.

Notice, in the first screen of *Figure 1*, that *Custom setting bank* has an "A" after it. This means that your D300 is using bank A. If any

letter other than A is showing, you are in a different *Custom setting* bank. Let's set the D300 bank to A, and add a bank name so that you'll be able to see at a glance what this particular bank is set up to accomplish. Scroll the Multi Selector to the right. The Monitor LCD will change to look like screen two of *Figure 1*.

Assuming that you have not yet renamed any of your *Custom setting* banks, you'll see the four default banks called A, B, C, and D, and a selection called *ABC Rename*. Scroll down to *ABC Rename* and then scroll to the right. Your screen will now look like the third screen in *Figure 1*. This is the bank "rename" screen. The factory default for an unnamed bank is simply a blank field. In other words, if you haven't yet named your banks, you'll simply see the single capital letter for that bank, followed by a blank field. Let's rename our bank, by selecting bank A, and then scrolling to the right. The screen will now look like the fourth screen in *Figure 1*.

You'll see a series of symbols, numbers, and letters on top, with a line of dashes at the bottom. The dashes are where we will put our text to rename the bank. In the upper left corner of the characters area is a blank spot which represents a blank character for insertion in the line of text, which is helpful for separating words. If you scroll down past the uppercase letters, you'll find some lowercase letters too.

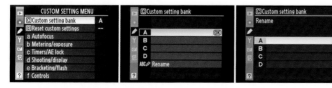
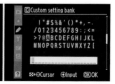

Figure 1 – Renaming *Custom setting* banks

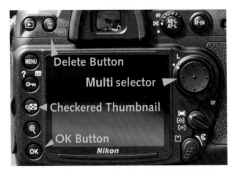

Figure 2 – Camera controls for renaming banks: Multi Selector, *Checkered Thumbnail*, *Delete*, and *OK* buttons

Below is a series of steps to use while creating the new bank name. Refer to *Figure 2* for the camera controls to use in renaming.

Steps to input new characters:

- Use the Multi Selector to scroll through the numbers and letters to find the characters you want to use. Scroll down for lowercase letters.
- Press the center of the Multi Selector to select a character. Keep selecting new characters until you have the entire new bank name in place.
- If you make a mistake, hold down the *Checkered Thumbnail* button while using the Multi Selector to move to the position of the error. Push the garbage can "Delete" button on the top left of the back of the D300. The unwanted character will disappear.
- Press the *OK* button to save the new name.

Excellent! You have named bank A to a more meaningful name so that you can quickly recognize the custom set of functions.

Now, scroll the Multi Selector to the left until the *Custom Setting Menu* appears, or just press the *MENU* button to return to the start.

Configuring the Custom Settings

Let's start by looking at the *Reset custom settings* screen. Then we'll proceed through all 48 of the individual *Custom settings*.

Reset custom settings

Be careful with this selection. It does what it sounds like, and resets the *Custom setting* menu for the currently selected bank back to factory default settings. Page 399 of the User's Manual shows the default settings.

This is a rather simple process. As seen in screen two of *Figure 3*, simply scroll to *Yes* or *No* and press the *OK* button, or scroll to the right. That's about it. If you select *Yes*, the *Custom setting* bank you're currently using will be reset to factory defaults.

Autofocus

(User's Manual pages 267-274)
Custom setting a1 to a10
Custom settings a1 and a2 – AF-S and AF-C priority selection

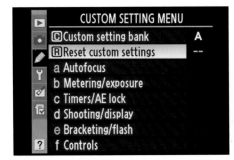

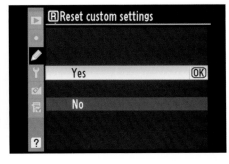

Figure 3 – *Reset custom settings* screens

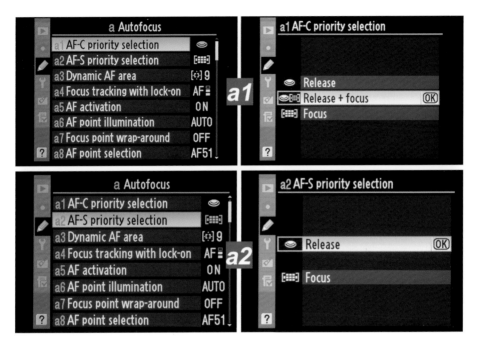

Figure 4 – *Autofocus* screens

Shown in *Figure 4* are the screens used to configure *Custom settings a1* and *a2*. I have combined these two settings into one section, since they are closely related and work basically the same way.

These particular settings help control how your camera's autofocus works in *Continuous-servo AF* or *Single-servo AF*. (For a review of these *Focus Modes*, see **Chapter 3 – Multi-CAM 3500DX Autofocus**.)

Focus – This setting is designed to prevent your D300 from taking a picture with the viewfinder's green in-focus indicator off. In other

Important Note Regarding a1 and a2

Please read the following section entitled **"Special Section on the Usage of a1 and a2."** Configuring *a1* and *a2* correctly will affect how many in-focus images you can capture. It is very important that you understand why, or you may get quite a few out of focus images.

words, if the picture is not in focus, the shutter will not release. It does not mean that the camera will always focus on the correct subject. It simply means that when your camera has focused on something out there, it allows the shutter release to activate. Nikon cameras do a very good job with autofocus, so you can usually depend on the AF Module to perform well. *Focus* will drastically increase your chances that your image is in correct focus.

Release (AF-C and AF-S) *or* **Release + focus** (AF-C only) — If the image must be taken, no matter what, then you will need to set *a1* and/ or *a2* to *Release*, or *Release+focus* (AF-C only). *Release* allows the shutter to fire every time you press it, even if the image is not in focus. *Release+focus* slows the frame rate for improved focus when the light is low, or the subject has little contrast with its surroundings, but still allows the shutter to fire even if it cannot find a good focus point. Just be aware that if you select either of these settings your D300 will take the picture even if the focus is not sharp. If you are well aware of the consequences of shooting

without a focus guarantee then use these settings to make your camera take a picture every time you press the shutter release or *AF-ON* button (*see Custom setting a5*). Your camera will shoot at its maximum frames per second (FPS) rate since it is not hampered by validating that each picture is in correct focus. You'll need to decide whether taking the image is more important than whether the image is in focus.

Custom setting a1 – for Continuous-servo AF (User's Manual pg. 267):

1. **Release** (default) – Photo can be taken at any time, even if not in focus.
2. **Release+focus** – Photo can be taken at any time, even if not in focus. The camera will slow down its maximum FPS rate when the subject is in low light, or low contrast.
3. **Focus** – The image must be in focus, or the shutter will not release. This also means that the shutter will not release unless the little green viewfinder light is on. This is the closest thing to a guarantee that your image will be in focus when you press the shutter release button.

Custom setting a2 – for Single-servo AF (User's Manual pg. 268):

1. **Release**– Photo can be taken at any time, even if not in focus.
2. **Focus** (default) – The image must be in focus, or the shutter will not release. This also means that the shutter will not release unless the little green viewfinder light is on. This is the closest thing to a guarantee that your image will be in focus when you press the shutter release button.

Special Section on the Usage of a1 and a2

Before we proceed to the next *Custom setting*, (*a3*), please consider the following special information.

Release priority vs. Focus priority (Custom settings a1 and a2)

Two of the more important settings in the *Custom settings* list are *a1* and *a2*. I am adding this special section so you'll understand why to pay very close attention to these two settings.

The two settings, *a1* and *a2*, are very important because they can affect how many images you get that are truly in sharp focus. These two set the camera to either *Focus* priority or *Release* priority. These apply to Continuous-servo AF and Single-servo AF. Continuous-servo AF uses *Custom setting a1*, while Single-servo AF uses *Custom setting a2*.

Focus priority simply means that your camera will refuse to take a picture until it can reasonably focus on something. *Release* priority means that the camera will take a picture when you decide to take it, whether anything is in focus or not!

Now, you might ask yourself, "Why is there such a setting as *Release* priority?"

Well, many professional photographers are shooting high-speed events at high-frame rates, taking hundreds of images, and are using depth-of-field (or experience and luck) to compensate for less than accurate focus. They are in complete control of their camera's systems, having a huge amount of practice in getting the focus right where they want it to be.

There are valid reasons these photographers have for not using *Focus* priority. However, most of those same photographers do not let the shutter release button start the autofocus either, since the focus would change every time the shutter release button is pressed. They set *Custom setting a5* so that the autofocus doesn't even activate until the *AF-ON* button is pressed. They then use the *AF-ON* button for their autofocus, and the shutter release button to take the picture. They separate the two functions instead of using the shutter release button for both.

You need to ask yourself, "What type of a photographer am I?" If you are a pro, shooting hundreds of pictures of fast race cars, *Focus* priority may not be for you. But, for the average photographer taking pictures of his kids running around the yard, a deer jumping a fence, beautiful landscapes, flying birds, or a bride tossing a bouquet, *Focus* priority is the best

choice. For most of us, it's better to have the camera refuse to take the picture unless it's able to focus on your subject.

When shooting at a high frame-rate, focus priority may cause your camera to skip a series of out-of-focus images. *Focus* priority will also slow down your camera's frame rate so that it will not reach the maximum 6 frames per second, in some cases. But, I have to ask, what is the point of 5 out-of-focus images and 5 in-focus images? Why waste the card space, and then have to weed through the slightly out-of-focus images?

I wanted you to pay special attention to these two settings. You will need to decide, based on your style of shooting, whether you want your D300 to refuse to take an out-of-focus image. If you set *a1* and *a2* to Focus priority and you try to take an out-of-focus image, the D300's shutter release will simply not respond. The little round green in-focus indicator in the viewfinder will have to be on before the shutter will release.

Personally, I set both *a1* and *a2* to *Focus* priority. I am not a high-speed shooter, so I don't need my camera to take a picture "no matter what" if that includes a series of out-of-focus images. What good are out-of-focus images?

Custom setting a3 – Dynamic AF area

Figure 5 shows the screens used to configure *Custom setting a3*.

This custom setting is designed to assist you with how *Dynamic-area AF* works. See the section "**AF-Area Modes in Detail**" in Chapter 3 for more information on *Dynamic-area AF*.

Review

Dynamic-area AF works by allowing you to control a single AF sensor, and initiate good focus with it. You can move your AF sensor selection around among the 51 sensors in the viewfinder by using the Multi Selector. Once sharp focus has been achieved with your selected AF sensor, the camera can track the subject, even if it loses focus on the subject with your selected sensor. It does this by allowing you to select extra sensors surrounding your selected sensor, in patterns. The patterns are 9 points, 21 points, or 51 points. Of course, if you select 51 points, all the AF sensors are in use. If you've selected 9 points, or 21 points, you can move this entire pattern in the viewfinder by using the Multi Selector. Unfortunately, you can only see the primary AF sensor you selected, not the pattern. Let's see how to set up the "points" pattern you decide to use.

Custom setting a3

(User's Manual, pg. 269):

1. **9 points** (default) – Use this setting when your subject is moving predictably. This uses an array of 8 AF sensors surrounding your selected and viewable AF sensor in the viewfinder. Examples might be subjects in a car race or airshow.

2. **21 points** – If your subject is moving unpredictably, this may be your best choice. This uses 20 sensors surrounding your viewable

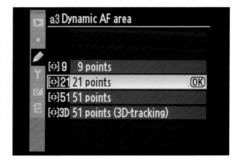

Figure 5 – *Custom setting a3* screens

Focus Tracking — Important Note

Very important! Please review the next section (*Custom setting a4*) about *Focus tracking with lock-on*. *Custom setting a4* is critical for working with sensor patterns and Dynamic-area AF. If you do not set *a4* to enabled (*On*), you may not be able to track your moving subject if an object comes between you and the subject briefly.

sensor in the viewfinder. A good example for this pattern setting might be players in a football or basketball game.

3. **51 points** (3-D-Tracking) – This is for worst-case scenario subjects that are small or moving rapidly and unpredictably, to the point that it is even hard to keep them in the viewfinder. All 50 sensors surrounding your selected sensor are active. An example might be a bird in flight.

Custom setting a4 – Focus tracking with lock-on

Here are the screens used to configure *Custom setting a4* and its "Lock-On" time-out period:

Custom setting a4 – (User's Manual pg. 270)

Custom setting a4 allows you to select the length of time that your camera will ignore an intruding object that blocks your subject. The a4 setting specifies the following:

- *Long* (about 2 seconds)

- *Normal* (about 1.5 seconds) This is the default setting.
- *Short* (about 1 second)

This allows you to fine tune how you want *Focus tracking with lock-on* to work. It can ignore an intruding subject for a second or more.

With Single-point AF, the camera will start the lock-on timeout as soon as the single AF sensor is unable to detect the subject.

With Dynamic-area AF or Auto-area AF and *Focus tracking with lock-on* enabled, I was amused at how adamant the camera was about staying with the current subject. I'd focus on a map on the wall, and then cover most of the focusing sensors with the D300 manual. As long as I allowed at least one or two AF sensors to remain uncovered so it could see the map, the focus did not switch to the manual. I could just hear the D300 muttering, "Hah, you can't fool me, I can still see a little edge of that map there, so I'm not changing focus!"

Only when I stuck the D300 manual completely in front of the lens, covering all the sensors, did the D300 decide to start timing the *a4* Lock-On time-out. After a second or two, the D300 would give up on the map and focus on the manual instead.

Try this yourself! It's quite fun, and will teach you something about the power of your camera's AF system.

Special Section on the Usage of Custom setting a4

Focus tracking with lock-on is a focus algorithm that allows your D300 to maintain focus on a

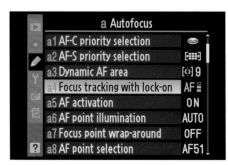

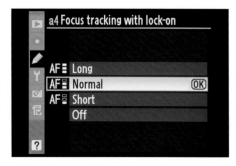

Figure 6 – Custom setting a4 screens

subject and ignore anything that comes between the camera and the subject for a period of time. It will "lock-on" and track where that subject is on the array of focus sensors. It is controlled by configuring *Custom setting a4* to a duration period or to *Off*.

This is a technology that has some misunderstanding surrounding it. Since it is designed to cause the autofocus to hesitate for a variable time period before seeking a new subject, it may seem to make the camera seem sluggish to some users.

But, this "sluggishness" is really a feature designed to keep you from losing your subject's tracked focus. Once the camera locks on to a subject's area of focus, it tries its best to stay with that subject even if it loses the subject briefly. That keeps the lens from racking in and out, and searching for a new subject as soon as the previous subject is no longer under an AF sensor.

It also causes the camera to ignore other higher-contrast, or closer intruding subjects while it follows your original subject. You will have to judge the usefulness of this technology for yourself. I suggest that you go to some event, or down to the lake, and track moving objects with and without Lock On enabled. Your style of photography has a strong bearing on how you'll use (or whether you'll use) *Focus tracking with lock-on*.

Custom setting a4 has little to do with *how well* the D300 focuses. Instead, it is concerned with what it is focused on. Here are some good reasons to leave *Custom setting a4* enabled in your D300.

Dynamic-area AF and Auto-area AF, with *Custom setting a4* set to Off, will instantly react to something coming between your subject and the camera. By enabling *Custom setting a4*, the camera will ignore anything that briefly gets between you and your subjects. If you turn *a4* off, your camera will happily switch focus to a closer subject even if it only appears in the frame for a moment. A good example of this is when you are tracking a moving subject and just as you are about to snap the picture a closer or brighter object enters the edge of the frame and is picked up by an outside sensor. The camera will instantly switch focus to the intruding subject.

If you turn off *Custom setting a4*, you'll have a camera that doesn't know how to keep its attention on the subject you are trying to photograph if something interferes. When using Dynamic-area AF or Auto-area AF modes, I call turning off *Custom setting a4*, "focus roulette!"

Configuring *Custom setting a4* is not difficult but first, you'll need to decide just how long you want your camera to lock-on to a subject before it decides that the subject is no longer available.

Custom setting a5 – AF activation

Here are the screens used to configure *Custom setting a5 (Figure 7)*.

This setting allows you to choose whether you want the shutter-release button to actually release the shutter. If you leave this setting at the factory default, the AF system will be activated when you press the shutter-release button half way down, or if you press the *AF-ON*

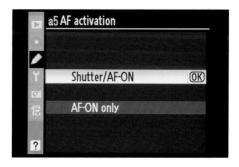

Figure 7 – *Custom setting a5 screens*

button. You can also select the setting that only allows the *AF-ON* button to initiate autofocus, and the shutter release button will not cause autofocus to happen.

> **Custom setting a5** – (User's Manual pg. 271)
> 1. **Shutter / AF-ON** (default) – Autofocus will happen if you press the shutter-release button half way, or if you press the *AF-ON* button.
> 2. **AF-ON Only** – Autofocus only works when you press the *AF-ON* button. The shutter-release button will not cause autofocus, but will only start metering and release the shutter.

Custom setting a6 – AF point illumination

Figure 8 shows the screens used to configure *Custom setting a6.*

This is a control that helps you see the little AF sensor when you first start autofocus. You have seen this little square in your viewfinder when it briefly highlights itself in red and then turns black. Sometimes the background is dark, and it might be difficult to see the black square. If that is the case, and setting a6 is turned off,

you will still have the black square, showing your selected AF sensor, but may not be able to see it. I leave this set to *Auto* on my D300, which is the factory default. See the descriptions below:

> **Custom setting a6** – (User's Manual pg. 271)
> 1. **Auto** (default) – If your background is dark, so that it might be difficult to see your AF sensor in use, it will briefly flash red when you start autofocus by pressing the shutter-release or *AF-ON* button. If the background is bright, and you'll have no trouble seeing your AF sensor's little black square, it does not flash red when you start autofocus.
> 2. **On** – The selected AF sensor is always highlighted in red when you start autofocus, regardless of the light level of the background.
> 3. **Off** - The selected AF sensor does not light up in red when you start autofocus. It always stays black.

Custom setting a7 – Focus point wrap-around

Figure 9 shows the screens used to configure *Custom setting a7.*

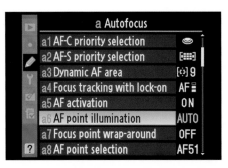

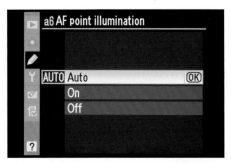

Figure 8 – *Custom setting a6 screens*

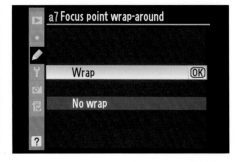

Figure 9 – *Custom setting a7 screens*

When you are scrolling your selected AF sensor to the right or left, or even up and down in the array of 51 sensors, eventually it will come to the edge of the sensor area. The setting allows you to set whether the AF sensor simply stops when it gets to the edge, or scrolls to the other side. So if you are scrolling the AF sensor to the left and come to the edge it will stop, unless you have *a7* set to *Wrap*, in which case it will not stop, and will reappear on the right side of the screen. It "wraps" around. It works the same way in an up and down motion. If you scroll off the top of the sensor area the AF sensor will reappear on the bottom.

Custom setting a7 – (User's Manual pg. 272)

1. **Wrap** – This setting allows the selected AF sensor to scroll off of the viewfinder screen and then reappear on the other side.
2. **No wrap** (default) – If you scroll the AF sensor to the edge of the screen, it stops there! You'll have to press the thumb button in the opposite direction to go back toward the middle.

Custom setting a8 – AF point selection

Figure 10 shows the screens used to configure *Custom setting a8*.

If you scroll your AF sensor often, it might get tiring to scroll through the full 51 focus points. In our older Nikon cameras, we had a maximum of 11 sensors to scroll through, so it wasn't too bad. However, with 51 AF sensors, it

could take longer than you want to scroll from one side of the viewfinder to the other. Or, you might just like the old ways better! Nikon has given you a choice. If you'd rather not scroll through 51 sensors, you can set *a8* to 11 sensors instead.

This does not modify the fact that there are 51 sensors available in *Dynamic-area AF* or *Auto-area AF*. It just means that your Multi Selector will make the selected sensor move farther with each press. It skips over sensors when you scroll in *Single-area AF* and *Dynamic-area AF*. This means that you cannot select "in-between" sensors as selected AF points, so you have a limited choice of sensors to start autofocus.

If you are not happy scrolling through 51 sensors, change it to 11. You can always change it back! Below are the details:

Custom setting a8 – (User's Manual pg. 272)

1. **51 points** (default) – Choose from any of the 51 focus points (AF sensors) when you are scrolling through them.
2. **11 points** – Choose from only 11 focus points (AF sensors) when you are scrolling through them. The other AF sensors are still available for autofocus, you just can't scroll directly to them as some are skipped. That means the Multi Selector will move the selected AF sensor around more quickly.

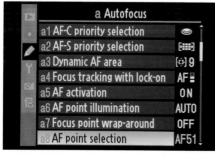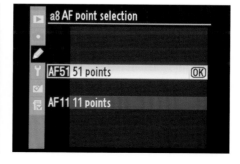

Figure 10 – *Custom setting a8* screens

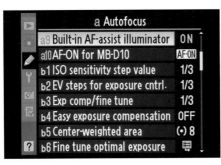
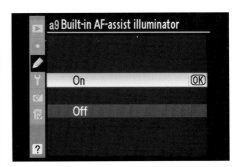

Figure 11 – *Custom setting a9* screens

Custom setting a9 – Built-in AF-assist illuminator

Figure 11 shows the screens used to configure *Custom setting a9*.

You've seen the little autofocus assist light on the front of the D300, near the grip. Well, this setting allows you to control when that little light comes on. Nikon calls this the *Built-in AF-assist illuminator*, and it lights up when low-light conditions are sensed, and when using certain AF-area modes (not all), to help with autofocus.

Custom setting a9 – (User's Manual pg. 273)

1. **On** (default) – If the light level is low, the *AF-assist illuminator* lights up to help light the subject enough for autofocus. This only works in certain modes, though:

 a) Single-servo AF as a Focus Mode at any time it's needed

 b) Auto-area AF as an AF-area Mode any time it's needed

c) Single-point AF and Dynamic area AF as an AF-area Mode if you are using only the center AF sensor as the selected sensor

2. **Off** – The *AF-assist illuminator* does not light up, so cannot help you in low-light autofocus situations. The D300 may not be able to autofocus in low light.

Custom setting a10 – AF-ON for MB-D10

Figure 12 shows the screens used to configure *Custom setting a10*.

This custom setting will only be used by those who have an MB-D10 battery pack attached to their D300 camera bodies. It modifies how the *AF-ON* button on the MB-D10 works, and provides some additional and useful functionality for MB-D10 users. This setting does not modify the functionality of the *AF-ON* button found on the D300 body. Note that using the *AF-ON* button on the MB-D10 will *not* activate vibration reduction when a VR lens is attached.

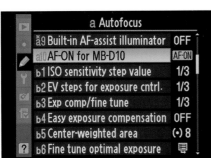
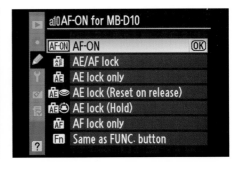

Figure 12 – *Custom setting a10* screens

Custom setting a10 – (User's Manual pg. 274)

1. ***AF-ON*** (default) – This setting means that the *AF-ON* button on the MB-D10 battery pack will work exactly like the regular *AF-ON* button on the D300 body.

2. ***AE/AF lock*** – Selecting this means that the MB-D10's *AF-ON* button executes *Focus and Exposure Lock* instead of normal *AF-ON*.

3. ***AE lock only*** - Selecting this means that the MB-D10's *AF-ON* button executes *Exposure Lock* instead of normal *AF-ON*.

4. ***AE lock (Reset on release)*** – When the MB-D10's AF-ON button is pressed it executes an *Exposure Lock*. The *Exposure Lock* stays active until the *AF-ON* button is pressed a second time, the exposure meter shuts off, or the shutter is released.

5. ***AE lock (hold)*** – When the MB-D10's *AF-ON* button is pressed, it executes an *Exposure Lock*. The *Exposure Lock* stays active until the *AF-ON* button is pressed a second time, or the exposure meter shuts off.

6. ***AF lock only*** – *Focus locks* while the MB-D10's *AF-ON* button is held down.

7. ***Same as FUNC. button*** – The MB-D10's AF-ON button performs whatever function has been selected in *Custom setting f4* (see User's Manual pg. 303 for information on *Custom setting f4*).

The Low-Down on EVs

What is an EV? EV simply means "Exposure Value", which is an agreed-upon value of exposure metering. It is spoken of in full or partial EV steps, like 1/3, 1/2, or 1. It simply means different combinations of shutter speeds and apertures that give similar exposures. An EV step corresponds to a standard logarithmic "power-of-2" exposure step, commonly referred to as a "stop." So, instead of saying "1 EV" you could substitute "1 stop." EV "0" (zero) corresponds to an exposure time of 1 second at an aperture of f/1.0, or 15 seconds at f/4. EV can be positive or negative. EV -6 equals 60 seconds at f/1.0. EV 10 equals 1/1000th at f/1.0 or 1/60th at f/4. The EV step system was invented in Germany back in the 1950s. Interesting, huh?

Metering/exposure

(User's Manual pages 267-274)

Custom setting b1 to b6

The next three custom settings (*b1*, *b2*, *b3*) affect how your camera views steps in its EV sensitivity. Most people might like to have their camera work very precisely, so they will use the *1/3 step* EV selection of *b1*, *b2*, or *b3*.

Others might not be as selective, and would prefer to change sensitivity in ½ EV, or whole steps.

Custom setting b1 – ISO sensitivity step value

Figure 13 shows the screens used to configure *Custom setting b1*.

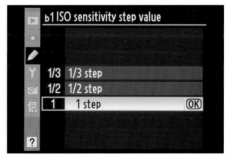

Figure 13 – *Custom setting b1 screens*

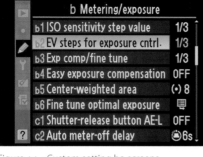
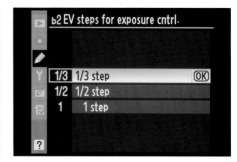

Figure 14 – Custom setting b2 screens

The D300's ISO "step" value is set with this *Custom setting*. As mentioned above, you can control the steps in the following values:

Custom setting b1 – (User's Manual pg. 275)

1. *1/3* or 1/3 step EV (ISO steps 200, 250, 320, 400, etc.)
2. *1/2* or 1/2 step EV (ISO steps 200, 280, 400, 560, etc.)
3. *1* or 1 step EV (ISO steps 200, 400, 800, 1600, etc.)

If you are concerned with maximum ISO sensitivity, then use the 1/3 step setting. It takes longer to scroll through the ISO selections if you manually set your ISO value in 1/3 steps. The *1/3 step* setting is the factory default value for *b1*.

With *b1* set to *1/3 step*, hold down your D300's ISO button on the top left of the camera and turn the rear *Main command* dial to the right. If your camera was set to ISO 200 initially, you'll see that the ISO number in the Control Panel LCD changes in this pattern:

200, 250, 320, 400, 500, 640, etc.

These are 1/3 steps of ISO sensitivity. Now, if you set *b1* to *1/2 step* instead, the pattern changes to:

200, 280, 400, 560, 800, 1100, etc.

These are ½ step sensitivity changes. Finally, if you set *Custom setting b1* to *1 step*, the pattern of changes are like this:

200, 400, 800, 1600, 3200, and HI 1 (6400)

Clearly, these are one full steps (or stops) in ISO sensitivity values. You can be as precise as 1/3 step EV, or as loose as 1 step EV when you change sensitivity.

Custom setting b2 – EV steps for exposure cntrl

Figure 14 shows the screens used to configure *Custom setting b2*.

EV steps for exposure cntrl refers to the number of the steps in your Shutter Speed and Aperture, since those are your main exposure controls. It also encompasses the exposure bracketing system.

Here are the three settings available for exposure control:

Custom setting b2 – (see User's Manual pg. 275)

1. *1/3* or 1/3 step (EV is 1/3 step, Bracketing can be 1/3, 1/2 or 1 EV)
2. *1/2* or 1/2 step (EV is 1/2 step, Bracketing can be 1/2 or 1 EV)
3. *1* or 1 step (EV and Bracketing are 1 EV each)

All this really means is that when you are adjusting the shutter speed or aperture manually, they will work incrementally in the following steps.

Shutter and Exposure

(starting at a random shutter speed or aperture)
1/3 EV step:

• Shutter: 1/100, 1/125, 1/160, 1/200, 1/250, 1/320, etc.

• Aperture: f/5.6, f/6.3, f/7.1, f/8, f/9, f/10, etc.

1/2 EV step:

- Shutter: 1/90, 1/125, 1/180, 1/250, 1/350, 1/500, etc.
- Aperture: f/5.6, f/6.7, f/8, f/9.5, f/11, f/13, etc.

1 EV step:

- Shutter: 1/60, 1/125, 1/250, 1/500, 1/1000, 1/2000, etc.
- Aperture: f/4, f/5.6, f/8, f/11, f/16, f/22, etc.

Bracketing

- *1/3 EV step* - Bracket: 0.3, 0.7, 1.0 (or 1/3, 2/3, 1 EV steps)
- *1/2 EV step* – Bracket: 0.5, 1.0 (or 1/2 and 1 EV steps)
- *1 EV step* – Bracket: 1.0 (or 1 EV step)

Nikon chose to lump shutter speed, aperture, and bracketing all under this one custom setting. *1/3 step* is the factory default value for setting *b2*.

Custom setting b3 – Exp comp/fine tune

Figure 15 shows the screens used to configure *Custom setting b3*.

Custom setting b3 – (User's Manual pg. 275)

Custom setting b3 is concerned with exposure compensation or flash compensation. Most of us will, at one time or another, use the exposure compensation or flash compensation system. The exposure compensation adjustments are made with the *Exposure compensation* button on the top right of the D300. The *Flash compensation* button is right below the button

Figure 15A – *Flash compensation* button

that opens the popup Speedlight flash on the D300 *(Figure 15A)*.

Holding the *Exposure compensation* button and turning the *Main command* dial allows you to adjust the exposure compensation. Holding the *Flash compensation* button and turning the *Sub-command* dial allows you to adjust flash compensation.

Maybe *Matrix Metering*, or your popup flash, is giving you a little less exposure than you'd like, so you "fine tune" by adding a little extra exposure with the *Exposure compensation / Flash compensation* buttons. These buttons can be configured by setting *b3* so that they work in a finer or coarser way for the exposure fine tuning. Compensation can be added or subtracted in 1/3, 1/2, or 1 EV steps, up to 5 EV (5 stops).

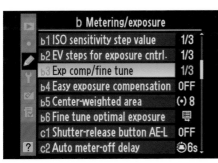

Figure 15 – *Custom setting b3* screens

Exposure or Flash Compensation

1/3 step:

- +/- Exposure/Flash EV compensation of 0.3, 0.7, 1.0, 1.3, 1.7, 2.0, 2.3, 2.7, 3.0, etc. (up to 5.0), plus or minus)

1/2 step:

- +/- Exposure/Flash EV compensation of 0.5, 1.0, 1.5, 2.0, 2.5, 3.0, 3.5, 4.0, etc. (up to 5.0), plus or minus)

1 step:

- +/- Exposure/Flash EV compensation of 1.0, 2.0, 3.0, 4.0, 5.0, plus or minus

The factory default for *Custom setting b3* is *1/3 step*. Most shooters will leave it set to 1/3, since that allows fine control over the amount of exposure or flash compensation.

Custom setting b4 – Easy exposure compensation

Figure 16 shows the screens used to configure *Custom setting b4*.

Custom setting b4 – (User's Manual pg. 276)

This particular series of settings took me a bit of thinking to wrap my brain around. The bottom line is that you can set the D300's exposure compensation without using the +/- *Exposure compensation* button.

There are three settings in *b4*, as follows:

1. *Reset On* (Auto reset)
2. *On*
3. *Off*

If you set the D300 to *Reset On (Auto reset)* or simply to *On* you can use the command dials to do exposure compensation, instead of the

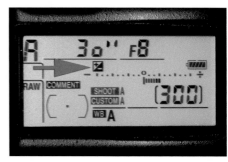

Figure 16A – Control Panel LCD with compensation dialed in

normal +/- *Exposure compensation* button. *Off* means what it says. If you use the normal +/- *Exposure compensation* button, it overrides the settings of b4.

Each exposure mode (*P,S,A,M*) reacts somewhat differently to *Custom setting b4*. Let's consider how the *P-Program, S-Shutter Priority,* and *A-Aperture Priority* modes act when you use the three settings above. The *M-Manual* mode does not seem to be affected by *Custom setting b4*, although it does work with the normal +/- *Exposure compensation* button.

Notice in *Figure 16A* how the Control Panel LCD uses the "+/-" icon to show the compensation value you've dialed into the D300. Here are the values, and how they work:

Reset On (Auto reset)

Using the *Sub-command* dial in *P-Program* or *S-Shutter Priority* modes, or the *Main command* dial in *A-Aperture Priority* mode, you can dial in exposure compensation without using the normal +/- *Exposure compensation* button.

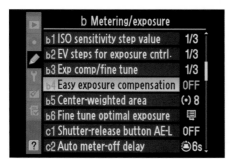

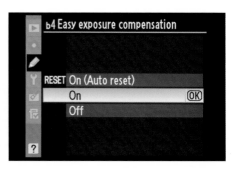

Figure 16 – *Custom setting b4* screens

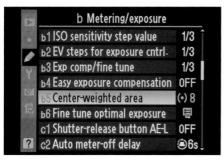
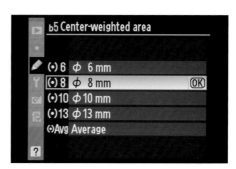

Figure 17 – *Custom setting b5* screens

Once you allow the meter to go off, or turn the camera off, the compensation value you dialed in is "reset" back to 0. That's why it's called "Auto reset."

If you already have a compensation value set, using the normal +/- *Exposure compensation* button, then the process of dialing in compensation with the *Sub-command* dial simply adds more compensation to what you originally put in with the +/- *Exposure compensation* button. When the meter resets, it only returns back to the compensation value you added with the normal compensation button, and not to 0.

On

This works the same way as *Reset On (Auto reset)* except that the compensation you've dialed in does not reset but stays in place, even if the meter or camera is turned off.

Off

Only the normal +/- *Exposure compensation* button applies exposure compensation.

Custom setting b5 – Center-weighted area

Figure 17 shows the screens used to configure *Custom setting b5*.

Custom setting b5 – (see User's Manual pg. 277)

Years ago, our cameras didn't have *Matrix Metering*. Back in the good old days, we all had averaging, or partially averaging meters, or none at all. If you prefer not to use Nikon's built-in database of image scenes, otherwise know as Matrix Metering, and you only use Spot Metering as needed, you are most likely using the Center-weighted area meter. It's cool that Nikon gives us a choice. You have three meter styles in your D300, thereby adding to its chameleon status.

Here is a picture of the control used to set the metering mode types *(Figure 17A)*.

The center-weighted meter can be configured to use a central area of the viewfinder to do most of its metering, with less attention paid to

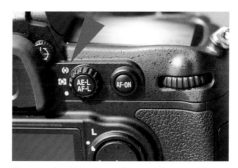

Figure 17A – *Metering mode* control, surrounding the AE-L / AF-L button

subjects outside this area, or it can be set up to simply average the entire frame.

Here are the five settings used by the D300's *Center-weighted area* metering system:

1. 6 or 6mm
2. 8 or 8mm
3. 10 or 10mm
4. 13 or 13mm
5. *Avg* or Average

Using this mode, the metering system uses an invisible circle in the center of the viewfinder to meter the subject. Setting it down to 6mm is almost small enough to be a spot meter, since the real *Spot metering* mode of the D300 uses a 3mm circle surrounding the currently selected AF sensor.

The center-weighted meter does not appear to move around with the currently selected AF sensor point, as the true spot meter does. Instead, it assigns the "greatest weight" to the center of the viewfinder frame, and everything outside the circle in the center is not as important.

How large is the invisible circle? Well, from my own experimentation, I've noticed that the 13mm setting brings the edges of the best metering to about where the big circle shows in the viewfinder. Experiment for yourself to see if your D300 notices when brighter light passes that circle in 13mm mode. So, the 6mm setting would be about half of the diameter of that big visible circle on the viewfinder. Each size increase from 6, 8, 10, to 13 will of course increase the sensitivity of the center of the screen, so that more emphasis is given to a larger area in the middle.

If you select the *Avg – Average* setting, then the entire viewfinder frame is used to meter the scene. The D300 takes an average of the entire frame, by including all light and dark areas mixed together for an averaged exposure.

Personally, I use 3D *Matrix Metering*, and have my *Func* (Fn) button set up to switch to the spot meter temporarily. That way, I am using Nikon's incredible *3D Color Matrix* system, with

its ability to consider brightness, color, distance, and composition. It gives me the best metering I've had with any camera yet!

Custom setting b6 – Fine tune optimal exposure

Nikon has taken the stance that most major D300 systems should allow the user to fine-tune them. The exposure system is no exception. *Custom setting b6* allows you to fine-tune the *Matrix*, *Center-weighted*, and *Spot metering* systems by +1/-1 EV in 1/6th EV steps.

In other words, you can force the three metering systems to add or deduct a little exposure from what it normally would use to expose your subject. This stays in effect with no further notice until you set it back to zero. It is indeed fine-tuning, since the maximum 1 EV step up or down is divided into 6 parts (1/6th EV). If you feel that your D300 is too conservative with the highlights, mildly underexposing, and you want to force your D300 to add ½ step exposure, you simply add 3/6th EV to the compensation system for that metering system.

This works like the normal compensation system, except it only allows you one EV of compensation. As screen three of *Figure 18* shows, an ominous looking warning appears, telling you that your D300 will not show a compensation icon, like it does with the normal *+/- Exposure compensation* button when you use the metering fine-tune system. This simply means that while you have this fine-tuning system dialed in for your light meter, the D300 will not keep reminding you that it is fine-tuned by showing you a compensation icon. If it did turn on the compensation icon (+/- on the Control Panel LCD and in the viewfinder), then how could it show you the same icon when you were using normal compensation at the same time as meter fine-tuning?

This light meter fine-tuning only applies to the custom setting bank you are currently working with. If you are working in Bank A, Banks B through D are not changed.

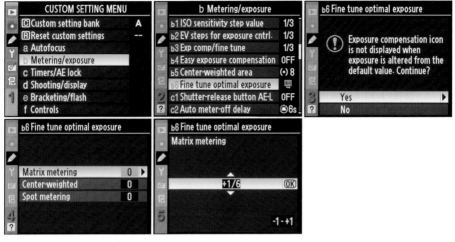

Figure 18 – *Custom setting b6* screens

In *Figure 18* we see the steps to fine-tune your favorite metering system.

Custom setting b6 – (User's Manual pg. 277)

1. Select setting **b – Metering/exposure** from the *Custom Setting Menu*.
2. Select **b6 – Fine tune optimal exposure** from the screen.
3. Select **Yes** from the warning screen and scroll right.
4. Select the metering system you want to adjust. In *Figure 18*, I have **Matrix metering** selected.
5. Scroll up or down in 1/6 EV steps, until you reach the fine-tuning value you would like to use.
6. Press the *OK* button.

That's all there is to it! Since the D300 will not remind you, just remember that you have "optimal exposure" fine tuning turned on. Watch your histogram to make sure that you're not regularly underexposing or overexposing images once you have the fine-tuning adjustment in place. If so, just go back in and adjust the fine-tuning up or down, or turn it off.

Timers/AE Lock

(User's Manual pages 279-280)

Custom settings c1 to c4

Custom setting c1 – Shutter-release button AE-L

Figure 19 shows the screens used to configure *Custom setting c1*.

Figure 19 – *Custom setting c1* screens

Custom setting c1 – (User's Manual pg. 279)

There are only two selections in Custom setting c1:

1. *On*
2. *Off* (default)

This feature is designed to allow you to lock your D300's exposure when you press the shutter release button down halfway. Normally that type of exposure lock only happens when you press and hold the *AE-L / AF-L* button.

However, when you have it set to *On*, your D300 will act like you have pressed the *AE-L / AF-L* button every time you start autofocus and take a picture.

This function allows you to meter from one area of the scene, then recompose to another area, without losing the meter reading from the first area. For sunset shooters who like to include the sun in their image, this is a nice function. I don't think I'd leave it turned on all the time, since I might be holding the shutter release button halfway down to track a moving subject through light and dark areas. I only use this feature when I really need it, then turn it off. The rest of the time, I just use the *AE-L / AF-L* button to lock my exposure.

Custom setting c2 – Auto meter-off display

In *Figure 20* we see the screens used to configure *Custom setting c2*.

The default amount of time that your D300's light meter stays on after you press the shutter release button halfway is six seconds. If you would like your light meter to stay on longer for whatever reason, such as multiple-exposures, you can adjust it to the following settings:

Custom setting c2 – (User's Manual pg. 279)

1. *4s* – 4 seconds
2. *6s* – 6 seconds (default)
3. *8s* – 8 seconds
4. *16s* – 16 seconds
5. *30s* - 30 seconds
6. *1m* – 1 minute
7. *5m* - 5 minutes
8. *10m* - 10 minutes
9. *30m* - 30 minutes
10. ∞ - No limit (meter stays on until camera is turned off)

There are times when you want the light meter to stay on longer, or shorter, than normal. When I'm shooting multiple exposures, I leave mine set to *No limit*, but when shooting normally it stays at *8 seconds*. You can adjust it from four seconds to no limit. Easy enough!

The longer the light meter stays on, the shorter the battery life, so only extend the meter time if you really need it.

Custom setting c3 – Self-timer delay

Figure 21 shows the screens used to configure *Custom setting c3*.

When you set your self-timer for those groups shots or self-portraits, do you find yourself running around wildly trying to get in position before the camera fires? Have you ever knocked anyone or anything down, or tripped and made a fool of yourself in the process? Come on now, admit it. I know I have!

Well, those problems are solved with the D300's adjustable self-timer delay. Whether you are shooting a group shot, or just using the self-timer as a cheap cable release, it's good to be

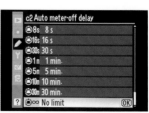

Figure 20 – *Custom setting c2* screens

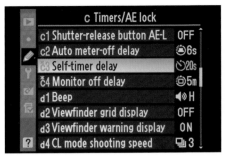

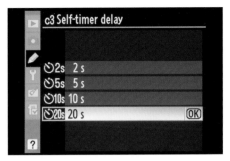

Figure 21 – *Custom setting c3* screens, shown with 20 sec delay

able to adjust the time before release - up to 20 seconds, or down to two.

Custom setting c3 – (User's Manual pg. 280)

1. *2s* – 2 seconds
2. *5s* – 5 seconds
3. *10s* – 10 seconds (default)
4. *20s* – 20 seconds

Often, if I don't want to take the time to plug in a remote release cable, I'll just put my D300 on a tripod, and set the self-timer to two or five seconds. This lets me make a hands-off exposure to keep from shaking the camera or tripod.

Mirror Up for Steadier Shots

This side point is not exactly related to the self-timer delay, but is relevant. Many do not realize it, but you can also use the Mirror-up (*MUP*) function for even steadier releases. If you use a tripod, and start an exposure with the camera set to mirror up, the camera will wait thirty seconds and then fire the shutter before moving the mirror. Macro shooters often use either this feature, or the self-timer delay, to get the sharpest possible images.

Custom setting c4 – Monitor off delay

In *Figure 22* we are shown the screens used to configure *Custom setting c4*.

When I take a picture, I like to review it on the monitor. I admit I am a shameless "chimper" (slang for Checking Image Preview). In the old film days, one could not tell whether the image was just right. Now that I have an opportunity, I love to look at each image. If it looks good, I then move on to another image opportunity. The Monitor LCD on the D300 is one of the best ever invented for a camera, with better than 1174 X 768 dot XGA resolution. It is like a small computer monitor. You can really zoom in and see how sharp a portion of the image is.

Custom setting c4 – (User's Manual pg. 280)

1. *10s* – 10 seconds
2. *20s* – 20 seconds (default)
3. *1m* – 1 minute
4. *5m* – 5 minutes
5. *10m* – 10 minutes

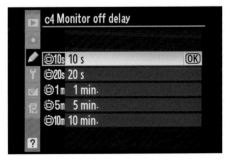

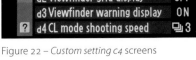

Figure 22 – *Custom setting c4* screens

I set my *Monitor off delay* to *1 minute*, since I often want to show the image to someone. If you want to conserve battery power, leave it at the default of 20 seconds, or change it to 10 seconds. If you want, you can eliminate image reviewing after each shot for maximum battery life. Simply go the *Playback Menu*, which is the top menu on the D300, and select *Image review*. You can set the review on or off there.

The longer the monitor stays on, the shorter the battery life, so only extend the monitor time if you really need it. Like a small notebook computer screen, that big luxurious 3 inch XGA LCD pulls a lot of power. This screen and the Control Panel backlight are probably the biggest power drains in the entire camera.

Shooting/Display

(User's Manual pages 281-287)
Custom settings d1 to d3
Custom setting d1 – Beep

Figure 23 shows the screens used to configure *Custom setting d1.*

I don't like my camera beeping at me, but you might love it. Either way, we can have our wish. You can set the camera to beep at you with a high-pitched or low-pitched beeping sound. The low-pitched sound is not very loud, while the high-pitched sound is quite audible. In fact, it sets up a harmonic resonance with the bones in my skull and causes my eyeballs to vibrate.

The D300's self-timer *Beep* function is to let you know when the self-timer is about to fire. It counts down the seconds with a beep or two per second, then at the last moment it doubles the beeping frantically to say, "Hurry up!"

Custom setting d1 – (User's Manual pg. 281)
1. *High* (default)
2. *Low*
3. *Off*

If *Beep* is enabled, the D300 will let you know when you have focused successfully in *Single-servo Autofocus* (AF-S), by beeping once. It does not beep in *Continuous-servo Autofocus* (AF-C), since it would be beeping constantly as the focus adjusts to the subject. If you have *Custom setting a2* configured to *Release priority*, the beep will not sound for autofocus in AF-S.

The fact that the D300 is set to beep as a default belies the professional level of the camera. If I am using my camera in a quiet area, why would I want it beeping at me, disturbing those around me? I can just imagine zooming in on that big grizzly bear, pressing the shutter release, and listening to the grizzly roar his displeasure at my camera's beep. I want to live, so I turn off *Beep*.

When the beep is active, you'll see a little musical note displayed in the top right of your Control Panel LCD.

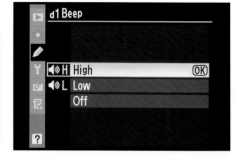

Figure 23 – *Custom setting d1 screens*

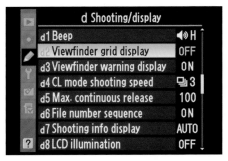
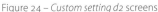
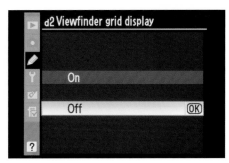

Figure 24 – *Custom setting d2* screens

Custom setting d2 – Viewfinder grid display

In *Figure 24* we see the screens used to configure *Custom setting d2*.

A few years ago, the 35mm film Nikon F80 was released with a viewfinder grid display, and I was hooked. Later, as I bought more professional cameras, I was chagrined to find that they did not have the "on-demand" gridlines that I had grown to love.

With the D300, you have not only viewfinder gridlines, but also *Live View* (LV) gridlines. The best of both worlds! There are only two selections in *Custom setting d2*:

Custom setting d2 – (User's Manual pg. 281)
1. *On* – On-demand gridlines are displayed in viewfinder and LV mode.
2. *Off* – No gridlines are displayed.

I use these gridlines to line up things I shoot so that I won't have weird tilted horizons and such. If you turn these things on, I doubt you'll turn them back off. The nice thing is that you can turn them on and off at will. You don't have to buy an expensive viewfinder replacement screen for those times you need gridlines. Good stuff, Nikon!

Custom setting d3 – Viewfinder warning display

Figure 25 shows the screens used to configure *Custom setting d3*.

We need our low-battery warning in the viewfinder so we'll know when our batteries are getting low. However, if that low-battery viewfinder warning bugs you—guess what?—you can turn it off! Here's how:

Custom setting d3 – (User's Manual pg. 282)
1. *On* (default)
2. *Off*

The normal battery power-level display always shows on the Control Panel LCD, but shows in the viewfinder only when you have *d3* turned *On*, which is the default setting.

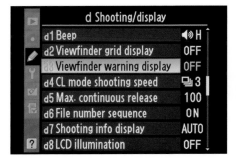
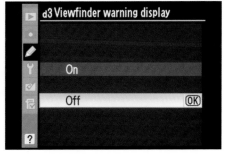

Figure 25 – *Custom setting d3* screens

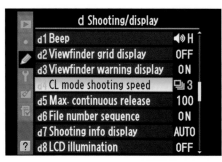

Figure 26 – *Custom setting d4 screens*

Custom setting d4 – CL mode shooting speed
In *Figure 26* we see the screens used to configure *Custom setting d4*.

Custom setting d4 – (User's Manual pg. 282)

The CL mode is for those of us who would like a conservative frame-advance rate. With the proper power, the D300 can record 7 frames per second. However, unless you are shooting 200 MPH race cars, and have large memory cards, you may not want 43 frames of the same subject a few milliseconds apart.

As the last screen in *Figure 26* shows, you can adjust *Custom setting d4* so that your D300 shoots at any frame rate between 1 and 7 frames per second. The default is 3 frames per second. Remember, you always have CH mode for when

you want to blast off images like there's no end to your memory card, or when you want to impress bystanders with that extra cool Nikon shutter clicking sound.

Just the other day, I was over at a super-store parking lot, waiting in the car for my wife to spend all our money. For whatever reason, there were about a dozen seagulls flying around the parking lot. I got bored, pulled out my camera, and in just a few minutes had 450 images of gulls in every possible flying position. *Figure 26A* shows one of my favorites.

See how my camera blended just the right amount of cool wing motion blur, with a nice sharp eye, and somehow even positioned my gull shot using the rule of thirds.

Figure 26A – Gull flying

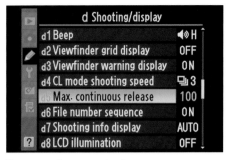
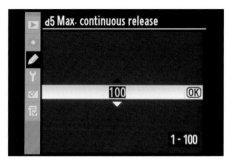

Figure 27 – *Custom setting d5* screens

Use your favorite CL shooting speed, and grab a few, or many, frames with each press of the shutter release button.

Custom setting d5 – Max. continuous release

Figure 27 shows the screens used to configure *Custom setting d5*.

This custom setting is a bit misleading. It sets the maximum number of images you can shoot in a single burst. It sounds like you can just start blasting away with your D300, shooting in a single burst until you have reached the number specified in screen two of *Figure 27*, which is up to 100.

While it is possible that you could reach 100 images in a single burst, it is improbable. As shown on page 402 of the D300 User's Manual, your camera is limited by the size of its buffer, and the type of image you are shooting. Here is a list of what your D300's buffer will allow:

Custom setting d5 – (User's Manual pg. 282)
- **NEF Raw Files** – 18 to 27 images (according to whether you are shooting in 12 or 14-bit

color-depth, and whether you are using compression or not.
- **TIFF Files** – 16 to 29 images, according to whether you are shooting L, M, or S size.
- **JPEG files** – 16 to 100 images, according to whether you are shooting in L, M, or S size, in *Fine*, *Normal*, or *Basic*, and finally whether you have selected *Optimal quality* or *Size priority* compression.

So, unless you are shooting smaller *Basic* JPEG files, you'll fill up your camera buffer long before you reach the maximum of 100 shots specified by *Max. continuous release*.

If you have a need to limit your camera to a maximum number of images in each shooting burst, simply change this number from its default of 100 images, to whatever you feel works best for you.

Custom setting d6 – File number sequence

Figure 28 shows the screens used to configure *Custom setting d6*.

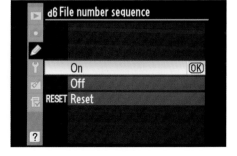

Figure 28 – *Custom setting d6* screens

This setting allows your camera to keep count of the image numbers in a running sequence from 0001 to 9999. After 9999, it rolls back over to 0001. Or, you can cause it to reset the image number to 0001 when you format or insert a new memory card. Here are the settings, and an explanation of how they work:

Custom setting d6 – (User's Manual pg. 283)

- **On** (default) – Image file numbers start at 0001 and continue running in a series until you exceed 9999, at which time the image numbers roll over to 0001 again. This process is used when a new folder is created, a new CF card is inserted, or the current CF card is formatted. If the file number exceeds 9999 during a shoot, the D300 will create a brand new folder on the same memory card, and start writing the new images in numbering order from 0001 into the new folder. Similarly, if you accumulate 999 images in the current folder, the next image-capture will result in the D300 creating a new folder, but the file numbering will not be reset, unless that 999th image had a file number of 9999.
- **Off** – Whenever you format a CF card or insert a new CF card, the number sequence starts over at 0001. If you exceed 999 images in a single folder, the D300 creates a new folder and starts counting images at 0001 again.
- **Reset** – This works in a way that is similar to the *On* setting. However, it is not a true

Reaching Limits with the CH Setting

The D300 manual page 283 describes an unusual situation that few of us will ever see. However, just in case you leave your frame rate set to CH and never let up on the shutter release button, you might want to read this paragraph carefully. Each time you exceed 999 images in a folder, the D300 will create a new folder. If your current folder is #999, and has either 999 images or an image is numbered 9999, your D300 will stop responding to shutter release button presses.

running total to 9999 solution, since the image number is dependent on the folder in use. The D300 simply takes the last number it finds in the current folder, and adds 1 to it, up to 9999. If you switch to an empty folder, the numbering starts over at 0001.

I guess it figures that you have taken quite enough images in this session! The only way you will get your D300 to feel better and agree to take more pictures is to set *Custom setting d6* to *Reset*, and format or insert a new memory card. What they mean by this weird sounding notice in the manual is clearly that you should never number a folder up as high as 999 and then shoot over 999 images, or let the D300's running total of images exceed 9999 in a folder numbered 999. Next time you manually create a folder, or set up active folder numbering (*Shooting Menu – Active folder* setting), keep your folder numbers less than 999 if you are going to shoot more than 999 images that day, or if your number sequence in that folder is about to exceed 9999. Read this paragraph over 999 times, and you'll understand just what I'm talking about.

Custom setting d7 – Shooting info display

Figure 29 shows the screens used to configure *Custom setting d7*.

This next feature is a primary reason why I say that the Nikon D300 is one of the coolest cameras I have ever used.

Look on the back of your D300 for the info button, just below the *MENU* button. It looks like a key (*Figure 29A*) and is a multifunction button. This key locks an image when you have one displayed, does nothing when a menu is being displayed, and brings up a helpful info screen when nothing else is showing on the Monitor LCD (*Figure 29B*).

The extremely cool thing about this shooting info display is that it can adjust its color and brightness according to the ambient light the D300 senses through its lens. Try this: With your lens cap off, camera turned on, and nothing showing on the rear screen, press the *info* button. If you have even dim ambient light

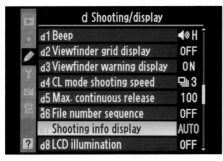

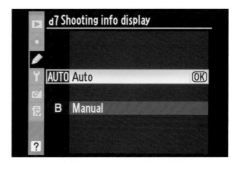

Figure 29 – *Custom setting d7 screens*

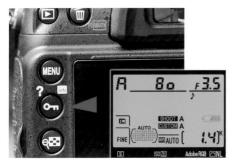

Figure 29A – *info* button Figure 29B – Info screen

present where you are, you'll see a light blue info screen, with black letters. Now, go into a dark area, or put your lens cap on, and cover the eyepiece with your hand. You'll see that any time there is a dark ambient light condition, the D300 changes the info screen to light gray characters on a black background. This keeps from blinding you when you display info in a dark area.

This may not impress you much, but I am easily entertained. Here are the selections in *Custom setting d7*:

> **Custom setting d7** – (User's Manual pg. 284)
> - **Auto** – The D300 decides through its capless lens or uncovered eyepiece how much ambient light there is and changes the color and contrast of the *info* screen accordingly.
> - **B Manual** – This manual setting allows you to select the light or dark versions of the info screen manually. The two screens are *B*–dark on light, and *W*–light on dark.

If you want to impress your friends and make your enemies envious, just show them how cool your D300 is when it is smart enough to adjust its screen to current light conditions. I warned you that I'm easily entertained, didn't I?

Custom setting d8 – LCD illumination

In *Figure 30* we see the screens used to configure *Custom setting d8.*

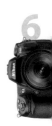

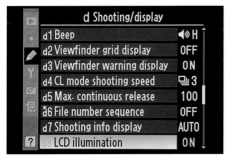

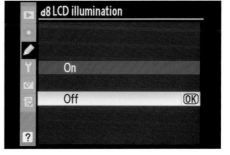

Figure 30 – *Custom settings d8 screen*

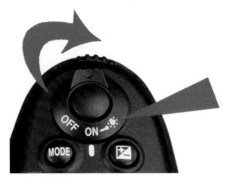

Figure 30A – Lever to turn on the Control Panel LCD back light

This is a simple little setting that allows you to set how the illumination of the Control Panel LCD works. Here are the two choices:

Custom setting d8 – (User's Manual pg. 285)
1. *On*
2. *Off* (default)

Off - If you leave *LCD illumination* set to *Off*, the Control Panel LCD will not turn on its backlight unless you tell it to with the "light on" setting on the ring surrounding the shutter release button. If you use your shutter finger to pull the lever to the right, the Control Panel LCD will light up (*Figure 30A*).

On – This setting makes the Control Panel LCD illumination come on anytime the light meter is active. If you are shooting in the dark and need to refer often to your Control Panel LCD, then switch this setting to *On*.

This setting will affect battery life, since backlights pull a lot of power, so I wouldn't suggest using the *On* setting unless you really need it.

Custom setting d9 – Exposure delay mode

Shown in *Figure 31* are the screens used to configure *Custom setting d9*.

This setting is **very** important to me. As a nature shooter, I use it frequently. When I am shooting handheld, or on a tripod, and want a really sharp image, I use this mode to prevent mirror movement from adding to any motion blur I might introduce. Here are the settings:

Custom setting d9 – (User's Manual pg. 285)
1. *On*
2. *Off* (default)

On - The D300 first raises the mirror and then waits about one second before firing the shutter. This allows the vibrations from the mirror to dissipate before the shutter fires. Of course, this won't be useful at all for shooting moving subjects, or for taking any type of action shots. But for slow shooters of static scenes this is great and keeps you from having to use Mirror up (MUP), which requires two shutter-release presses to take a picture. It has the same effect as MUP, but only requires one shutter-release press.

Off – Shutter has no delay when this setting is turned off.

If you handhold your camera, shoot static subjects, and want sharp pictures, this will help. On a tripod, this is a time saver compared to *Mirror up* mode.

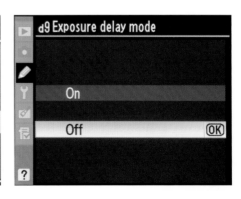

Figure 31 – *Custom setting d9* screens

Figure 32 – *Custom setting d10 screens*

Custom setting d10 – MB-D10 battery type

Figure 32 shows the screens used to configure *Custom setting d10*.

If you do not have an MB-D10 attachment for your D300, this does not apply to you. It also applies only when you choose to use AA-sized batteries of various types in your MB-D10, not when you are using normal Nikon EN-EL3e, EN-EL4, or EN-EL4a Li-ION batteries, since they are intelligent and communicate with the camera.

If you do have an MB-D10, and plan on using cheaper AA batteries, then you'll need to tell the D300 what type of AA batteries you are using for this session. It certainly is not a good idea to mix AA battery types. Here are the types the D300 will accept:

Custom setting d10 – (User's Manual pg. 285)

1. *LR6* – AA Alkaline Batteries
2. *HR6* – AA Ni-MH Rechargeable Batteries
3. *FR6* – AA Lithium Batteries
4. *ZR6* – AA Ni-Mn Rechargeable Batteries

Nikon allows (but does not recommend using) AA batteries, especially Alkaline and Ni-Mn (nickel-manganese). Their primary objection to these two types (LR6 & ZR6) is that they do not work well at lower temperatures. In fact, once you go below 68 degrees F (20 degrees C), an Alkaline battery starts losing the ability to deliver power, and will die rather quickly. You may not get as many shots out of a set of AA batteries, so your cost of shooting may rise.

However, AA batteries are readily available, and relatively cheap, so many people like to use them. If you do choose to use AA batteries, why not stick with Lithium types (FR6) since that is the same type of cell used in the normal Nikon EN-EL batteries, and is not affected as much by a low ambient temperature.

Custom setting d11 – Battery order

In *Figure 33* we see the screens used to configure *Custom setting d11*.

Figure 33 – *Custom setting d11 screens*

If you use an MB-D10 attachment, you will need to choose in what order you want the batteries to be used: Camera first, or MB-D10 first. Here are your choices:

Custom setting d11 – (User's Manual pg. 287)
1. *MB-D10* – Use MB-D10 batteries first (default)
2. *D300* – Use camera battery first

Which battery do you want to draw down first? Personally, I like to use the MB-D10 batteries first, and have my camera's internal battery available as a backup. That way, if I remove the MB-D10, my camera won't suddenly go dead due to a depleted battery. Nikon thinks the same way I do, evidently, since the D300 defaults to MB-D10 – *Use MB-D10 batteries first.*

Bracketing/Flash

(User's Manual pages 288-300)
Custom settings e1 to e7
Custom setting e1 – Flash sync speed

Figure 34 shows the screens used to configure *Custom setting e1.*

The D300 has a more flexible *Flash sync speed* than many cameras. You can select a basic sync speed from 1/60th of a second (s) to 1/250 s. Or, if you prefer, you can use the two

Auto FP modes of your D300 (*1/250 s Auto FP,* or *1/320 s Auto FP*). These *Auto FP* modes are only available with certain external Speedlights, and *not* with the built-in popup Speedlight. At the time of writing this book, the three Nikon Speedlights that are compatible with the D300 in *Auto FP* high-speed sync mode are:

* SB-800
* SB-600
* SB-R200

Auto FP high-speed sync enables the use of fill-flash even in bright daylight with wide aperture settings. It allows you to set your camera to the highest shutter speed available, up to 1/8000 s, and still use the external flash unit to fill in shadows. Here are your choices:

Custom setting e1 – (User's Manual pg. 288)
* *1/320 s (Auto FP)*
* *1/250 s (Auto FP)*
* *1/250 s*
* *1/200 s*
* *1/160 s*
* *1/125 s*
* *1/100 s*
* *1/80 s*
* *1/60 s*

When you are using *Auto FP* mode, the Guide Number of your flash is reduced by about one stop. This poses two questions.

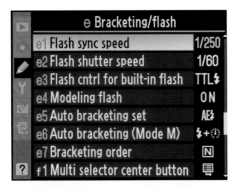

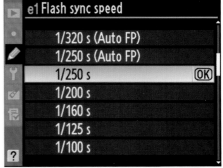

Figure 34 - *Custom setting e1* screens

Why? Plus, how does the D300 allow me to shoot at any shutter speed I want, while firing my flash, and without cutting off part of the frame like in the old days?

Auto FP High-Speed Sync Review

The answers are simple. In a normal flash situation, with shutter speeds of 1/250th of a second and slower, the entire shutter is fully open and the flash can fire a single burst of light to expose the subject. It works like this: There are two shutter curtains in your D300. The first shutter curtain opens, exposing the sensor to your subject, the flash fires providing correct exposure, and then the second shutter curtain closes. For a very brief period, the entire sensor is uncovered. The flash fires during the time that the sensor is fully uncovered.

However, when your camera's shutter speed goes above 1/250th of a second, the shutter curtains are never fully open for the flash to expose the entire subject in one burst of light. The reason is because, at higher shutter speeds, the first shutter curtain starts opening, and then the second shutter curtain immediately follows it. In effect, a slit of light is scanning across the surface of your sensor, exposing the subject. If the flash fired normally, the width of that slit between the shutter curtains would get a flash of light, but the rest of the sensor would be blocked by the curtains. So, you would have a band of correctly exposed image, and everything else would be underexposed.

What happens to your external Speedlight to allow it to follow that slit of light moving across the sensor? It changes into a strobe unit, instead of a normal flash unit. Have you ever danced under a strobe light? A strobe works by firing a high speed series of pulses of light. When your camera's shutter speed is so high that the Speedlight cannot fire a single burst of light for correct exposure, it uses its FP mode, and fires a series of light

bursts over and over as the shutter curtain slit travels across the sensor. The speedlight can fire thousands of bursts per second, but to a photographer or subject it still looks like one big flash of light, even though, in reality, it is hundreds or thousands of bursts of light firing off consecutively.

When you are in *Auto FP* mode, you'll see something like this on your Speedlight's LCD monitor: "TTL FP" or "TTL BL FP".

This tells you that the D300 and Speedlight are ready for you to use any shutter speed you'd like, and still get a good exposure. Even with wide open apertures!

You can safely leave your camera set to *1/320 s Auto FP* or *1/250 s Auto FP* all the time, since the high-speed sync mode does not kick in until you crank the shutter speed above the maximum setting (1/250th or 1/320th). Below those shutter speeds, the flash works in normal mode, and does not waste any power by pulsing the output. This pulsing of light reduces the maximum output of your flash by about one stop, but allows you to use any shutter speed you'd like while still firing your external Speedlight. Now you can use wide apertures to isolate your subject in direct sunlight, which requires high shutter speeds. The flash will adjust and provide great fill light, if you are using *Auto FP* high-speed sync mode.

If you are only using the built-in pop-up Speedlight, your D300's maximum flash shutter speed is limited to 1/320 s. If you use the external Speedlights SB-800, SB-600, or SB-R200, you can use any shutter speed, and the flash will adjust.

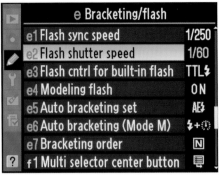

Figure 35 – *Custom setting e2* screens

Custom setting e2 – Flash shutter speed
In *Figure 35* we see the screens used to configure *Custom setting e2*.

This particular custom setting controls the minimum shutter speed your camera can use in various flash modes. Let's consider each of the modes and the minimum shutter speed for it:

Custom setting e2 – (User's Manual pg. 291 and 176)

Front-curtain sync (default), **Rear-curtain sync**, or **Red-eye reduction** - In *P-Program* mode or *A-Aperture Priority* mode, the slowest shutter speed can be selected from the range of 1/60 second to 30 seconds (*Figure 35*). *S-Shutter Priority* mode and *M-Manual* mode cause the camera to ignore *Custom setting e2*, and the slowest shutter speed is 30 seconds.

Slow sync, **Red-eye reduction with slow sync**, or **Slow rear-curtain sync** – These three modes ignore *Custom setting e2*, and the slowest shutter speed is 30 seconds.

The User's Manual is a bit confusing on this feature, but my explanation is a result of my study and testing. Additionally, *Custom setting e2* is only partially used by the flash modes, since the default is preset to 30 seconds in *Shutter Priority* and *Manual* modes, as listed above.

Custom setting e3 – Flash cntrl for built-in flash
Figure 36 shows the screens used to configure *Custom setting e3*.

The D300 has four distinct ways to control flash output. **Chapter 9 –Nikon Creative Lighting System** of this book is devoted to using Nikon's Creative Lighting System (CLS) and covers each of the modes in much greater detail than the summary found here. Let's briefly consider each of these modes.

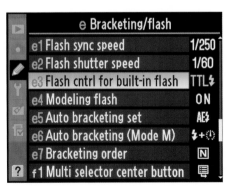
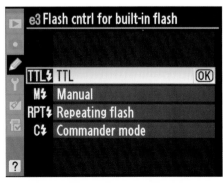

Figure 36 – *Custom setting e3* screens

Custom setting e3 – (User's Manual pg. 291)

1. **TTL** – Also known as iTTL, this mode is the standard way to use the D300 for flash pictures. TTL stands for Through The Lens, and allows very accurate and balanced flash output using a pre-flash method to determine correct exposure before the main flash burst fires. This is a completely automatic mode, and will adjust to distances, along with the various shutter speeds and apertures your camera is using.

2. *M* – **Manual** *(Figure 36A)* – This mode allows you to manually control the output of your flash. The range of settings can go from *Full* power to *1/128* power, and a range of settings in between.

3. *RPT* – **Repeating flash** – This setting turns your D300 into a strobe unit, allowing you to get creative with stroboscopic multiple

flashes. There are three settings, as shown in *Figure 36B*. These are:

- **Output** – You can vary the output of the flash from *1/4* to *1/128* of full power. The more power the flash uses the more it will cut down on the number of times the flash can fire. Here is a table of how many times the built-in popup flash can fire using the different *Output* levels:

 1/4 – 2 times
 1/8 - 2-5 times
 1/16 – 2-10 times
 1/32 – 2-10 or 15 times
 1/64 – 2-10, 15, 20, 25 times
 1/128 – 2-10, 15, 20, 25, 30, 35 times

- **Times** – Refer to the table above to set the number of times the flash can fire. Increasing the power output – going toward ¼ - will lower the number of times, while decreasing the power – going toward 1/128 – will

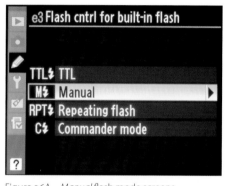

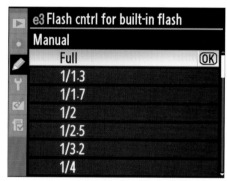

Figure 36A – *Manual* flash mode screens

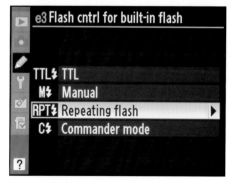

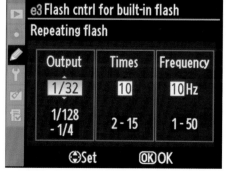

Figure 36B – *Repeating flash* mode screens

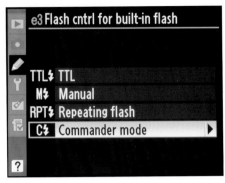
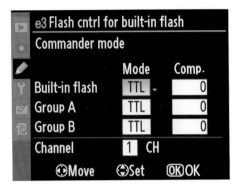

Figure 36C – *Commander mode screens*

increase the number of times the flash can fire like a strobe.

- *Frequency* – This setting controls the number of times the flash will strobe per second, between 1 and 10, then by 10 to 50. If you have *Output* set to 1/128, and *Times* set to 5, and Frequency set to 50, that means the the D300 will fire its built-in popup Speedlight at 1/128 of full power, 5 times, with each flash burst divided up into (50 * shutter speed) pulses. Therefore, the flash will pulse a total of 250 times at 1/128th power for a one-second exposure, or 4 times for a 1/60 second exposure. *(Figure 36C)*

4. **C - Commander Mode** (User's Manual pgs. 294-297) – This mode allows your camera to become a Commander or controller of up to two banks of an unlimited number of external CLS-compatible Speedlight flash

units. The range of the farthest external flash unit is about 33 feet (10.05 Meters) from the camera. See **Chapter 9 –Nikon Creative Lighting System** for details on how to use the built-in Commander mode to control external Nikon Speedlights.

Custom setting e4 – *Modeling flash*

Figure 37 shows the screens used to configure *Custom setting e4*.

Custom setting e4 – (User's Manual pg. 298)
1. *On* (default)
2. *Off*

On - This setting allows you to see (somewhat) how your flash will light the subject. If you have this setting turned *On*, the depth-of-field preview button strobes the popup flash, or any attached/controlled external SB Speedlight unit, in a series of rapid pulses. These pulses

Figure 37 – *Custom setting e4 screens*

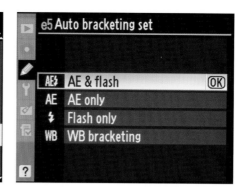

Figure 38 – *Custom setting e5* screens

are continuous and simulate the lighting that the primary flash burst will give your subject. The *Modeling flash* can only be used for a few seconds at a time, to keep from overheating the flash unit, so look quickly.

Off – This means that no *Modeling flash* will fire when you press the depth-of-field preview button.

I often forget that I have this turned on and want to check my actual depth-of-field on a product shot. Instead of depth-of-field I get the modeling light. I don't find this feature to be particularly useful, and it often startles me. One of these days, I'll get around to turning it off. You might like it if you do a lot of flash photography. Give it a try, but just be prepared. The pulsing of the flash sounds like an angry group of hornets about to attack your face.

Custom setting e5 – Auto bracketing set

In *Figure 38* we see the screens used to configure *Custom setting e5*.

This setting allows you to control how auto bracketing exposure are made. You have four choices.

Custom setting e5 – (User's Manual pg. 298)

1. *AE & Flash*
2. *AE only*
3. *Flash only*
4. *WB bracketing*

AE & flash – When you set up a session for bracketing, the camera will cause any type of shot you take to be bracketed, whether standard exposures, or using flash. See how to bracket, below.

AE only – Your bracketing settings will only affect the exposure system, and not the flash.

Flash only – Your bracketing settings will only affect the flash system, and not the exposure.

WB bracketing – White balance bracketing is described in detail in **Chapter 4 – White Balance**. It works the same as we read below for exposure and flash bracketing, except it is designed for bracketing color in "mired" values, instead of light in EV step values.

Figure 38A – *Fn* button; *Main command* dial; Control Panel LCD with bracket marks

How to Use the Auto Bracketing System (Bracketing Explained)

The following assumes that you have *Custom setting f4 – Assign Func. Button's* setting called "*Func. Button + dials*" set to *BKT - Auto bracketing*. If you have changed this basic way to use auto-bracketing, you'll need to use your preferred method to turn bracketing on instead. The FUNC button is also known as the Fn button.

As shown in *Figure 38A*, choose the number of shots in the bracket by pressing and holding the function (*Fn*) button on the right front of the D300. Turn the *Main command* dial to select the number of shots in the bracket.

Look for the *BKT* symbol to appear on the Control Panel LCD, along with lines below the +/- scale to show the number of shots you've selected, up to nine shots total. The number of lines hanging below the +/- scale equal the number of shots in the bracket. If you hold the *Fn* button and rotate the *Main command* dial to select five lines below the scale, that means the D300 will take a total of five exposures in the bracket: two underexposed, one exactly as the meter requires, and two overexposed.

You can use *Custom setting e7* to set the order of the exposures. We'll discuss that in the *Custom setting e7* section below. The default order is *normal > underexposed > overexposed*. You can change it to *underexposed > normal > overexposed*, if you'd like.

While holding the *Fn* button you can rotate the *Sub-command* dial to change the EV value of each image in the bracket, in steps of 1/3, 1/2, or 1 EV. The EV step value is set in *Custom setting b2 – EV steps for exposure control*.

Therefore:

- *Fn* button plus *Main command* dial = number of exposures
- *Fn* button plus *Sub-command* dial = EV step value of bracketed exposures. (1/3, 1/2, or 1 EV step)

Figures 38B through *38D* are a series of pictures of the Control Panel LCD set to various bracketing values.

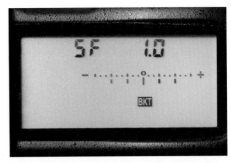

Figure 38B – Bracketing set for 5 exposures at 1.0 EV

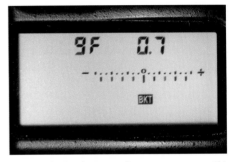

Figure 38C – Bracketing set for 9 exposures at 0.7 EV

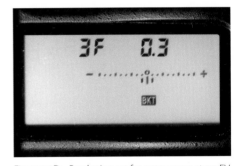

Figure 38D – Bracketing set for 3 exposures at 0.3 EV

Figure 38B shows a total of five exposures (5F) with 1.0 EV between each exposure.

Figure 38C shows a total of nine exposures (9F) with 0.7 EV between each exposure.

Figure 38D shows a total of three exposures (3F) with 0.3 EV between each exposure.

I normally bracket with a 1 EV step value (1 stop) so that I can get a good spread of light values in High Dynamic Range (HDR) images. In most cases, I will do a three image bracket, with

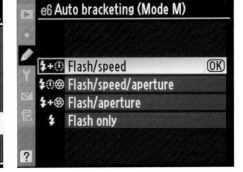

Figure 39 – Custom settings screens e6

one image overexposed and one image underexposed by 1 stop. If the image is really important to me I'll do a five exposure bracket with 1 stop between each exposure.

This type of bracketing allows detail in the highlight and dark areas to be combined later in-computer, for the HDR exposures everyone is experimenting with these days.

Custom setting e6 – Auto bracketing (Mode M)

In *Figure 39* we are shown the screens used to configure *Custom setting e6*.

Custom setting e6 – (User's Manual pg. 299)

- *Flash/speed* (Default)
- *Flash/speed/aperture*
- *Flash/aperture*
- *Flash only*

Flash/speed – This setting allows those who want to control the aperture for best depth-of-field, while still doing bracketing. The camera will control the shutter speed. If *Custom setting e5* is set to *AE & Flash*, the D300 will vary the shutter speed and flash level to expose the bracketed images. If *e5* is set to *AE only*, then the camera will only vary the shutter speed to get the exposures.

Flash/speed/aperture – This setting allows those who want to control the shutter speed and aperture, while still doing bracketing. If *Custom setting e5* is set to *AE & Flash*, the D300 will vary the shutter speed, aperture, and flash level to expose the bracketed images. If *e5* is set to

AE only, then the camera will vary the shutter speed and aperture to get the exposures.

Flash/aperture – This setting allows those who want to control the shutter speed for best action shots, while still doing bracketing. The camera will control the aperture. If *Custom setting e5* is set to *AE & Flash*, the D300 will vary the aperture and flash level to expose the bracketed images. If *e5* is set to *AE only*, then the camera will only vary the aperture to get the exposures.

Flash only – This setting allows those who want to control only the flash while doing bracketing. The camera will only vary the flash level to get the bracketed exposures. *AE only* obviously does not apply with this setting.

Since I am mostly a nature shooter, I leave my D300 set to *Flash/speed*, so that the camera will vary the shutter speed but not the aperture. That way I can control how much depth-of-field I allow in my images.

If I were shooting important outdoor action shots, and wanted to bracket, I'd be shooting in *Flash/aperture* so that the camera will control the aperture, and I can control the shutter speed.

If I were letting my flash control the exposure, like with indoor shots, I might use *Flash only*.

Finally, if I wanted to let the camera decide how to get the best exposure I might use *Flash/speed/aperture*, so that all I have to do is shoot and let the camera do the rest.

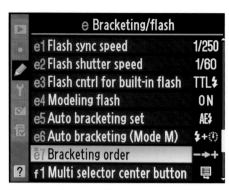

Figure 40 – *Custom setting e7 screens*

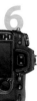

Custom setting e7 – Bracketing order

Figure 40 shows the screens used to configure *Custom setting e7*.

There are two bracketing orders available in the D300. These allow you to control which images are taken first, second, and third in the bracketing series.

- MTR = Metered value
- Under = Underexposed
- Over = Overexposed

Custom setting e7 – (User's Manual pg. 120, 124, and 300)

1. *MTR > under > over* (default)
2. *Under > MTR > over*

MTR > under > over – With this setting, the normal exposure (MTR) is taken first, followed by the underexposed image, then the overexposed image. If you are taking a group of five images in your bracket (see *Custom setting e5*), the camera will take the images like this:

- Normal exposure > most-underexposed > least-underexposed > least-overexposed > most-overexposed

Under > MTR > over – Using this order for bracketing means that the bracket will be exposed in the following manner:

- Most-underexposed > least-underexposed > normal exposure > least-overexposed > most-overexposed

I leave mine set to the default, so that when the images are displayed in series by the camera, I can see the normal exposure first, then watch how it varies as I scroll through the bracketed images.

Controls

(User's Manual pages 301-311)

Custom settings f1 to f10

Custom setting f1 – Multi Selector center button

Custom setting f1 concerns how the Multi Selector's center button works. This setting comes in two parts, according to what mode the D300 is currently using. The two modes are:

- *Shooting mode*
- *Playback mode*

Shooting mode is when you are actually using the camera to take pictures.

Playback mode is when you are examining pictures on the Monitor LCD.

First, let's examine how pressing the center of the Multi Selector works in *Shooting mode*. *Figure 41* shows the screens used to configure *Custom setting f1* in *Shooting mode*.

There are three selections in *Shooting mode*, as follows:

Custom setting f1 – Shooting mode (User's Manual pg. 301)

1. *Select center focus point* (default)
2. *Highlight active focus point*
3. *Not used*

Select center focus point – Often when shooting, you'll be using your thumb to move the selected focus point (AF sensor bracket) around the viewfinder. You'll be using the spot meter or AF sensor to focus on the most appropriate area of your subject. When you are done, you have

Figure 41 – *Custom setting f1* screens – *Shooting mode*

to scroll the AF sensor back to the center. Not anymore! If *Select center focus point* is selected, the focus point pops back to the center point of the viewfinder when you press the center of the Multi Selector button. This is the default action of the button.

Highlight active focus point – Sometimes, when viewing certain subjects, it may be a little hard to see the small black AF sensor bracket in the viewfinder. When *Highlight active focus point* is selected, and you press the center of the Multi Selector button, the AF sensor lights up in red for easy viewing of its current location. Careful, though, because the Multi Selector button is sensitive to sideways movement and it is easy to move the sensor while trying to find it.

Not used – This does what it says, and nothing happens when you press the Multi Selector button. When I first saw this setting, I thought it was a reserved setting for some future use. Finally, I realized that it means that the center of the Multi Selector button is disabled when *Not used* is selected. Since the Multi Selector button is so sensitive, it may act like this selection actually does something, unless you are

Multi Selector Button Sensitivity

I wish Nikon would consider putting an actual small button in the center of this toggle switch, like the D4ox has. It sure would make it a lot easier to use this rather sensitive button accurately. Even a little side-ways pressure on the center of the Multi Selector button causes it to perform some other function than what was intended. Use it carefully. I've found that it seems more accurate to use when I place the entire pad of my thumb completely over the button and press down, instead of inserting the very tip of my thumb into the middle of the button. You try and see which way works better for you.

pressing directly on the center instead of slightly off center.

Now, let's look over how the center of the Multi Slector button can be used in *Playback mode*. *Figure 41A* shows the screens used to configure *Custom setting f1* in *Playback Mode*.

Custom setting f1 – Playback mode (User's Manual pg. 301)

Figure 41A – *Custom setting f1* screens – *Playback mode*

1. *Thumbnail on/off*
2. *View histograms*
3. *Zoom on/off*
4. *Choose folder*

Thumbnail on/off – This feature allows you to switch from viewing one image on your camera's Monitor LCD to viewing multiple thumbnails instead. It's a toggle, so you can press the center of the Multi Selector button to turn thumbnail view on and off.

View histograms – I discovered this really cool feature while I was writing this book, and immediately switched to it as my default setting. I love this! It shows a yellow "luminance" histogram, which seems to most closely represent the Green channel of the RGB. When *f1* is set to *View histograms*, I can have an image open on my monitor, then press and hold the middle of the Multi Selector button to view the histogram. This saves a lot of scrolling around through the data, RGB histograms, and information screens. It's a quick histogram view that disappears when the Multi Selector button is released. Great feature!

Zoom on/off – If you regularly want to zoom into your image on the monitor without using the normal zoom in and out buttons, this is a good feature for you. If you have a monitor image showing, and *Zoom on/off* is selected, when you press the center of the Multi Selector the image zoom jumps immediately to one of

three levels of zoom, skipping the middle steps. Here are the three levels shown in *Figure 41B*:

- *Low magnification*
- *Medium magnification*
- *High magnification*

Low magnification seems to be the same as viewing the image at 100% pixel-peeping level. *Medium magnification* is two levels deeper magnification, past 100%. And, finally, *High magnification* is as far in as the zoom will go; the highest point of magnification, which is way past 100%. The zoom display centers on the focus point used to take the image.

If you are using thumbnail view, you can select from a series of images on the monitor. When you have one of the images selected, even though it is not full size, you can press the center of the Multi Selector button and the image first goes to full size, then zooms to whichever of the three zoom magnification levels you selected previously. When you press the button again, it switches back to thumbnail view.

Choose folder – Some photographers like to use the multi-folder capability of the D300. (See Chapter 5 under the *Shooting Menu* named "Active folder" for more information.) If you have multiple folders on the current CF memory card in your D300, and have *Choose folder* selected in *Custom setting f1*, the camera will present you with a menu of folders to choose from, as seen in *Figure 41C*.

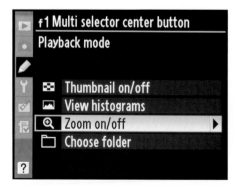

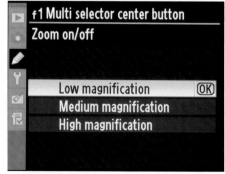

Figure 41B – *Custom setting f1 screens* – *Playback mode* – magnification levels

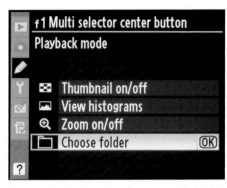
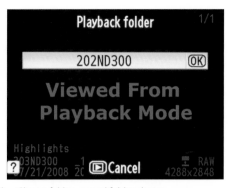

Figure 41C – *Custom setting f1 screens – Playback mode – Choose folder* – actual folder choice

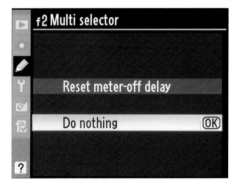

Figure 42 – *Custom setting f2 screens*

Obviously, if your current memory card only has one folder, this setting will have little effect, except to display the one folder.

There's quite a flexible series of functions all imbedded in the center of the Multi Selector button, as controlled by *Custom setting f1*.

Custom setting f2 – Multi selector

The screens used to configure *Custom setting f2* are shown in *Figure 42*.

Custom setting f2 – (User's Manual pg. 302)

1. *Reset meter-off delay*
2. *Do nothing* (default)

Reset meter-off delay – This setting is a handy way to turn the exposure meter on without pressing the shutter release button halfway down. Maybe you'd like to meter the subject, but not cause autofocus to start, so instead of using

the shutter release to turn the meter on, you can use the Multi Selector button instead.

I find this to be a useful function for another reason. I'll often want to move the AF sensor's focus point around the viewfinder, but the light meter has gone off, so it won't move. I have to press the shutter release halfway to activate the meter, then scroll the AF point around the viewfinder. When *Reset meter-off delay* is selected, any usage of the Multi Selector button causes the light meter to come on. *Custom setting c2* controls how long it stays on; the default is 6-seconds.

Do nothing – If the light meter is off, and you press the Multi Selector button, it stays off.

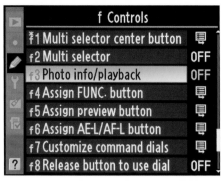 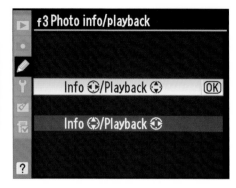

Figure 43 – *Custom setting f3* screens

Custom setting f3 – Photo info/playback
Figure 43 shows the screens used to configure
Custom setting f3.

 Custom setting f3 – Photo info/playback
(User's Manual pg. 302)
1. Info (left-right) / Playback (up-down)
 (default)
2. Info (up-down) / Playback (left-right)

Info (left-right) / Playback (up-down) – This is
the default value for *Custom setting f3*. When you
are viewing a series of pictures, you can press the
Multi Selector button left/right to scroll through
your images, or up/down to view each data screen
and its histogram on a single screen.

 Info (up-down) / Playback (left-right) – If
you prefer scrolling through your memory card's

images by pressing the Multi Selector button
up/down, this is the setting to use. Left/right
takes you through each data screen and its his-
togram on a single screen.

 Nikon seems to want to make the D300 very
flexible, so that it can meet the needs of a wide-
range of user preferences.

Custom setting f4 – Assign FUNC. Button
Custom setting f5 – Assign preview button
Custom setting f6 – Assign AE-L / AF-L button

These three separate *Custom settings* are dis-
cussed in this one section. All three work exactly
the same, so, instead of repeating the same
instructions three times, I chose to explain

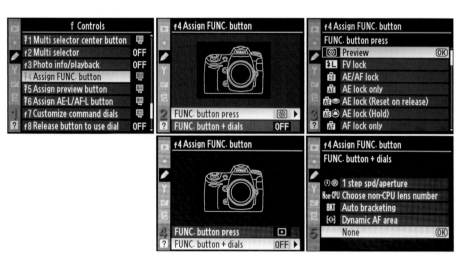

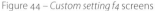

Figure 44 – *Custom setting f4* screens

them below. When I speak of the **Selected** button, I am talking about the *Func.* (Fn), Preview, or *AE-L / AF-L* buttons.

Figure 44 shows the screens used to configure *Custom setting f4* (User's Manual pg. 303).

Figure 45 shows the screens used to configure *Custom setting f5* (User's Manual pg. 306).

Figure 46 shows the screens used to configure *Custom setting f6* (User's Manual pg. 307).

Custom setting f6 is designed to let you customize the usage of the **Selected** button alone, or the **Selected** and command dials combination.

There are many different functions to select from.

Carefully review the following list (1-13), paying close attention to the functions marked with a double asterisk (). Setting those functions will disable functionality in another part of the D300.**

Custom settings f4, f5, and f6:

· *f4 – FUNC. button press*
· *f5 – Preview button press*
· *f6 – AE-L / AF-L button press*

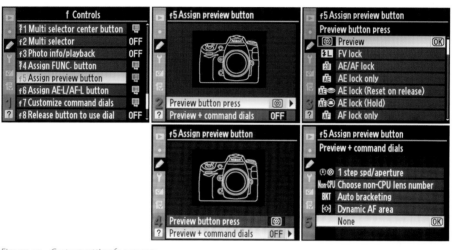

Figure 45 – *Custom setting f5 screens*

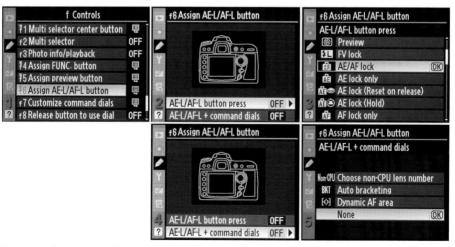

Figure 46 – *Custom setting f6 screens*

1. **Preview**** – Normally, the depth-of-field function is controlled by the *Depth of field preview* button. Some users may not like the location of the *Depth of field preview* button, and since it is configurable too, they may decide to switch the *Fn* button with the *Depth of field preview* button. When *Preview* is selected in *Custom settings 4*, the *Fn* button will activate depth of field preview. Setting this function disables other functionality in the D300. (*See note at end of this list.*)

2. **FV lock**** – If you set *f4*, *f5*, or *f6* to *FV lock*, the **Selected** button will cause the built-in Speedlight, or the external Speedlight, to emit a monitor pre-flash and then lock the flash output to the level determined by the pre-flash, until you press the **Selected** button a second time. (See page 180 in the D300 User's Manual for more information on *FV lock*.) Setting this function disables other functionality in the D300. (*See note at end of this list.*)

3. **AE / AF lock** – Enabling this function causes AE (exposure) and AF (focus) to lock on the last meter and AF system reading while the **Selected** button is held down.

4. **AE lock only** – This allows you to lock AE (exposure) on the last meter reading when you hold down the **Selected** button.

5. **AE lock (Reset on release)**** – Enabling this function causes AE (exposure) to lock on the last meter reading when the **Selected** button is pressed once. It stays locked until the shutter is released, the exposure meters turn off, or you press the **Selected** button again. In other words, the **Selected** button can be used to toggle AE lock. Setting this function disables other functionality in the D300. (*See note at end of this list.*)

6. **AE lock (Hold)**** – Setting this function disables other functionality in the D300. (*See note at end of this list.*).

7. **AF lock only** – When set, this function locks the AF system (focus) on the last autofocus reading while you hold down the **Selected** button.

8. **Flash off** – This is a temporary way to disable the flash for when you want to leave your flash turned on and still be able to take a non-flash picture. When you hold down the **Selected** button, the flash is disabled.

9. **Bracketing burst** – Normally during a bracketing sequence with the shutter release set to *Single Frame Release Mode* (the *S* next to *CH* and *CL* on the *Release mode* dial), you have to press the shutter release once for each of the images in the bracket; the only way to shoot all the images in the bracketed series without letting up on the shutter release is to set the *Release mode* dial to CL or CH. If you set *Bracketing burst* in *Custom setting f4*, *f5*, or *f6*, then you can hold down the **Selected** button, while holding down the shutter release, and the camera will take all the images in the bracket without letup. This seems a bit redundant to me. I think I'd rather just set my *Release mode* to CL or CH and not fool with this additional complexity. This applies to both exposure and white balance bracketing.

10. **Matrix metering** – If you do not use matrix metering as your primary metering system, but want to use it occasionally, this setting allows you to turn matrix metering on while you hold down the **Selected** button. When you release the **Selected** button, the camera returns to your normally-selected metering type, such as spot or center-weighted.

11. **Center-weighted** – If you normally use matrix metering, or even spot metering as your primary metering system, you can temporarily use center-weighted metering by setting *f4*, *f5*, or *f6* to *Center-weighted*, then holding down the **Selected** button. When you release the button, the camera returns to your customary meter type, such as spot or matrix.

12. **Spot metering** – I personally use *Matrix metering* as my normal light meter. However, I often want to use the spot meter to meter more difficult subjects. I assigned my *Fn* button to *Spot metering* here in setting *f4*. Now,

I shoot normally, and whenever I want my spot meter, I just hold down the *Fn* button. Easy and fast! You can, of course, use any of the *Selected* buttons instead of the *Fn* button, if you wish.

13. **None** (default) – When this setting is enabled, the *Selected* button reverts to its default function.

** Warning! Setting Some Functions May Disable Others

If you decide to use this particular function, please realize that it will disable the *Selected* button + command dials feature of the D300. It will set *Selected* button + command dials to *None* as soon as you select this feature. You'll see a warning on the screen when you set it, but by then it will have turned the *Selected* button + command dials to *None*. If you then go back and try to set a value under *Selected* button + command dials, the D300 will give you a warning and set the *Selected* button function to *None*. Both settings cannot be used at the same time.

Custom setting f4, f5, and f6:
- *f4 - FUNC. button + dials*
- *f5 – Preview + command dials*
- *f6 – AE-L / AF-L + command dials*

1. *1 step spd/aperture* (does not apply to *f6*)
2. *Choose non-CPU lens number* (default)
3. *Auto bracketing*
4. *Dynamic AF area*
5. *None*

1 step spd/aperture – If you have *Custom setting b2* set to 1/3 EV steps like most photographers, you can change your D300's shutter speed and/or aperture in 1/3 EV steps, while in *A-Aperture priority*, *S-Shutter priority*, and *M-Manual*. However, you may want to use larger EV steps occasionally. By setting *1 step spd/aperture* in *f4* or *f5*, you can hold down the *Selected* button and the camera will then allow you to change the shutter speed or aperture in 1 stop

increments (1 EV step), instead of the normal 1/3 EV steps. Example shutter speeds in 1/3 EV steps are: 1/100, 1/125, 1/160, 1/200. Example shutter speeds in 1 EV step are: 1/100, 1/200, 1/400, 1/800.

Choose non-CPU lens number – If you have configured non-CPU lenses under the D300's *Setup menu – Non-CPU lens data*, then you'll be able to hold down the *Selected* button, while rotating the *Sub-command* dial, to scroll through a list of up to nine non-CPU lenses.

Auto bracketing – This is the default action of *Custom setting f4 – FUNC. button + dials*. This works quite well for me, since I can hold the Fn button down with a finger while rotating the *Main command* dial to set the bracketing amount. Nikon was wise to provide this functionality after removing the *BKT* button from the D300. I use bracketing quite often for High Dynamic Range (HDR) images. This is not quite as good as a *BKT* button, but works well enough. If you choose to, you can use any of the *Selected* buttons to do *Auto bracketing* instead.

Dynamic AF area – This function only works under specific circumstances:

1. *Continuous-servo AF* must be on. (*Focus mode selector* is on *C*)
2. *Dynamic-area AF* is selected (*AF area mode selector* is in middle position)

If you have chosen to use the *Dynamic-area AF*, and you set *Custom Settings f4, f5*, or *f6* (*Selected* button + dials), you can rotate either of the command dials on the camera's front or back and it will change the number of AF points to one of these four available settings:

1. 9 points
2. 21 points
3. 51 points
4. 51 points (3D-tracking)

(*See Chapter 3 - Multi-CAM 3500DX Autofocus for details on these point selections.*)

None – Nothing happens when you hold down the *Selected* button and rotate the command dials.

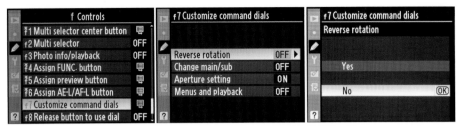

Figure 47 – *Custom setting f7 screens*

Custom setting f7 – Customize command dials

Figure 47 shows the screens used to configure *Custom setting f7*.

There are four settings under Custom setting f7, as follows.

Custom setting f7 – (User's Manual pg. 308)

1. *Reverse rotation*
2. *Change main/sub*
3. *Aperture setting*
4. *Menus and playback*

Reverse rotation – This setting allows you to change the functionality of the rotation direction of the command dials. There are two selections:

- **Yes** – The command dials are reversed. An example is this: Normally when the D300 is set to *A – Aperture Priority mode*, and you rotate the *Sub-command* dial to the right, it changes the aperture in a smaller direction, like f/5.6 to f/6.3 to f/7.1, etc. If you set *Yes*, then the direction of aperture changes will be reversed when you turn the *Sub-command* dial to the right, like this: f/5.6 to f/5 to f4.5, etc. Instead of getting smaller, the aperture gets larger. It is reversed.

- **No** – The direction of the command dials is set to the factory default.

Change main/sub – This setting allows you to swap the functionality of the two command dials. The *Main command* dial will take on the functions of the *Sub-command* dial, and vice-versa. There are two settings.

- **On** – When set to *Off* the *Main command* dial controls shutter speed, while the *Sub-command* dial controls aperture. By selecting *On*, you reverse the functionality, so that the *Sub-command* dial controls shutter speed, while the *Main command* dial controls aperture.

- **Off** – The functionality of the command dials is set to the factory default.

Aperture setting – *Figure 47B* shows the two selections that allow you to modify how the D300 treats CPU-lenses that have aperture rings on the lens (non-G lenses):

- *Sub-command* dial – This is the factory default setting. The aperture is set using the *Sub-command* dial.

- *Aperture ring* – This setting allows photographers with older non-G type lenses with a CPU to use the lenses' aperture ring to adjust

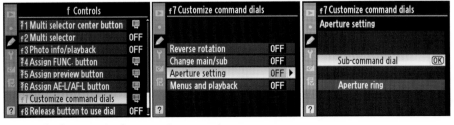

Figure 47B – *Custom setting f7 screens: Aperture setting*

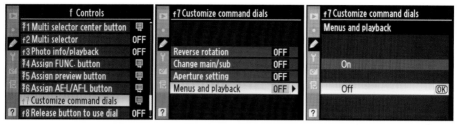

Figure 47C – *Custom setting f7 screens: Menus and playback*

Non-CPU Lenses and Aperture Setting

When a non-CPU lens is used, the aperture ring must always be used to set the aperture instead of the *Sub-command* dial. If you are using a G-type lens with no aperture ring, you clearly can't set the aperture with a non-existent aperture ring, so the camera ignores this setting. Live View is not available when you change *Aperture setting* to *Aperture ring*!

the aperture instead of using the *Sub-command* dial. The EV increments will only display in 1EV steps when this is active. *(Figure 47C)*

Menus and playback – There are two selections for how the menus and image playback works when you would rather not use the Multi Selector:

* ***On*** – While viewing images during playback, turning the *Main command* dial to the left or right scrolls through the displayed images. Turning the *Sub-command* dial left

or right scrolls through the data and histogram screens for each image. While viewing menus, turning the *Main command* dial left or right, scrolls up or down in the screens. Turning the *Sub-command* dial left or right scrolls left or right in the menus. The Multi Selector button works normally, even when this is set to *On*. This setting simply allows you to have two ways to view your images and menus.

* ***Off*** – This is the default action. The Multi Selector button is used to scroll through images and menus, as normal.

When using either of these settings, you can press *OK*, or press the center of the Multi Selector button, to make a selection.

Custom setting f8 – Release button to use dial

Figure 48 shows the screens used to configure *Custom setting f8*.

This custom setting allows those who hate holding down buttons and turning command dials at the same time to change to a different method.

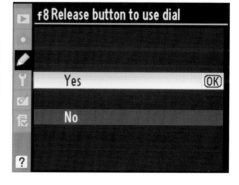

Figure 48 – *Custom setting f8 screens*

Custom setting f8 – (User's Manual pg. 309)

- ***Yes*** – This setting changes a two-step operation into a three-step operation. Normally, you will press and hold down a button while rotating a command dial. When you select *Yes*, the D300 allows you to press and release a button, rotate the command dials, then press and release the button again. The normal (*No*) actions are: 1. press and hold a button, turn a command dial. The *Yes* actions are: 1. press and release button, 2. turn dial, 3. press and release button. The initial button press locks the button, so that you do not have to hold your finger on it while turning the command dial. Once you have changed whatever you are adjusting, you must press the button a second time to unlock it.

- ***No*** – This is the default setting. You must press and hold down a button while rotating the command dials in order to change camera functionality.

If the exposure meter turns off while the *Yes* operation is active, you must press it again to lock the action.

Custom setting f9 – *No memory card?*

Figure 49 shows the screens used to configure *Custom setting f9*.

This setting defaults to enabling the release of the shutter when you try to take an image without a CF memory card inserted in the

Limitations of the Internal Camera Buffer Memory

I tried using the OK setting for other purposes, as an experiment. Without a memory card present, I set *f9* to OK – *Enable release* and went around the house taking pictures. Using *RAW – lossless compression*, I was able to take about 40 pictures before I ran out of internal camera buffer memory. The Monitor LCD displayed DEMO on each image I took while the card was out of the camera, and I could scroll around in the pictures normally. Around picture 41 or 42 the camera dumped all the images, and went back to number one. So, once it reaches the end of buffer memory, the buffer is cleared. Okay, well, maybe I can just shoot some images, turn the camera off and then insert a memory card to write the buffer out to the CF card? Nope! As soon as I turned off the camera, it flushed the buffer, and no images were left. Hmm, maybe I can just shoot some images, and without turning off the camera, insert a memory card? No, again! Even though I had several images waiting around in buffer memory, as soon as I inserted the card, the camera switched to the inserted card and dumped the buffer again, deleting my lovely buffer images in the process. I can find no way to write any of the images in the buffer out to a memory card. If you are the curious type, I hope this saves you some time.

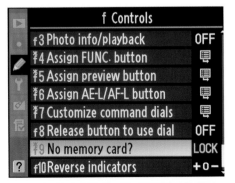

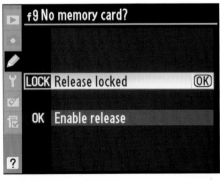

Figure 49 – *Custom setting f9 screens*

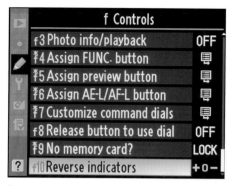
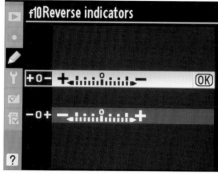

Figure 50 – *Custom setting f10* screens

Figure 50A –*info* exposure indicator: +/- on the left, and -/+ on the right

camera. By enabling it you can take pictures without a memory card. Here are the two settings:

Custom setting f9 – (User's Manual pg. 310)

LOCK – Release locked – By choosing this default setting, your camera will refuse to release the shutter when there is no memory card present.

OK – Enable release – Use this setting if you want to simply preview a set of shots on the Monitor LCD without recording any images to the memory card. Note that a small red box containing the word 'Demo' will appear in the upper-left corner of the displayed image.

Custom setting f10 – Reverse indicators

In *Figure 50* we see the screens used to configure *Custom setting f10.*

Normally, any time you see the exposure indicators in your D300's Control Panel LCD, viewfinder, or the Monitor LCD's info display, the "+" is on the left, and the "–" is on the right. See *Figure 50A* where I show the info screen and the exposure indicator.

If you want, you can reverse this indicator so that the "–" is on the left and the "+" is on the right. Notice how the second screen of *Figure 50A* has the exposure indicator reversed. Here are the two settings:

Custom setting f10 – (User's Manual pg. 311)

+0– : This is the normal polarity (+/–) of the exposure indicator.

–0+ : This is the reversed polarity (–/+) of the exposure indicator.

Select your favorite indicator direction for maximum camera comfort!

My Conclusions - Using the Shooting Banks and Custom Banks Together

Now that you have set up and named each of the banks you are interested in using, you are ready to make your D300 act like a chameleon (or herd of chameleons). You know how each Shooting Bank and Custom Bank is configured. Now you can use them together.

Often, I will use a combination of Shooting Bank A and Custom Bank A, but nothing prevents you from using Shooting Bank B with Custom Bank D, or Shooting Bank C with Custom Bank A. Choose whatever combination you'd like to use.

That's where the D300's extreme flexibility comes in. Maybe you have Shooting Bank A set for Fast Best Quality JPEGs and are shooting it with Custom Bank A, which is set for no Focus-Tracking. Suddenly, a flock of geese flies by and you realize you must use Focus-Tracking to accurately capture the one big fat goose you like. You simply press the *MENU* button, scroll to Custom Bank B, and you are set. (You did configure Custom Bank B for Focus-Tracking, right?)

Or, maybe while you're using Shooting Bank A for Good Quality JPEGS, an incredibly beautiful rainbow appears. You quickly switch to Shooting Bank B, where you've previously set Uncompressed RAW mode for maximum quality.

Get the point? Your camera can change the way it shoots on the fly, in much less time than it takes to talk about it. Now that you've read this over, before you set up a few banks on your D300, give it some serious thought. Think of the ways you most often take pictures, and configure your D300 for each of those ways. Your camera will be customized to you!

Playback Menu

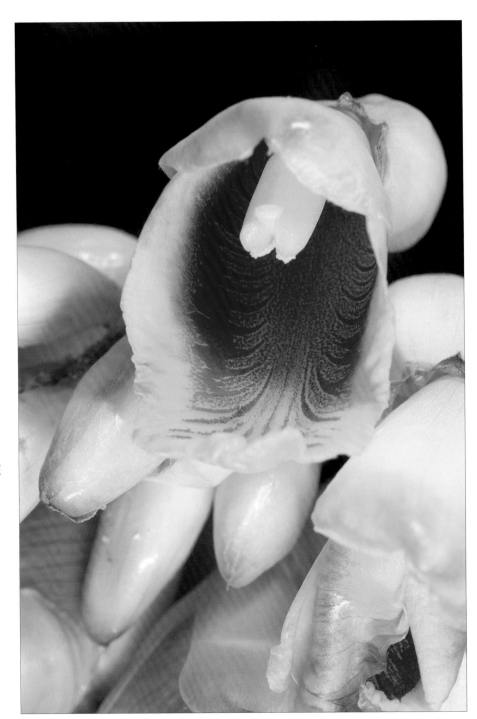

The D300 is one of the Nikon DSLRs with a monitor screen that has enough resolution, size and viewing angle to really enjoy using it to pre-view images. Plus, the battery lasts long enough that it doesn't seriously impact shooting time to enjoy the results of your work immediately.

Everything you need to control your D300's image playback is concentrated in a series of menu selections. They're found under the first menu in the camera, the *Playback Menu*.

We'll examine the nine selections of the *Playback Menu* in detail in the sections below.

Delete Function

The *Delete* function allows you to selectively delete individual images from a group of images in a single or in multiple folders. It also allows you to clear all folders of images, without delet-ing the folders. This is sort of like a card format that only affects images. If you have protected

or hidden images this function will not delete them.

There are two parts to the *Delete* screen:
1. *Selected*
2. *All*

Selected - Here are the screens you'll use to con-trol the *Delete* function for *Selected* images:

Notice in screen 3 of *Figure 1* that you have a list of images with their folder numbers and images numbers just below them. The numbers look like "102-1," which stands for *folder number 102, image 1*. I only have two folders showing in screen 3, which are 102 and 202. There are three images in each folder.

To delete one or more images, you'll need to locate them with the Multi Selector, and then press the center of the button with your thumb to mark them for deletion.—I've found it best to use the pad of your thumb over the whole Multi Selector instead of sticking the end of your thumb into the middle of the button. Once

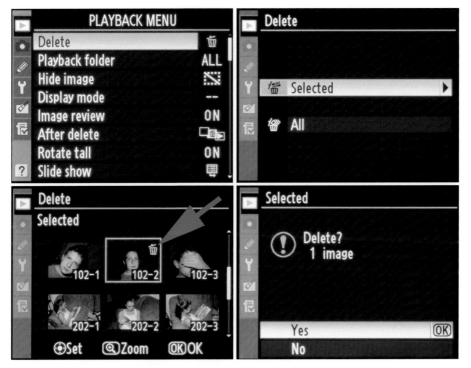

Figure 1 – *Delete* screens for the Selected option

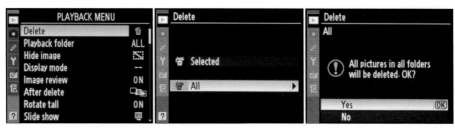

Figure 1A – *Delete* screens for the *All* option

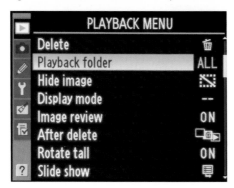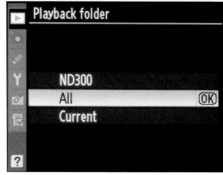

Figure 2 – *Playback folder* screens

you've marked an image for deletion, a small garbage can symbol will appear in the top right corner of the image. Select the images you want to throw away, and then press the *OK* button. A screen like the last screen in *Figure 1* will appear asking you to validate the deletion of the number of images you have selected. To delete them, select *Yes*, and press *OK*. To cancel, select *No* and *OK*, or just press the Menu button.

All – This is like a card format, except that it will not delete folders, only images. As mentioned previously, it will not delete protected or hidden images, either. This is a quick way to "format" your card while maintaining a favorite folder structure. *(Figure 1A)*

To delete all the images in all the folders, simply select *All*, then *Yes* from the next screen with the big red exclamation point, and the urgent warning "*All pictures in all folders will be deleted. Ok?*" (See the last two screens in *Figure 1A*)

When you select *Yes*, a final screen informing you that the dire deed has been accomplished or has been "Done," will pop up briefly.

Being the paranoid type, I tested this well, and found that the D300 really will not delete protected and hidden images. Plus, it will keep any folders you have created. However, if you are a worrier, maybe you should transfer the card data before deleting any images.

Playback Folder

If you regularly use your CF card in multiple cameras like I do and sometimes forget to transfer images, adjusting the *Playback folder* is a good idea.

I use a D300 and D2X on a fairly regular basis. Often, I'll grab an 8 or 16 gigabyte card out of one of the cameras and stick it in another for a few shots. If I'm not careful, later I'll transfer the images from one camera and forget that I have one or more folders on the CF card created by the other camera. It's usually only after I have pressed the format buttons that I remember the D2X images on my D300's memory card. The D300 comes to my rescue with its "*Playback folder – All*" function.

Let's look at how the *Playback folder* function works, by first looking at the screens in *Figure 2*.

Here are the three selections you can choose from:

1. *ND300* (default)
2. *All*
3. *Current*

ND300 – Leaving your camera set to this default mode means that the image playback will show you images in all the folders that have been created by the D300 only. If there are other folders from other cameras on the memory card, it will ignore those images during playback.

All – This maximum flexibility setting has saved my buns several times, when I thought to check my camera for images *before* I formatted the card and found that I had other images on the card besides D300 images. During playback the D300 will display images from other Nikons you've used with the current memory card.

Each camera creates its own unique folders. In this mode, the D300 intelligently displays its own images, as well as any other Nikon images on the card. I leave my D300 set to this playback mode.

Current – This is the most limited playback mode available. Whatever folder your camera is using currently will be displayed during playback. No images from other folders will be displayed.

Hide Image

If you sometimes take images that would not be appropriate for others to view until you have a chance to transfer them to your computer, this setting is for you. You can hide one or many images, and once hidden they cannot be viewed on the camera's monitor screen in the normal way. Once hidden, the only way the images can be viewed in-camera is by using the *Hide Image* menu, as shown in *Figure 3*.

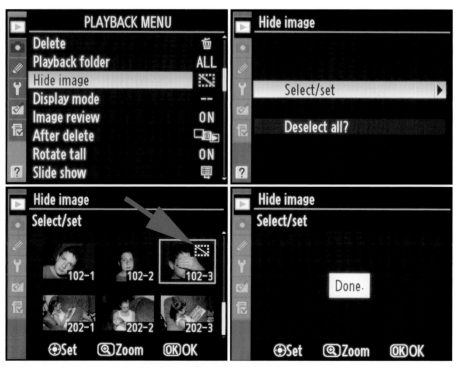
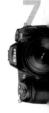

Figure 3 – *Hide image* screens - *Select/set* option

Figure 3A – *Hide image* screens – *Deselect all* option

There are two selections in this menu item.

1. *Select/set*
2. *Deselect all?*

Select/set – This selection allows you to hide one or many images. You'll see them as shown in screen three of *Figure 3*.

To hide an image:

1. Scroll to it.
2. Press the center of the Multi Selector to select it.
3. Press the *OK* button.

You can select multiple images before pressing the *OK* button to hide more than one image at once. When an image is selected for hiding it will show a little dotted rectangle with a slash.

The images that have been selected with the Multi Selector will be hidden when you press the *OK* button. When you have selected and hidden the images, the camera will briefly display "Done" on the LCD monitor.

The number of images reported does not change when you hide images. If you have 50 images on the card, and you hide 10, the camera still displays 50 as the number of images on the card. A clever person could probably figure out that there are hidden images, if they are watching the number of images as they scroll through the viewable ones. If you hide all the images on the card, and then try to view images, the D300 will tersely inform you, "All images are hidden."

You can also use these menus to unhide one or many images, by reversing the process described above. As you scroll through the images, as shown in screen 3 of *Figure 3*, you

Losing Protection When You Unhide

If you have images that are both hidden and protected, and then unhide them, the protection is also removed at the same time. (For information on protecting images, see your D300 User's Manual, page 221.)

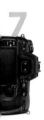

can re-select them with the Multi Selector, then press *OK* to unhide them.

Deselect all? – This is a much simpler way to unhide *all* the images on the card at once. As shown in screen 3 of *Figure 3A*, at the "Reveal all hidden images?" screen, select Yes and press *OK*. All hidden images on the card will be revealed and viewable. As the images are being unhidden, the camera's monitor will display "Marking removed from all images."

Display Mode

This selection allows you to customize how the D300 displays all those histogram and data screens for each image. If you want to see a lot of information on each image, you can select it here. Or, if you would rather take a minimalist approach to image information, turn off some of the screens.

If you turn off certain screens, the camera still records the information for each image, such as lens used, shutter speed, and aperture. However, with no data screens selected you'll only see two screens. One is the main image view, and the other is a summary screen with a luminance histogram and basic shooting information. I have not found a way to turn this summary screen off. You get to the screens by using the Multi Selector to scroll vertically. I leave my camera set so that I can scroll through my images by pressing left or right on the Multi Selector. Then I can scroll through the data screens by scrolling up or down with the Multi Selector.

Here are the selections found in this menu item, and a description of what each does:

Basic photo information

1. *Highlights*
2. *Focus point*

Detailed photo information

3. *RGB histogram*
4. *Data*

When you make changes to these selections, be sure to scroll up to the word *Done* and press the *OK* button to save your setting. I keep forgetting to do this when I make changes. *(See Figure 4.)*

Basic photo information

Highlights – If you put a checkmark next to the *Highlights* selection, as shown in *Figure 4A*, you will turn on what I call the "blinky" mode of the camera.

You'll see the word "Highlights" protruding slightly into the image on the bottom left. When any part of the image is overexposed, that section will blink an alternating white and black. This is a warning that certain areas of the image are overexposed, and have lost detail. You will need to use exposure compensation, or manually control the camera to contain the exposure within the dynamic range of the camera's sensor.

Blinking white-to-black-to-white indicates the areas of the image that have lost all detail, or have been "blown out." If you examine the histogram for the image, you'll see that it's cut off, or "clipped" on the right side. Current software cannot usually recover any data from the blown out sections. The exposure has exceeded the range of the sensor, and has become completely overexposed in the blinking area.

Figure 4 – *Display mode* menu screens

Blinky mode is an immediate way to allow your camera to warn you when you have surpassed what its sensor can capture, and you are therefore losing image data.

Focus point – If you are curious about which AF sensor(s) focused on your subject during the exposure, this mode makes it easy to see. As shown in *Figure 4B*, if you are using Single-point AF or Dynamic-area AF, you'll see a single red AF indicator where the camera was focused when you took the picture; *see Figure 4B*. (If you are using Single-servo auto focus and Auto-area AF

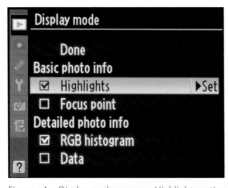

Figure 4A – *Display mode* screens - *Highlights* option

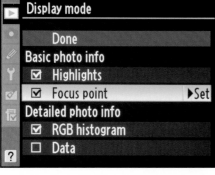

Figure 4B – *Display mode* screens - *Focus Point* option

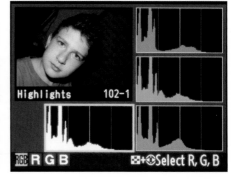

Figure 4C – *Display mode* screens - *RGB Histogram* option

you'll see all the AF sensors that were providing autofocus in your image.

This is a useful function for reviewing how the camera's AF system performs in different imaging situations.

Detailed photo information

RGB histogram – I like this feature, because it allows me to view, not just a basic luminance histogram (which is a combination of all three color channels), but all three color histograms and a luminance histogram in one screen *(Figure 4C)*.

Each color channel—Red, Green, and Blue—is displayed with its own small histogram. This is quite useful, since it is possible to over-expose, or "blow out" only one color channel, as happens often with the Red channel, in my case.

You can view the three individual color histograms on the right, and see the small combined luminance histogram on the bottom left, with a small version of the image on the top left *(Figure 4D)*.

Data – Checking this setting will give you three additional image data screens to scroll though. The data found on these screens is quite detailed, and includes the following information:

Image data, screen 1

• Light meter in use (Matrix, Spot, or Averaging), Shutter speed, and Aperture
• Exposure Mode (P,S,A,M) and ISO
• Exposure mode fine tuning (I leave mine set to 3/6+ on Matrix)
• Lens focal length
• Lens Overview (e.g, 18-70mm f/3.5 – 4.5)
• AF/VR
• Flash Mode and Compensation

Image data, screen 2

• White balance
• Color space (sRGB, AdobeRGB)

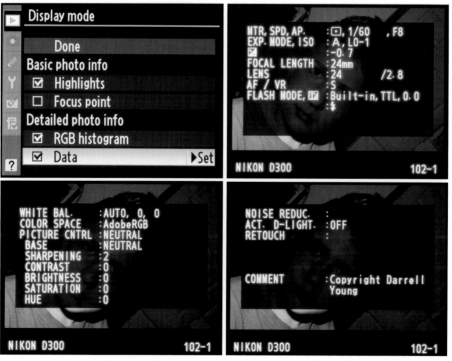

Figure 4D *Display mode* screens - Data option

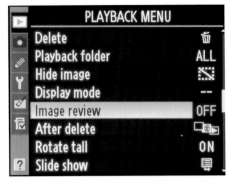

Figure 5 – *Image review* screens

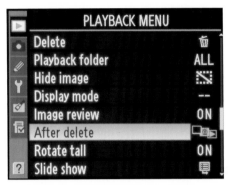

Figure 6 – *After delete* - screens

- Picture control detail Base (Neutral, Standard, Vivid, Monochrom), Sharpening, Contrast, Brightness, Saturation, Hue (for Monochrome, the Saturation and Hue options are replaced with Filter and Toning)

Image data, screen 3
- Noise reduction
- Active D-Lighting (Off, Low, Normal, High)
- Retouching
- Comment

This large array of screens to scroll through provides a great deal of information on the image. Look how far we've come from the old film days of writing some date information on the lower right of the image, permanently marking it, or between the frames on the pro-level cameras.

Including the two standard display screens, there are six screens just brimming with data, if you enable all the *Display modes* (seven, if you used a GPS). Or, you can get by with the main image display and one summary display. Complex control at your fingertips!

Image Review

The factory default for the D300 is to leave the monitor turned off during picture taking. This saves battery life. However, the D300's battery is long-lived, since the camera does not use a lot of power. If you prefer to review or "chimp" each image after you take it, then you'll need to turn this feature *On (Figure 5)*.

Image review settings:

1. *On* – Shows a picture on the monitor after each shutter release.
2. *Off* – Monitor stays off when you take pictures (Default).

Most of us will turn this feature on right away, otherwise the only way to view an image after taking it is to press the *Playback* button.

After Delete

This is one of those weird functions that makes me scratch my head and wonder. Why is this needed?

If you delete an image during a playback session, after taking it and chimping, or after pressing the *Playback* button, one of your other images will display on the camera monitor. This function lets you select which image is displayed after you delete an image.

The three selections are:

1. *Show next* (default)
2. *Show previous*
3. *Continue as before*

Show next – If you delete an image, and it wasn't the last image on the memory card, the very next image will display in the monitor. If you delete the last image on the card, the previously next to last image will display. *Show next* is the default setting of the D300.

Show previous – If you delete an image, and it was the first image on the memory card, the next image will display. If you delete an image somewhere in the middle or at the end of the memory card, the previous image will display.

Continue as before – This weird little setting shows the flexibility of computer technology in all its glory. If you were scrolling to the right (order in which they were taken), and decide to delete an image, the camera uses the *Show next* method listed above to display the next image. Since the computer in your D300 is aware which direction you are scrolling, if you happen to be

scrolling to the left (reverse-order from which the images were taken) when you decide to delete a picture, the camera will use the *Show previous* method, instead.

Rotate Tall

When you shoot an image as a vertical or portrait image where you turn your camera sideways, the image is recorded to the card as a horizontal image lying on its side. You can look at the image later, and the D300 will default to leaving it on its side, so that you must turn the camera to view it comfortably.

If you would rather that the camera automatically rotate the image to normal viewing perspective, even though that causes a smaller upright vertical image, you'll need to set this option to *On (Figure 6A)*.

Here are the two available settings:

1. **On** – When you take a vertical image, the D300 will rotate it so that you don't have to turn your camera to view it. This sizes the image so that a vertical image fits in the normal horizontal frame of the monitor. The image will be quite a bit smaller than normal to view.
2. **Off** – Vertical images are left in a horizontal direction so that you'll need to turn the camera to view it as it was taken. This provides a larger view of the image.

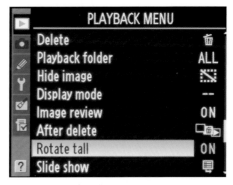
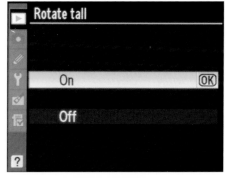

Figure 6A – *Rotate tall* screens

I leave mine set to *On*, since I can zoom in if I want more detail. That way I can view an occasional vertical image in its natural vertical orientation without turning my camera. However, if you've mounted your camera on a tripod for an extensive series of portraits, you will want to set this option to *Off*.

Slide Show

I used to do slide shows back in the old film days. I'd set up my screen, warm up my projector, load my slides, and watch everyone fall asleep by the 100th slide. For that reason, I hadn't been using the *slide show* functionality of my camera. However, all that changed recently.

One day I was up in the Great Smoky Mountains, shooting beautiful waterfalls and cascades. The day was about over, so I headed back into town with my lovely images, and a desire for supper. I stopped in at the local buffet, got some food, set my camera up on one of those silver metal napkin boxes, and started watching my own little show while I ate. Before long, I was hearing ooohs and aaahs from people at the next table. Soon, there were several folks standing behind me watching the show. I became an instant celebrity.

It was so popular that I think I'll go back this spring, and this time be prepared to charge admission! With this D300's giant 3 inch monitor and XGA resolution, it should be a satisfying experience for any tourist.

Here's how to set up a slide show with your D300.

As shown in *Figure 7*, the easy way is to simply select the *Playback Menu's Slide show* setting, scroll right and select *Start*. The slide show will commence immediately and have a default display time of two seconds per image.

If you want to allow a little more time for each image to display, you'll need to change the display time to a value of 3, 5, or 10 seconds. Shown in *Figure 7A* are the menu screens to make the change.

You can select:

- **2s** – 2 seconds (default)
- **3s** – 3 seconds
- **5s** – 5 seconds
- **10s** – 10 seconds

To start the slide show, repeat the steps shown in *Figure 7*, except that, this time, the show will run at your new slower speed.

There are several options that will affect how the images display during the slide show. These are as follows:

Skip back/Skip ahead – During the slide show, you can go back to the previous image for another viewing (duration is dependent on your *Frame Interval* setting) by simply pressing left on the Multi Selector. You can also see the next image with no delay by pressing right on the Multi Selector. This is just a quick way to skip

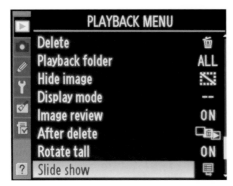
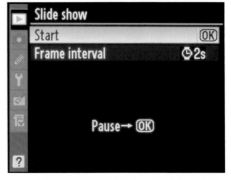

Figure 7 – *Slide show* screens

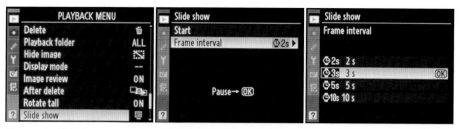

Figure 7A – *Slide show* screens - *Frame Interval* option

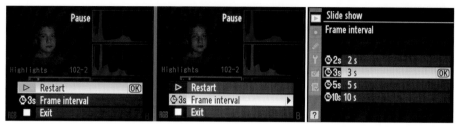

Figure 7B – *Slide show* screens - *Pause* option

images or review previous images without stopping the slide show.

View additional photo info – While the slide show is running, you can press up or down on the Multi Selector to view the additional data screens. This is dependent on how you have your D300's *Display mode* configured (see *Display mode* section above) for Highlights, Focus Point, RGB Histogram, and Data. If any of these screens are available, they can be used during the slide show.

Pause slide show – During the slide show you may need to pause, change the image display time, or even exit. By pressing the *OK* button, the slide show pauses and you are presented with screen 1, as shown in *Figure 7B*.

Using screen 1, you can select:

1. **Restart** - Pressing *OK*, or scrolling to the right on the Multi Selector continues the slide show from the image following the one last viewed.

2. **Frame interval** – Scrolling to the right with the Multi Selector takes you to the screen that allows you to change the display time to one of four values. You can choose 2, 3, 5, or 10 seconds. After choosing the new *Frame*

interval value, you'll have to select Restart to continue where you left off in the slide show.

3. **Exit** – This does what it says – exits the slide show.

Exit to the *Playback Menu* – If you want to quickly exit the slide show, simply press the *Menu* button, and you'll jump directly back to the top of the *Playback Menu*, with no items selected.

Exit to playback mode – By pressing the *Playback mode* button (the right arrow key, with a rectangle around it, on the top rear left of the D300), you'll stop the slide show and change to normal full-frame or thumbnail image view of the last image seen in the show. This exits the show on the last image viewed.

Exit to shooting mode – Pressing the shutter-button halfway down stops the slide show. The camera is now in "*Shooting mode*," meaning that it is ready to take some pictures.

Using any of the buttons above affects the slide show in the ways listed.

Print Set (DPOF)

This feature allows you to connect your cam-
era directly to a PictBridge compatible printer,
or any device that supports the Digital Print
Order Format (DPOF). You will be creating a
"print order" that allows a connected PictBridge
compatible printer, or service, to print only the
images you have selected on your memory card
via the PictBridge menu of the D300. This is not
a difficult process to use, but quite complex to
describe. In fact, it would almost take another
entire chapter in this book to go over the
nuances of PictBridge printing.

Since the D300 is aimed squarely at semi-pro
and professional users, it is highly likely that
few readers of this book will be interested in
printing directly to PictBridge printers, prefer-
ring instead to use their computers to carefully
post-process each image. They are also likely to
use a professional lab service to obtain optimum
image quality for themselves and their clients.
The D300 User's Manual on pages 230 to 241
gives a very detailed description of how to use
PictBridge and DPOF for those who want to
make use of this feature.

My Conclusions

Wow! The D300 sure does have a lot of screens
and menus. I remember the old days when to
"playback" some images, you'd have to find the
old shoebox full of pictures, or open an album
and flip pages. Sometimes, I miss photo albums.
You know what? I am going to run down to the
super-store right now and buy several albums.
Then, I'll have some actual images printed and
put into those albums. Better yet, I think I'll go
buy a PictBridge compatible printer, so I can
print my own images for the albums, and be able
to write about it in my next book.

Setup Menu, Retouch Menu, and My Menu

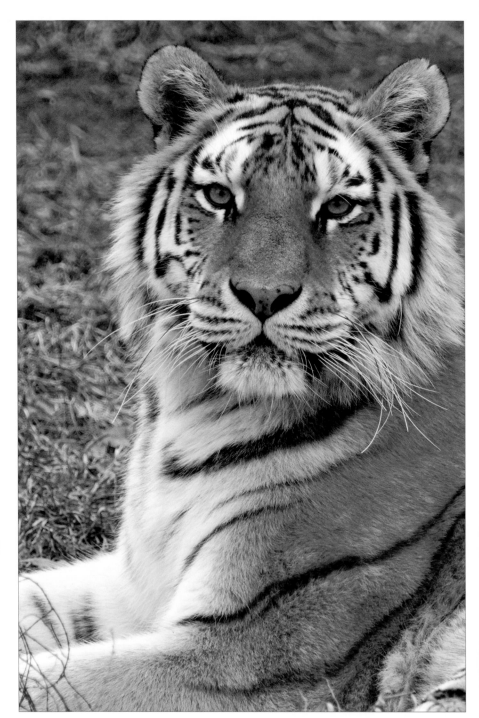

The three sections of this chapter cover the last three menu systems in the Nikon D300: the *Setup Menu*, *Retouch Menu*, and *My Menu*.

Section 1: The *Setup Menu* is quite extensive with 20 distinct features and settings that control various aspects of the camera. Also included are references to optional computer software and external devices such as GPS units and cables.

Section 2: The *Retouch Menu* is composed of seven in-camera image adjustments which allow you to do things to the image that normally would only be done in a graphics program on your computer.

Section 3: *My Menu* is whatever collection of menu items you want it to be. If you use certain menus or settings in the camera on a regular basis, you can add them to *My Menu*, and then use them without searching through other menus and screens.

In addition to the detailed information found in this chapter, there are many page references to the Nikon "EN" D300 User's Manual. Between this book and the User's Manual, you should be able to gain a very detailed knowledge of your camera's operation.

Section 1: *Setup Menu*

(D300 User's Manual page 312)
The *Setup Menu* on the Nikon D300 is a series of menu items for basic camera settings not generally related to taking pictures. They cover things

Figure 1– *Setup Menu* screen

like how bright you'd like the Monitor LCD, battery info, firmware version, the default language, image sensor cleaning, and many other basic settings.

These menu items are most likely the first you'll use when you prepare your new D300. You'll want to set your *World Time* and *Date* right away, then format a memory card and set your Monitor LCD brightness.

The *Setup Menu* is identified with a symbol that looks like a wrench. It is about mid-way down the menu tree, on the left. See *Figure 1* for a look at the *Setup Menu* layout.

Let's examine each of the menu items in detail.

Format memory card

(D300 User's Manual page 313)
If you don't like using the external camera controls to format a memory card, the D300 allows you to do it with this screen instead. In *Figure 2* are the screens involved in the process.

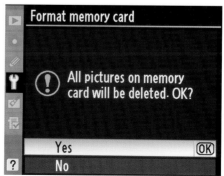

Figure 2 – *Format memory card* screens

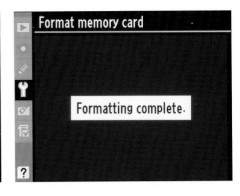

Figure 2A – *Format memory card* screens

There are four screens you'll see when formatting a memory card. You'll only make selections from two of them. Here are the three steps to formatting a memory card:

1. Select *Format memory card* from the first screen.
2. Select *Yes* from the screen with the big red exclamation mark and the words *All pictures on memory card will be deleted. OK?*
3. Press the *OK* button.

Once you press the *OK* button, you'll see the two screens in *Figure 2A* in quick succession:

While the actual formatting is happening, the first screen in *Figure 2A* will be shown. When the card has been successfully formatted, you'll see the last screen in *Figure 2A* that says *Formatting complete*. Then the camera switches back to the *Setup Menu's* first screen. The card is now formatted.

LCD brightness

(D300 User's Manual page 313)

This setting is more important than many people realize. If you set the Monitor LCD brightness too dimly, you'll have trouble seeing your images in bright light. If you set it too brightly, you might allow some images to be underexposed because, in previewing, they look fine on the Monitor LCD. If the Monitor LCD is too bright, even a seriously underexposed image will look okay.

You can select from seven levels of brightness, from -3 to +3, as shown in *Figure 3*. Here are the available values:

$$-3, -2, -1, 0, +1, +2, +3$$

Once you've selected *LCD brightness* from the *Setup Menu*, you'll see a screen like the second one in *Figure 3*. Use the Multi Selector to scroll up or down through the values listed above. Press the *OK* button once you've found the value you like best.

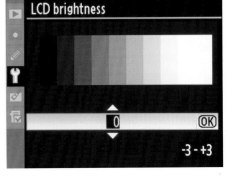

Figure 3 – *LCD brightness* settings

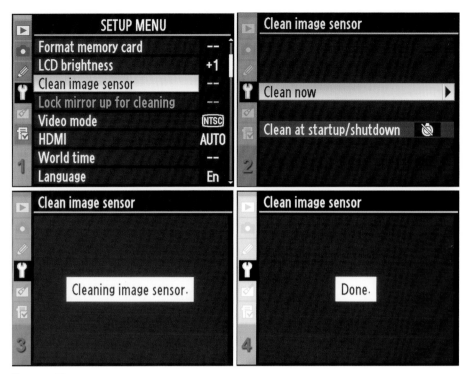

Figure 4 – *Clean now* screens

The camera defaults to o (zero), which is right in the middle, yet is quite bright. I feel that o is a little too bright, and makes my images look like they are exposed more brightly than when I see them later in the computer. Recently, I've been using -1 on my D300, as that seems bright enough for outdoor use, but doesn't make my images appear overly bright.

Using the bars with varying levels of brightness, as shown on screen 2 of *Figure 3*, adjust the brightness until you can barely make out a distinction between the last two dark bars on the left, which may be the best setting for your camera. Mine is best at -1 in normal outdoor light. Decide for yourself what looks best for you.

If you choose to set your camera to a level higher than about o, just be sure that you check the histogram frequently to validate your exposures. Otherwise, you may find that you are allowing the camera to slightly underexpose your images. The D300 has one of the best exposure meters I've seen in a camera, yet it is not perfect and needs your help sometimes. Letting

your Monitor run too brightly might mask those times that it needs help. Use your histogram!

Clean image sensor

(D300 User's Manual page 314)

Dust is everywhere, and eventually will get on your camera's imaging sensor. Fortunately, the D300 provides sensor cleaning by vibrating the low-pass filter. These high-frequency vibrations will dislodge dust, making it fall off the filter, so that you won't see it as spots on your pictures.

The low-pass filter is directly in front of the imaging sensor, so dust should never really get on the sensor itself. However, if you go to the beach, where sand is blowing in the wind, and change your lenses a few times, you might develop a dust problem. In that case, look at the next section, *Lock mirror up for cleaning*

Figure 4A shows the screens used to clean the camera's sensor. You have a few options. (See User's Manual pages 371-373 for more detail.)

1. *Clean now* and 2. *Clean at startup/shutdown*

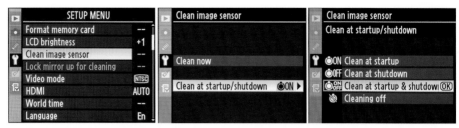

Figure 4A – *Clean at startup/shutdown* screens

Clean now – This option allows you to clean the sensor anytime you feel like it. If you detect a dust spot, or just get nervous because you are in a dusty environment with your D300, you can simply select *Clean now*, and the camera will execute a cleaning cycle. To execute the cleaning function, select *Clean now* as shown in the second screen of *Figure 4*, and then scroll to the right with the Multi Selector. While the cleaning is taking place, you can briefly hear small squeaking sounds if you hold your camera close to your ear. A screen will appear that says *Cleaning image sensor*. When the process is complete, another screen will appear that says *Done*. Then the camera switches back to the *Setup Menu*.

Clean at startup/shutdown – For preventative dust control, many users will set their cameras to clean the sensor at start up, shutdown, or at both. There are four selections for startup/shutdown cleaning:

1. *Clean at startup*
2. *Clean at shutdown*
3. *Clean at startup & shutdown*
4. *Cleaning off* (default)

These settings are all self-explanatory and do what they say. I find it interesting that I do not detect any startup or shutdown delay when using the startup/shutdown cleaning modes. I can turn my camera on and immediately take a picture. The cleaning cycle seems to be very brief when using this mode.

Nikon suggests that you have the camera at the same angle as when you are taking pictures (camera in landscape orientation, with lens pointing to the horizon) when you use these modes to clean the sensor.

Clean Now vs. At Startup/Shutdown

When I am really concerned about cleaning the sensor, I use the *Clean now* method. That method seems to shake the low-pass filter for a longer period. I only suspect this due to testing how quickly I can shoot an image with *Clean at startup/shutdown* mode selected. However, even the seemingly brief shake of the filter on startup/shutdown should help prevent dust from staying on your filter.

Lock mirror up for cleaning

(D300 User's Manual page 314)
If the high-frequency vibration method of cleaning your D300's sensor does not dislodge some stickier-than-normal dust, you may have to clean your sensor more aggressively.

In many cases, all that's needed is to use a dust blower to remove the dust with a puff of air. I remember having to do this with my Nikon D100 in 2002, and I was always afraid I might ruin the shutter if I did it incorrectly. With the D100, I had to hold the shutter open in bulb mode with one hand, while I blew off the sensor with the other.

The D300 helps out by providing this *Lock mirror up for cleaning* mode, so that you can more safely blow a stubborn piece of dust off the low-pass filter. (See User's Manual pages 374-376 for more detail.) Using this function, it is much safer to blow off the sensor.

Here are the three screens you'll use to select this mode for manual sensor cleaning:

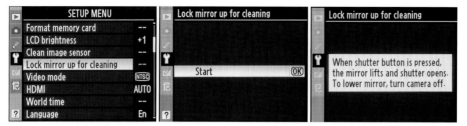

Figure 5 – *Lock mirror up for cleaning* screens

As shown in *Figure 5*, select *Lock mirror up for cleaning* from the *Setup Menu* and scroll to the right. Next, select *Start* from the second screen, then press the *OK* button. When the camera is ready to lock the mirror and shutter in an open position and expose the low-pass filter in front of the sensor, you'll see the third screen that says:

"When shutter button is pressed, the mirror lifts, and shutter opens. To lower mirror, turn camera off."

Make sure you have a fresh battery in the camera, since that's what holds the shutter open for cleaning. It must be above a 60% charge, or the camera will refuse to allow you to start the process.

You'll need a good professional sensor-cleaning blower such as my favorite, the Giottos Rocket-Air blower with its long red tip for easy insertion. I bought mine from the Nikonians' Pro Shop (PhotoProShop.com).

At this point, remove the lens, and press the shutter. You'll see that the mirror moves up out of the way, and the shutter opens. When you look inside the front of the camera, you'll see the bluish looking low-pass filter in front of the sensor.

Carefully insert the tip of a blower, without touching the sensor, and blow it off with a few puffs of air. Turn the camera off to lower the mirror and close the shutter.

Wet Cleaning Your Sensor? Be Careful!

If an air blower fails to remove stubborn dust or pollen, you will have to either have your sensor professionally cleaned, or do it yourself. Nikon states that you will void your warranty if you touch the low-pass filter. However, many people still wet or brush clean their D300's sensor. I've done it myself, although I'll never admit it! It is critical that you are aware of the following information if you choose to wet clean your sensor:

The Nikon D300 has a special tin-oxide coating on the low-pass filter that is designed to make it harder for dust to stick to its surface. Unfortunately, this coating is adversely affected by the normal cleaning fluids that have been used for several years to clean sensors. You must purchase the correct cleaning fluid to wet clean the low-pass filter. It is called Eclipse E2, and is safe for the cleaning the filter without damaging the tin-oxide coating.

If all of this makes you nervous, then send your camera off to Nikon for approved cleaning, or use a professional service. Fortunately, a few puffs of air will often remove dust too stubborn for the high-frequency vibration method to remove. It helps to have the proper tools, such as the Giottos Rocket-Air blower from the Nikonians' PhotoProShop.com.

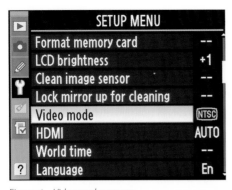 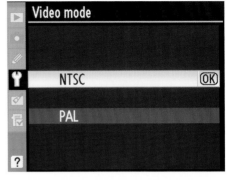

Figure 6 – *Video mode* screens

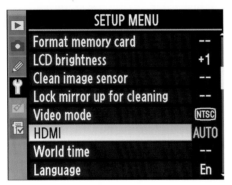

Figure 6A – *HDMI* screens

Video mode

(D300 User's Manual page 314)

If you plan on connecting your D300 to a video device, you'll need to be sure and use the correct video mode for communication with the device.

There are two video modes available in the D300, and they are:

1. *NTSC*
2. *PAL*

Figure 6 shows the screens used to select the video mode.

You'll need to refer to the manual of your television, VCR, or other device, to determine what video input it uses. The *Video Out* port is under the rubber flap on the side of the D300. Use screen 2 of *Figure 6* as a reference for selecting the modes.

High-Definition Multimedia Interface (HDMI)

(D300 User's Manual page 315)

If you would like to display your images on a high-definition monitor or television, your D300 has the modes and connector you need. You'll need an HDMI "Type A" cable, which is not included with the camera but is available from many electronic stores.

Before you connect the camera to your HDMI display, you'll need to set one of these HDMI formats *(Figure 6A)*:

1. *Auto* (default) – This allows the camera to select the most appropriate format for displaying on the currently connected device.
2. *480p (progressive)* – 640 x 480 progressive format.
3. *576p (progressive)* – 720 x 576 progressive format.

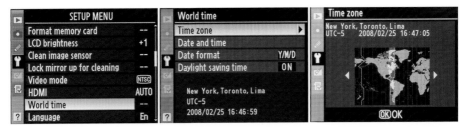

Figure 7 – *Time zone* screens

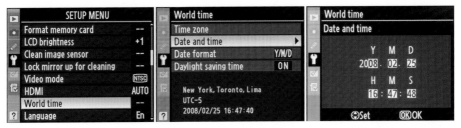

Figure 7A – *Date and time* screens

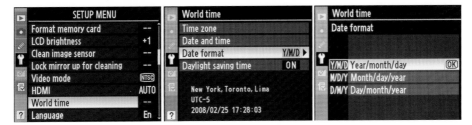

Figure 7B – *Date format* screens

4. *720p (progressive)* – 1280 x 720 progressive format.
5. *1080i (interlaced)* – 1920 x 1080 interlaced format.

Clearly, the D300 can interface with both progressive and interlaced devices. The HDMI display will take the place of the Monitor LCD on the back of your D300. The Monitor will turn off as soon as you connect an HDMI device.

World Time

(D300 User's Manual page 316)

There are several functions to set under the *World Time* section of the *Setup Menus*:

1. *Time zone*
2. *Date and time*
3. *Date format*
4. *Daylight saving time*

Time zone – *Figure 7* shows the *Time zone* configuration screens. The screen used to set the zone uses a familiar world map interface to select the area of the world in which you are using the camera. To set the time zone, simply navigate to the last screen in *Figure 7* and then use the Multi Selector to scroll left or right until your time zone is under the yellow vertical bar in the center. Once you have your time zone selected, press the *OK* button to save the setting.

Date and time – *Figure 7A* shows the three *Date and time* configuration screens. The final screen in the series allows you to select the Year, Month, and Day (Y, M, D), and the Hour, Minute, and Second (H, M, S). Using the Multi Selector, scroll left or right until you have selected the value you want to change. Then scroll up or down to actually change the value. When you have set

the correct date and time, press the *OK* button to save the settings. Please note that the time setting uses the 24-hour military-style clock. To set 3 p.m., you would set the H and M settings to 15:00. For your convenience, here is a listing of the 24 hour time equivalents:

24 Hour Time Equivalents

A.M. Settings
12:00 a.m. = 00:00 (Midnight)
01:00 a.m. = 01:00
02:00 a.m. = 02:00
03:00 a.m. = 03:00
04:00 a.m. = 04:00
05:00 a.m. = 05:00
06:00 a.m. = 06:00
07:00 a.m. = 07:00
08:00 a.m. = 08:00
09:00 a.m. = 09:00
10:00 a.m. = 10:00
11:00 a.m. = 11:00

P.M. Settings:
12:00 p.m. = 12:00 (noon)
01:00 p.m. = 13:00
02:00 p.m. = 14:00
03:00 p.m. = 15:00
04:00 p.m. = 16:00
05:00 p.m. = 17:00
06:00 p.m. = 18:00
07:00 p.m. = 19:00
08:00 p.m. = 20:00
09:00 p.m. = 21:00
10:00 p.m. = 22:00
11:00 p.m. = 23:00

Interestingly, there is no 24:00 time (midnight). After 23:59, comes 00:00 instead.

Date format – The D300 gives you three different ways to format the date including the following (*see Figure 7B*):
1. *Y/M/D* = Year/month/day (2009/12/31)
2. *M/D/Y* = Month/day/year (12/31/2009)
3. *D/M/Y* = Day/month/year (31/12/2009)
United States D300 owners will probably use setting 2, which matches the MM/DD/YYYY format so familiar to Americans. Other areas of the world can select their favorite date format.

Daylight savings time – Many areas of the USA use daylight savings time to "spring forward or fall back." In the spring many American residents set their time forward by one hour on a specified day each year. Then in the fall they set it back, leading to the clever adage quoted above. There are two choices you have for *Daylight savings time*; namely, *On* or *Off*. If you live in an area that implements daylight savings time, select *On* and press *OK* to save the setting. Your camera will now automatically "spring forward and fall back," adjusting your time forward by one hour in the spring and back one hour in the fall of the year, in accordance with the established dates as of 2008.

Language
(D300 User's Manual page 316)
Nikon is a company that sells cameras and lenses around the world. For that reason, your D300 can speak up to 15 languages. In *Figure 8* are the screens used to select your choice of language. Screens 2 and 3 of *Figure 8* are continuations of a single menu item that, of course, won't fit on a single D300 Monitor screen.

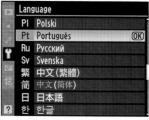

Figure 8 – *Language* screens

The languages included with the D300 using firmware version 1.01 include the following:

1. German
2. English
3. Spanish
4. Finnish
5. French
6. Italian
7. Dutch
8. Polish
9. Portuguese
10. Russian
11. Swedish
12. Traditional Chinese
13. Simplified Chinese
14. Japanese
15. Korean

The D300 should default to the language of the area in which you purchased the camera.

Image Comment

(D300 User's Manual page 317)

This is a useful setting that you can use to attach a comment to each image you shoot. I attach the words "Copyright Darrell Young" to my images. Unfortunately, Nikon does not include the copyright symbol © in the list of numbers and letters or I would include that in my copyright notice.

The three screens shown in *Figure 9* are used to add a comment to each subsequent image.

From the second screen shown in *Figure 9*, you'll select the *Input comment* line and scroll to the right with the Multi Selector. In screen 3, you'll see a series of symbols, numbers, and letters on top, with a line of dashes at the bottom.

The dashes are where we will put our text to attach a comment. In the upper left corner of the characters area is a blank spot which represents a blank for insertion in the line of text. This is good for separating words. If you scroll down past the uppercase letters, you'll find some lowercase letters too.

Below is a series of steps to use while creating the image comment. You'll use the external camera controls shown in *Figure 9A* while creating and saving an image comment.

Steps to input new characters:

1. Use the *Multi Selector* to scroll through the numbers and letters to find the characters you want to use. Scroll down for lowercase letters.
2. Press the center of the Multi Selector to select a character. Keep selecting new characters until you have the entire *Image comment* in place (maximum is 36 characters).
3. If you make a mistake, hold down the *Checkered Thumbnail* button while using the Multi Selector to move to the position of the error.

Figure 9A – Camera controls for adding an *Image comment*: Multi Selector, *Checkered Thumbnail*, *Delete*, and *OK* buttons.

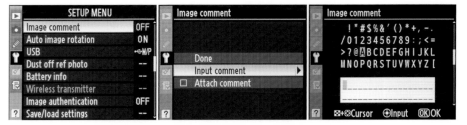

Figure 9 – *Image comment* initial screens

Push the garbage can *Delete* button on the top left of the D300. The unwanted character will disappear.

4. Press the *OK* button to save the *Image comment*.

5. The camera will switch back to the second screen (as seen in *Figure 9*). You'll need to select the *Attach comment* check box, so that the comment will attach itself to each subsequent image. Scroll to the *Attach comment* line and press the *OK* button. You'll see a check mark appear in the little box.

6. Scroll up to *Done*, then press *OK* again. That completes the process.

Any comment you create here will be added internally to the metadata of the image. It *will not* show on the image itself.

Auto Image Rotation

(D300 User's Manual pages 318 and 251)
This function is concerned with how a vertical image displays on the back of your camera, and later, on your computer. Horizontal images are not affected by this setting. The D300 has a direction-sensing device so that it knows how a picture is oriented. This setting allows you to make use of that device.

If you are not using the MB-D10 Battery Pack on your D300, you may take a vertical picture one time with the camera handgrip held down, and another time with it held up. Of course, the two image directions are 180 degrees apart and are upside down from each other.

According to how you have *Auto Image Rotation* set, and how you hold your D300's handgrip, the camera will display vertical images as upright portrait images with the top of the image at the top of the Monitor LCD, or as images lying on their sides in a horizontal direction with the top to the left or right.

Here, in *Figure 10*, are the two screens used to set the *Auto Image Rotation* function.

The two selections you have are:

1. *On* (default)
2. *Off*

On – With *Auto Image Rotation* turned *On*, the D300 will automatically display a vertical image in an upright position on your camera's Monitor LCD. If you have *On* selected, it saves the orientation information with the image so that it will display correctly in Capture NX and ViewNX.

Off – If it is turned *Off*, then the vertical image will be displayed as a horizontal image lying on its side. The top of the image will be on the left or right, according to how you held the hand grip, up or down. The camera does not record orientation information with the image.

CL or CH Mode and Image Orientation

If you are shooting in Continuous frame-advance mode (CL or CH), the way you are holding your camera for the first shot sets the direction the images are displayed, even if you change direction while shooting.

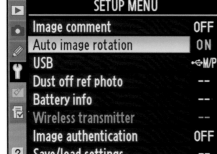

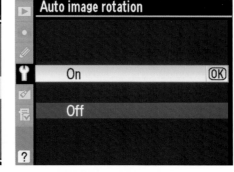

Figure 10– Camera screens for *Auto Image Rotation*

This setting must be set to *On* in order to enable the *Playback Menu* setting *"Rotate Tall"* (User's Manual page 251). If you have *Auto Image Rotation* set to *Off*, the camera does not record orientation information for the image, so no matter how you have *Playback Menu's Rotate Tall* set, the image still will be displayed in a horizontal direction.

The User's Manual states that you might want to choose *Off* if you are pointing the lens up or down. However, I have tested it well, and the D300 seems quite good at determining when you have the camera held horizontally or vertically, even when you do have the lens pointed up or down. Test this for yourself and determine which you would prefer. I leave mine set to *On*, and I've had no problems.

USB

(D300 User's Manual pages 225 and 317) Nikon provides us with two separate USB protocols, namely *MTP/PTP* and *Mass Storage*.

Here, in *Figure 11*, are the screens to choose the appropriate setting.

The two selections are:

1. *Mass Storage*
2. *MTP/PTP* (default)

Mass Storage – The first protocol is *Mass Storage (MSC)*, which is used to make your D300 act like a portable hard drive when attached to your computer with a USB cable. It will show up as a drive letter in your hard drive browser (Windows Explorer, etc.).

MTP/PTP – Media Transfer Protocol (MTP) is a set of custom extensions to Picture Transfer Protocol (PTP), so they are included together. PTP was designed for transferring pictures from digital cameras. MTP was created mainly for transferring music and video files. *MTP/PTP* is the default setting.

Which should I use?

Choose your setting according to your usage and computer type. Both USB protocols will successfully transfer images from your camera to a computer. *Mass Storage* or *MSC* causes your camera to appear with a drive letter, like a hard drive, in a Microsoft Windows computer. *MTP/PTP* causes the camera to appear as a "device" instead of a hard drive letter assignment.

Computer Operating Systems – When transferring images directly from your camera to a computer using Microsoft Windows XP or Windows Vista, you can choose either protocol. The same applies to Mac OS X versions 10.3.9 or above. If you are using Microsoft Windows 2000, you should choose *Mass Storage* only.

MTP is part of the Windows Media Framework and needs Windows Media Player 10.x or higher installed on the computer, if using Windows XP. Vista has built-in support. Mac and even Linux have software to support it too.

The default setting is *MTP/PTP*. Try hooking your camera to your computer and see which you prefer. I always play it safe by never hooking my camera to the computer with the camera turned

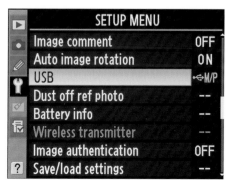

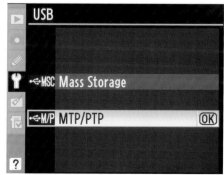

Figure 11 – Camera screens for *USB* protocols

on. I know that USB should allow us to connect/disconnect at will, but I will not endanger my camera by doing so, especially if using the *Mass Storage* protocol. How wise do you think it is to unplug a live hard drive, which is what your camera effectively becomes using *Mass Storage* protocol? The real solution is to transfer your images via a card reader, which is faster in many cases, too.

If you do use a USB cable, please turn your camera on only after you connect it to the computer, and turn it off before disconnecting. It would be a shame to blow out the electronics on an expensive camera like the D300 because of a static electricity spark. I'm a bit paranoid about this one.

Camera Control Pro Software – If you have your D300 connected to your computer when running Camera Control Pro 2.x or greater, it is important that you use *MTP/PTP* only. Camera Control Pro does not support *Mass Storage*, since you are controlling your camera with the computer. This mode acts more like a hard drive, which is what *Mass Storage* protocol makes your D300 appear to be to your computer.

Windows 2000 (specifically) – Do not use *MTP/PTP* with Windows 2000! Select *Mass Storage* now, if that's your computer operating system. Your camera or computer won't explode if you plug it in with *MTP/PTP*. Instead, Windows 2000 will often start up the *New Hardware Wizard*, as if you are trying to install a piece of hardware. If that happens, just exit the wizard and switch your camera to *Mass Storage* protocol.

Pictbridge Printer or WT-4 Wireless Transmitter – Use *MTP/PTP* protocol only.

For more information on this subject, see your D300's User's Manual on pages 225 and 319.

Dust off ref photo
(D300 User's Manual page 319-321)
Often, you may go out and do an expensive shoot, only to return and find that some dust spots have appeared in the worst possible place in your images. If you then create a *Dust Off* reference photo, you can use it to remove the dust

spots from your images, and afterward clean the sensor for the next shooting session. Here's how it works.

When you use the instructions below to create the *Dust Off* reference photo, you will be shooting a blank unfocused picture of a pure white or gray background. The dust spots in the image will then be readily apparent to *Nikon Capture NX* software. When you load the image to be cleaned into Capture NX, along with the dust-off image, it will use that image to remove the spots in your production image.

The position and amount of dust on the low-pass filter may change. It is recommended that you take reference images regularly and use a reference image that was taken within one day of the photograph you wish to clean up.

Finding a Subject for the Dust Reference Photo
First, we need to select a "featureless" subject to photograph for the reference photo. The key here is to use a material that has no graininess, such as bright white, slick plastic, or a white card. I tried using plain white sheets of paper held up to a bright window, but the resulting reference photo was unsatisfactory to Capture NX. It gave me a message that my reference photo was "too dusty" when I tried to use it.

After some experimentation, I finally settled on three different subjects that seemed to work well:
1. A slide-viewing light table with the light turned on
2. A computer monitor screen with a blank white word-processor document displayed
3. A plain white card in the same bright light in which your subject resides

All of these provided enough light and featurelessness to satisfy both my camera and Capture NX. The key is to photograph something fairly bright, but not too bright. You may need to experiment with different subjects if you have no light table or computer.

Now, let's prepare the camera for the actual reference photo.

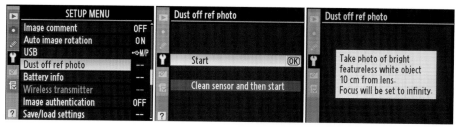

Figure 12 – *Dust off ref photo* screens

Menu and Screen Selections for Getting the Reference Photo

1. Press the *Menu* button on the back of your D300.

2. Select the *Setup Menu* and scroll down until you find the *Dust off ref photo* menu selection.

3. Once there, scroll to the right and you will find the *Start > OK* selection. There is also a *Clean sensor and then start* selection. However, since I desire to remove dust on current pictures, I won't use this setting. It might remove the dust bunny that is imprinted on the last 500 images I just shot! I'll clean my sensor *after* I get a good *Dust Off* reference photo.

4. Scroll right on the *Start > OK* selection and your camera is ready to take the reference image.

In *Figure 12*, you'll find the sequence of screens to prepare your camera for taking the photo.

After you have selected *Start > OK*, you will find the word rEF in the viewfinder and Control Panel. This simply means that we are ready to create the image.

Creating the Reference Photo

Once you have the camera ready, hold the lens about 4 inches (10 cm) away from the blank subject. The camera will not try to autofocus during the process, which is good, since you want the lens at infinity anyway. We are not trying to take a viewable picture, just create an image that shows where the dust is on the sensor. Focus is not important, and neither is minor camera shake. If you try to take the picture and the subject is not bright enough, or is too bright, you will see the following screen (*Figure 12A*).

Figure 12A – *Exposure settings are not appropriate* screen

Figure 12B – *Dust off ref photo* checkered screen

If you are having problems with too much brightness, use a gray surface instead of white. Most of the time this exposure-settings error is caused by insufficient light.

If you don't see the screen in *Figure 12A*, and the shutter fires, you have successfully created a *Dust Off* reference photo. You will find the image shown in *Figure 12B* on your camera monitor. A two-megabyte file is created on your camera's image card with an ending of .NDF instead of the normal .NEF, .TIF, or .JPG. (Example filename:

Figure 12C – Selecting *Dust Off* from Nikon Capture NX

DSC_1234.NDF.) This NDF file is basically a small database of the millions of clean pixels in your imaging sensor, and a few dirty ones.

You cannot display it on your computer. It will not open in Capture NX or any other graphics program that I tried.

Where to Store the Reference Photo

Copy the .NDF file from your camera's memory card to the computer folder containing the images that have dust spots on them, and for which you created this *Dust Off* reference photo.

Now we're ready to move into Nikon Capture NX and use our new reference photo on its related images.

Using the Dust Off Reference Photo in Nikon Capture NX

Load Capture NX and then open one of the dusty images from the folder containing the reference photo's .NDF file. You must have an

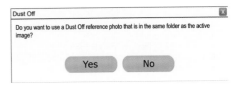

Figure 12D – Choosing the Dust Off photo – Step 1

image open to proceed, otherwise the menus will not display on the right side of Capture NX.

The Capture NX screen contains a toolbar on the right with a selection called *Base Adjustments*. Below that, select *RAW Adjustments*. The *Dust Off* selection is a sub-category under *RAW Adjustments*.

Select *Dust Off (Figure 12C)* from the menu and a small window will pop up on your computer screen. It will look like the one shown in *Figure 12D*.

Capture NX will automatically search the folder where you opened the test image, and will display this window. It allows you to use

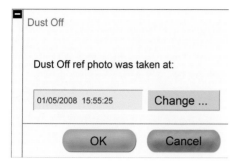

Figure 12E – Choosing the Dust Off photo – Step 2

the *Dust Off* reference photo stored with your images. To continue, click the Yes button.

Capture NX will now present you with a window that lets you verify that the *Dust Off* reference photo it found is the one you want to use. If more than one *Dust Off* reference photo is found, you will be presented with an options dialog to select which image to use. It is recommended that you select the image that was taken as close to the time of the current image as possible. *Figure 12E* shows the window that pops up when Capture NX finds one good *Dust Off* reference photo in the folder with your images.

Notice in *Figure 12E* that a date and time appears in the field to the left of the *Change* button. This represents the date and time of the selected *Dust Off* reference photo. Click *OK* and the *Dust Off* process will complete.

Nothing pops up to tell you it is done, so allow a few seconds. It's very fast, since all that is happening is the re-interpolating of the few pixels that have dust on them. This re-interpolation process simply uses pixels surrounding the dust particle to decide how best to represent the few pixels under the dust. You will rarely see any visible change in your image, unless you have a big old hairy dust particle blocking half the sky.

I have found that in areas like blue skies, the *Dust Off* process works very well. In images with a lot of fine detail, like a forest scene, sometimes not all the dust particles are mapped out, and I have to manually adjust a few pixels.

Fortunately, you can't often see dust particles mixed in with fine image detail. I've had some large dust particles get on my sensor a time or two. One showed up even in the middle of a mountain's tree line. The *Dust Off* process got most of it, but I had to work a little in Photoshop to remove the rest. This has only happened a time or two, and it was a really big piece of something on the sensor. I can understand why Capture NX might have problems in a background of confusing detail like tree leaves at a distance. How can it figure out how to re-interpolate something with no dependable pattern? I find that even I have trouble when I try to do it manually in Photoshop. I am surprised by how well the *Dust Off* process actually works.

This whole *Dust Off* technique can save you a lot of grief when you come back from an important shoot and find a big dust spot on all your images. It saves a lot of postprocessing work on individual images. Learn to use it, and you'll not worry so much about dust (even though you still should).

Sometimes during the *Dust Off* process, one or more of the following warning screens will appear. Let's look at each of them to see what they mean.

Capture NX Dust Off Warning Screens
Warning Screen 1 Text *(Figure 12F)*: "One or more Dust Off reference photos were found, but none of them closely match the active image. Would you like to use the closest match?"

The warning screen in *Figure 12F* shows up more often than not, even with *Dust Off* reference photos I've created on site. I normally just click Yes and let the process complete. I've had no untoward results, yet.

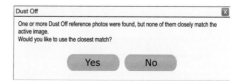

Figure 12F – Barely Matching *Dust Off* reference photo

Warning Screen 2 Text *(Figure 12G)*: "The selected Dust Off reference photo contains too much dust and could cause image details to be lost. Do you want to use it anyway? Note: It is possible to receive this warning if the reference photo was not taken of a featureless surface. The reference photo should be taken of a plain surface, and should be taken fairly close to that surface. Press the "Verify" button to see if the reference photo was captured correctly."

This warning screen is pretty self explanatory, and I would pay attention to it carefully. Don't ignore this one! Image damage might result. Why?

It means that the surface you used to create your *Dust Off* reference photo was grainy, dirty, or you were not close enough to it when you clicked the shutter.

Remember, all your camera needs to create a *Dust Off* reference photo is a good bright look at the camera's sensor, so that it can map the dirt spots into a .NDF file (ref photo file). If you hold your camera too far away from the white surface

you are photographing to create the ref photo, this warning will show up.

When your lens is a distance away from the surface, you might actually be photographing small dirt on the surface of your white subject. Those spots can mix in with the dust seen on the sensor and make an inaccurate *Dust Off* reference photo.

Later, when you use it to remove dust from an image, it removes the dust found on the sensor and all the other spots that were on the white surface. Those extra spots were not really on the image, so Capture NX is removing spots it shouldn't remove. The image quality may go down from all the unnecessary re-interpolation.

If you get the warning shown in *Figure 12G*, go shoot another *Dust Off* reference photo with a nice bright and clean white surface. Put the lens very close to the surface, and make sure it is not in focus. You might even want to manually set the lens to infinity if you are having problems with this often.

Once you've found your favorite white or gray surface for *Dust Off* reference photos, keep it safe and use it consistently.

If you want to "verify" the *Dust Off* reference photo, you can do it here *(Figure 12G)*. In fact, this is one of the only ways I've found to actually see a *Dust Off* reference photo. Click the *Verify* button and a little window will open with a view of the *Dust Off* reference photo. It's kind of small, so you won't see much, but it might satisfy your curiosity.

Figure 12G – Too much dust in reference photo

Figure 13– Battery info screens

Battery Info

(D300 User's Manual pages 322-323)

The *Battery Info* screen, as seen in *Figure 13*, will let you know how much battery charge remains (*Bat. meter*), how many images have been taken with this battery since the last charge (*Pic. meter*), and in what stage of *Charging life* the battery exists.

The D300 goes a step further than most cameras. Not only does it keep you informed as to the amount of "charge" left in your battery, but it also lets you know how much "life" is left. After some time, all batteries weaken and won't accept a full charge. You'll know when the battery needs to be replaced with the *Charging life* meter. It shows 5 stages of battery life, from New to "!" (! = replace) or 0-4, so that you'll be prepared for replacement before your battery gets too old to be of many-shot use.

In my opinion, it's important to use Nikon brand batteries in your D300, so that they work the best with the camera. Aftermarket batteries may not charge correctly in the D300 battery charger. In addition, they may not report correctly in the *Charging life* section of the battery screen. There may be an aftermarket brand that works correctly, but I've not found it personally. Instead, I choose to use the batteries designed by Nikon to work with this camera. I am a bit afraid to trust a camera that costs this much to a cheap aftermarket battery of unknown origin.

Figure 13A shows a picture of a genuine gray-colored Li-Ion Nikon EN-EL3e battery, for battery identification purposes.

Figure 13 A – Picture of EN-EL3e battery

Battery and Calibration Info

If you are using the MB-D10 battery pack with an EN-EL4a battery, or the EN-EL4 battery pack, your *Battery info* screen will also show *calibration* information. Calibration is optional, but could be required after many charge/discharge cycles, so that the Battery info screen will present accurate information. The battery charger for the Nikon D300 does not have a calibration feature, so many D300 users will have little knowledge of it. The battery charger for the EN-EL4a battery does. (If you also use a Nikon D2H/X/Xs you will be familiar with Calibration). The Battery info screen will change the amount of information it displays to a significant degree, according to whether you have an MB-D10 Battery Pack mounted, and what type of batteries are being used in the pack. There is a chart on page 323 of the User's Manual that shows the various informational items displayed according to the type of batteries.

This *Battery info* screen is just for information. There is nothing to set. When you have finished examining your *Battery info*, just press the *OK* button to exit.

Wireless Transmitter

(D300 User's Manual pages 229 and 323)

This menu system is concerned with having the WT-4 Wireless Transmitter attached to the D300. Using the WT-4, you can send images wirelessly to a computer or printer. You can also use Nikon's Camera Control 2.x software to control the D300 remotely.

Here are the four modes found in the D300 with a WT-4 attached:

1. **Transfer mode** – Using this mode you can upload new or existing images to a computer or even to a File Transfer Protocol (FTP) server.

2. **Thumbnail select mode** – This allows someone to preview images you are shooting on a remote computer. If they like the image(s) they can upload just the one(s) they like to the computer. Sports shooters love this!

3. **PC mode** – This might have been called "Studio Mode" instead. It allows a studio artist to control their D300 from a computer using the Nikon Camera Control Pro 2.x software.

4. **Print mode** – This allows someone shooting near a computer network to have the images printed on a printer connected to a network computer.

Be sure that you select the camera's *MTP/PTP* USB mode (see above) before attaching a WT-4 transmitter to the D300.

This book won't cover the use of the WT-4 transmitter in any more detail, since it has its own comprehensive feature set, and this book is limited to the Nikon D300. See page 229 in the D300 User's Manual for more detail.

Image Authentication

(D300 User's Manual page 324)
With film, one can easily detect whether a printed image has been modified from the original. All one must do is look at the original transparency or negative. However, with digital photography and programs like Photoshop, one can modify an image in amazing ways.

Many law enforcement agencies would like to use digital imaging to save money on film and processing costs, but have been hampered by this ability to modify digital images so easily. Some courts have refused digital images as evidence for this reason.

Some major editorial houses, like large newspapers and magazines, have been embarrassed

when one of their photographers modified a news image, and was later caught.

Clearly there is a need to prove that a digital image has not been modified from its original form. Nikon has answered that need with the Image Authentication feature of the Nikon D300 and other DSLR cameras. Working in conjunction with Nikon's *Image Authentication* Software, the D300 can stamp images with an electronic "seal" that allows an agency to prove that an image printed from the camera has not been modified in any way.

Figure 14A shows one of Nikon's image information screens with the authentication stamp icon.

There are two settings in the *Image Authentication* function, as shown in *Figure 14A*. These settings are:

1. *On*
2. *Off* (Default)

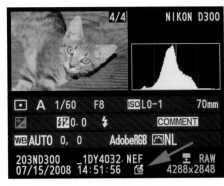

Figure 14 – Info screen with authentication stamp

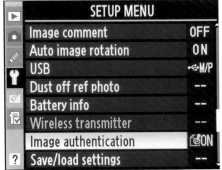

Figure 14A – *Image Authentication* Screens

On – *Image authentication* information, which can be used by Nikon's Image Authentication Software, is imbedded in the image. With this feature turned on, and with the authentication of the Nikon software, you can prove that a certain image has not been modified.

Off – No *Image authentication* embedding takes place. This is the default setting.

After a little thought, I decided to set my D300's *Image authentication* to *On*, and leave it that way. I figure that one day I'll be sitting in the car waiting for my wife at the local superstore, and a very important news event will occur right next to my car. I won't even have to get out of the car! In order to get my Pulitzer Prize I'll want to be able to prove later that the images I took have not been modified in any way.

Save/Load Settings
(D300 User's Manual pages 325-326)
Do you have your D300 set up exactly the way you like it? Have you spent hours and hours with this book, the User's Manual, or simply exploring menus and finally got all the settings in place? Are you worried that you might accidentally do a reset of your camera, or that it could lose its settings in one way or another? Well, worry no more!

Once you have your camera configured to your liking, or at any time during the process, simply use this *Save/Load Settings* function to save the camera configuration out to your CF memory card. It creates a tiny 2K file named NCSETUP1.BIN in the root directory of your compact flash card. You can then save that file to your computer's hard drive and keep a backup of camera settings.

Here are the two selections as shown in *Figure 15* above:

1. *Save settings*
2. *Load settings*

Save settings – Select this menu item and press the *OK* button. Your most important camera settings will be saved to your memory card.

Load settings – Insert a memory card with a previously saved NCSETUP1.BIN file on it, select *Load settings*, and press *OK*. The settings you previously saved will be reloaded into the D300.

Here is a list of settings saved and loaded when you make use of these functions. It doesn't save or load every last setting in the D300, only the ones listed here:

Playback Menu
- Display mode
- Image review
- After delete
- Rotate tall

Shooting Menu – This saves the settings in all four banks (A, B, C, D).
- Shooting menu bank
- File naming

Figure 15 – *Save/load settings* screens

- Image quality
- Image size
- JPEG compression
- NEF (RAW) recording
- White balance (includes your fine tuning adjustments and presets d-0 to d-4)
- Set Picture Control
- Color space
- Active D-Lighting
- Long exposure noise reduction (NR)
- High ISO noise reduction
- ISO sensitivity settings
- Live view settings

Custom settings

- All configurable Custom settings are saved.

Setup menu

(the menus discussed in this chapter)

- Clean image sensor
- Video mode

- HDMI
- World time
- Language
- Image comment
- Auto image rotation
- USB mode
- Image authentication
- GPS settings
- Non-CPU lens data

My Menu

- All items you've entered under the *My Menu* area.

If you change the name of the NCSETUP1.BIN file, the D300 will not be able to reload your settings from it. Also, if you save the settings when an existing NCSETUP1.BIN file exists on the CF card, it will be overwritten without prompting you for permission.

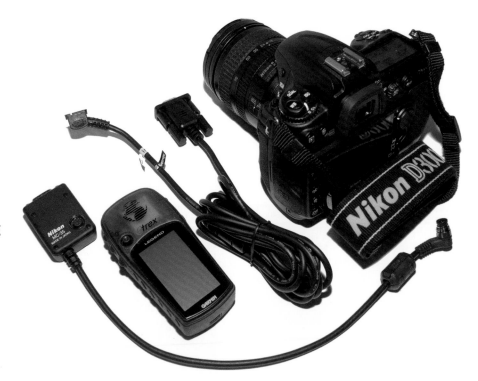

Figure 16 – Picture of D300, GPS and two cables

Figure 16A – *GPS* and *Auto meter off* screens

GPS

(D300 User's Manual pages 201 and 326)
Nikon has wisely included the ability to GEO-tag your images with GPS location data. Now when you shoot a spectacular travel image, you can rest assured that you'll be able to find that exact spot next year. The D300 will record the following GPS information about your location in the metadata of each image:

1. Latitude
2. Longitude
3. Altitude
4. Heading (North, South, etc.)
5. UTC Time

The GPS unit you use must be compatible with the National Marine Electronics Association (NMEA0183) version 2.01 or 3.01 data format. I bought a Garmin eTrex Legend GPS unit to use with my D300, since the eTrex series is mentioned on page 201 of the D300 User's Manual. I'll use it for my sample GPS in this section.

What You'll Need to Use a GPS Unit with Your D300

You'll need the following:

1. A GPS unit that meets the NMEA0183 data format
2. A data cable for that GPS unit that must have a D-sub 9-pin connector (not a USB).
3. The Nikon MC-35 GPS adapter cable.

The data cable for the GPS unit must have a D-sub 9-pin connector in order to plug into the Nikon MC-35 cable. The Nikon cable plugs into the larger of the connectors (10-pin remote connector) under the larger rubber flap on the right front of the D300. See *Figure 16* for a look at the equipment.

There are several screens used in setting up the D300 for GPS use. First, a decision should be made about the exposure meter when a GPS unit is plugged into the D300. While the GPS is plugged in, your exposure meter must be active to record the GPS data to the image. You'll have to do one of two things:

1. Set the exposure meter to stay on for the entire time that a GPS is plugged in, which, of course, will increase battery drain.
2. Press the shutter down half-way to activate the exposure meter before finishing the exposure. If you just push the shutter button down quickly, and the meter was not active, you may not record GPS data to the image. The meter must be on before GPS data will be added.

Figure 16A shows the screens to set the meter to stay on all the time the GPS is connected, or to act normally and shut down after the *Auto meter-off delay* expires (see *Custom Setting c2* – defaults to 6 seconds).

You can select either:

1. *Enable* (default)
2. *Disable*

Enable (default) – The meter turns off at the end of the *Auto meter-off delay* time, as set in *Custom Setting c2*. GPS data will only be recorded when the exposure meter is active, so take your time.

Disable – The exposure meter stays on all the time a GPS unit is connected. As long as you have good GPS signal, you will be able to record GPS data at any time.

There is also a *Position* setting, as shown in *Figure 16A*, screen 2. Notice that *Position* is grayed out in the image because a GPS is not attached. Once a GPS is attached, selecting

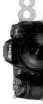

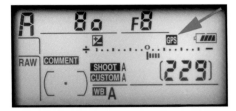

Figure 16B – GPS Icon on the Control Panel

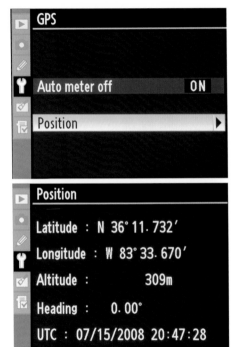

Figure 16C – Position information on the GPS screens

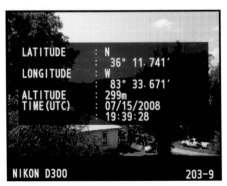

Figure 16D – GPS information page

Position displays the actual GPS location-data being detected by the D300.

When the D300 establishes communication with your GPS it does three things:

1. *Figure 16B* shows a small GPS icon will be displayed in the Control Panel LCD (page 202 of the User's Manual).
2. Position information supplied by the GPS is available, as shown in *Figure 16C*.
3. An additional GPS information page, as shown in *Figure 16D*, can be displayed when reviewing the captured images (page 215 of the User's Manual).

If the GPS icon is flashing on the Control Panel it means that the GPS is searching for a signal. If you take a picture with the GPS icon flashing, no GPS data will be recorded. If the GPS icon is not flashing, it means that the D300 is receiving good GPS data, and is ready to record data to a picture. If the D300 loses communication with the GPS unit for over two seconds, the GPS icon will disappear. Make sure the icon is displayed before you take pictures!

Compatibility of GPS Units

Many of the newer hand-held GPS units are not compatible with the D300 since they use a USB cable for interfacing, which is a good thing or a bad thing, according to how you look at it. The bad thing is that your brand new USB based GPS is useless for recording data to your images. The good thing is that you can buy older GPS units for very little money on eBay and even new (but dated) stock from dealers. I bought my *Garmin eTrex Legend* mapping GPS on Amazon.com for just over $100 USD. It came with a D-sub 9-pin data cable. I had to buy the Nikon MC-35 cable, and I was all set! Primarily, just be aware that the GPS unit must have a way to connect to the Nikon MC-35 cable in order to interface with the D300. Maybe a future firmware upgrade will give us the ability to use the built-in USB connector on our D300s with a USB-based GPS. Nikon, are you listening?

Some GPS units also include a digital compass. If you want the GPS heading information to be accurate, keep your GPS unit pointing in the same direction as the lens. Point the GPS in the direction of your subject and give it enough time to stabilize before you take the picture, or the *heading* information will not be accurate.

Nikon also suggests that you keep the GPS at least 8 inches (20cm) away from the Nikon D300. Maybe the D300 outputs enough electrical interference to throw off the digital compass!

Non-CPU Lens Data

(D300 User's Manual pages 198 and 327)
Do you still have several older AI or AI-S Nikkor lenses? I do! The image quality from the older lenses is simply outstanding with the D300, especially since the smaller DX-sized sensor uses only the sweet-spot center of the older lenses.

Since the D300 is positioned as a near-professional camera, it must have the necessary controls to use both auto focus (AF) and manual focus (MF) lenses. Many photographers on a budget use the older MF lenses to obtain professional-level image quality without having to break the bank on expensive lens purchases. One can acquire excellent AI/AI-S Nikkor lenses on eBay for $100-$300 USD and have image quality that only the most expensive zoom lenses can produce.

Since lens manufacturers like Zeiss and Nikkor are still making MF lenses, and many of

them do not have a CPU (electronic chip) that communicates with the camera, it is important to have a way to let the D300 know something about the lens in use. This *Non-CPU lens data* function allows you to do exactly that. You can store information on up to nine separate non-CPU lenses. Let's look at it how to do it.

There are four selections on the main *Non-CPU lens data* screen. Screen 2 of *Figure 17* shows them. They are:

1. *Done*
2. *Lens number*
3. *Focal length (mm)*
4. *Maximum aperture*

Done – When you have completed the setup of a particular lens, or several lenses, simply scroll to this selection and press the *OK* button. Your lens data will be saved within the D300. Later, you can put a non-CPU lens on your camera and select it from the list of nine lenses. You can use external camera controls, or the *Non-CPU lens data* menu item, to change to your current lens.

Lens number – Using the Multi Selector, you can scroll left or right to specify a numeric identifier for one of your lenses. There are a total of nine lens records available. When you select a lens number here, the focal length and maximum aperture of that lens will show up in the fields below the *Lens number* field. If you've not set a lens for a particular *Lens number*, then you'll see double dashes "--" in the *Focal length* and *Maximum aperture* fields.

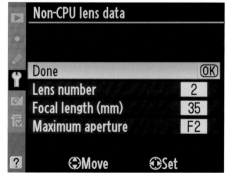

Figure 17 – *Non-CPU lens data* screens with lens No.2 showing on both screens

Focal length (mm) – This field contains the actual focal length of the lens number in use. You can select focal lengths from 6mm to 4000mm. Hmm, I didn't know they even made a 4000mm lens. I want one!

Maximum aperture – This field is for the maximum aperture of the lens. You can enter an F number from f/1.2 to f/22. Remember this is for the *maximum* aperture only (largest opening or f/stop). Once you've entered a maximum aperture, the camera will be able to determine the other apertures by your use of the aperture ring on the lens. (Remember those?)

Once you're done inputting your nine lenses, don't forget to use the *Done* selection to save your work! The *Done* selection serves double-duty by either allowing you to select a lens, or save changes to one or all of your nine lenses.

When you have selected a lens for use, the *Setup Menu's Non-CPU lens data* selection will show the number of the lens you've selected. It will be in the format of No.2, No. 5, or No.9, etc., which shows which of the nine lenses you have currently selected. Notice screen 1 of *Figure 17* where you can see the lens selection (No.2) at the end of the *Non-CPU lens data* line.

Selecting a Lens by Using the Non-CPU Lens Data Screen

When it's time to shoot pictures, you can select a non-CPU lens by doing the following:

1. Open the *Non-CPU lens data* screen.
2. Select a lens by scrolling left or right on the *Lens number* field.
3. Scroll up to the *Done* selection and pressing the *OK* button.

Selecting a Non-CPU Lens by Using External Camera Controls

The D300 allows you to customize many of its buttons to do things the way you want them to be done. You may only have a non-CPU lens or two, so it may be sufficient to just use the *Non-CPU lens data* screen to select a lens. However, if you are like me, with a good selection of AI

lenses, you may wish Nikon gave us more than nine lens selections in the non-CPU lens array.

Since I use a lot of AI Nikkors, I have mapped my *AE-L/AF-L* button, in combination with the *Main command* dial, to select any of my nine lens selections from the Control Panel LCD. Some people use the FUNC (Fn) button along with a command dial to do the same. The D300 allows you to be creative in that respect. I use the *FUNC* button / *Main command* dial as my bracketing controls, since I can operate that combo with one hand and shoot brackets quickly. This is why I use the *AE-L/AF-L* button, in combination with the *Main command* dial, to select my non-CPU lenses. It takes two hands to do the selection, but I've just changed lenses so I'm not ready to shoot anyway.

You can map any of several D300 buttons, in combination with a command dial, to select non-CPU lenses. Please see pages 303-310 of the Nikon D300 User's Manual for information on mapping buttons. Also, see **Chapter 6 – Custom Setting Banks** (*Custom Setting f1 to f10*) in this book for more detail on mapping buttons and dials.

AF Fine Tune

(D300 User's Manual pages 327-328) One thing that really impresses me about the D300 is its ability to be fine tuned in critical areas like metering and auto focus. Previous to the D300, if an AF lens had a back- or front-focus problem, you just had to tolerate it or send it off to be fixed by Nikon. Now, with the new *AF Fine Tune* system, you can adjust your camera so that the lens focuses where you want it to focus.

Nikon has made provision for keeping a table of up to 12 lenses that you've fine tuned. Nikon does not recommend that you use the fine tuning system unless you know what you are doing, and only when required. The idea behind fine tuning is that you can push the focus a little bit forward or backward in small increments. You can do this up to 20 increments in a forward or backward direction.

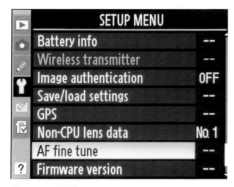
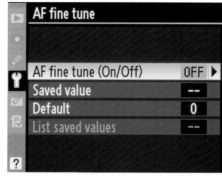

Figure 18 – *AF fine tune* screens

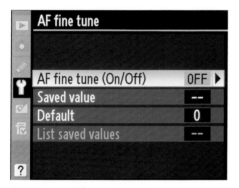

Figure 18A – *AF fine tune* screens

When the little round green AF indicator comes on in your viewfinder, and *AF Fine Tune* is enabled for a lens you've already configured, the actual focus is moved from its default position forward or backward by the amount you've specified. If your lens had a back-focus problem, and you moved the focus a little forward, the problem is solved.

There are four selections on the *AF fine tune* screens:

1. *AF fine tune (on/off)* – factory default is off
2. *Saved value*
3. *Default*
4. *List saved values*

Figure 18 shows the first two screens in the *AF fine tune* series. Each of the selections listed above (1-4) have their own screen for configuration. Let's look at each selection and discuss what it accomplishes.

AF fine tune (On/Off) – In *Figure 18A*, we see the *AF fine tune (On/Off)* screen and its configuration screen. The two values you can select are:

On – This setting turns the *AF fine tune* system on. Without this selection, the D300 focuses like a factory default D300.

Off – This default setting disables the *AF fine tune* system.

Saved value – With an AF lens mounted, this *Saved value* screen allows you to control the amount of front or back focus you'd like to allow for the lens currently listed. At the top left of the configuration screen, (see screen 2 in *Figure 18B*) just under the words *Saved value*, you'll see the focal length of the lens mounted on your camera along with the maximum aperture, as well as the numeric identifier you have assigned to the lens. If you are configuring a lens for the first time, you'll probably see No. --.

To the right of the lens information is a scale that runs from +20 on top to -20 on the bottom. The yellow pointer starts out at 0. You can move this yellow pointer up or down to change the amount of focus fine tuning you want for this lens. Moving the pointer up on the scale pushes the focal point away from the camera, while moving it down pulls the focal point toward the camera. Once you are done, press the *OK* button.

Default – The *Default* configuration screen looks a lot like the *Saved value* screen, except there is no lens information listed. This *Default* value will be applied to all AF lenses you mount on your D300. If you are convinced that your particular camera always has a back- or front-focus problem, and you are not able or ready to ship it off to Nikon for repair, you can use the Default value to push the auto focus in one direction or the other, until you are satisfied that your camera is focusing the way you'd like (*Figure 18C*).

To set a *Default AF fine tune* value, use the scale that runs from +20 on top to -20 on the bottom. The yellow pointer starts out at 0. You can move this yellow pointer up or down to change the amount of focus fine tuning you want for whatever lens you currently have on the D300, if no value already exists in the *Saved values* for the lens. Moving the pointer up on the scale pushes the focal point away from the camera, while moving it down pulls the focal point toward the camera. Once you are done, press the *OK* button.

This allows you to use the *Default* value as a value for any of your AF lenses that do not have a *Saved value*. I tested this by setting a *Saved value* of +1 for my AF-S Nikkor 18-70mm. While

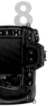

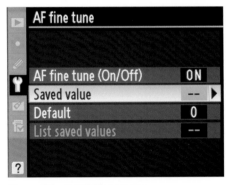
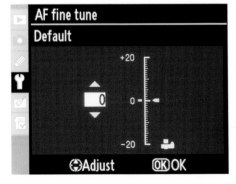

Figure 18B – *Saved value* screens

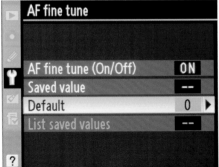

Figure 18C – *Default* screens

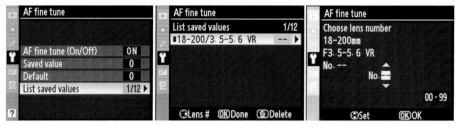

Figure 18D – *List saved values* screens

the 18-70 was still mounted, I also set a value of -2 for the *Default* value. When I removed the 18-70mm and mounted an AF Nikkor 60mm micro lens, the +1 in the *Saved value* field disappeared, but the -2 in the *Default* field stayed put. So, it looks like you could use the *Default* field either for *all* AF lenses that have no *Saved value*, or for a currently mounted AF lens that you want to adjust for this moment without saving a value.

List saved values – Notice in *Figure 18D* that there are several screens used to configure the list of saved values. This listing of lenses with *Saved values* helps you remember which lenses you've fine tuned the D300 to use. It also allows you to set an identification number for a particular lens.

Many people use the last two digits of the lens serial number as the number for the *Saved value* of that lens. In the second screen of *Figure 18D*, you'll see a list of lenses that have *Saved values*. As you'll see in the third screen, there is a little box in the middle after "No." This little box

is a scroll box that allows you to scroll the Multi Selector up or down to scroll from 00 to 99. That way, you can set whatever number you want to use for particular lenses. Note that you can configure a maximum of 12 lenses, regardless of the numbers you assign.

Firmware Version

(D300 User's Manual page 328)
This is a simple informational screen, like the *Battery info* screen. It informs you which version of the Nikon D300 firmware you are running. My D300 has the firmware included with the D300 from the factory, since a subsequent firmware update was not yet available at the time this book was published. In *Figure 19* we see the two screens that display the firmware verion numbers.

When a firmware update becomes available, and you install it, this is the screen you'll use to validate that the firmware update was successful.

Figure 19 – *Firmware* screens

Section 2: *Retouch Menu*

(D300 User's Manual page 329)

Retouching allows you to modify your images in-camera with no computer postprocessing. If you like to do digital photography, but don't particularly like to work on a computer later, these functions are for you!

You can use the *Retouch Menu* directly and choose an image to work with, or you can display an image in *Playback* mode and press the *OK* button to open the *Retouch Menu*. There are limitations imposed when you are working on an image that has already been retouched.

When you use the *Retouch Menu* items, the D300 does not overwrite your original file, but always creates a JPEG file with the next available image number. (Although the original image can be a RAW, JPEG, or TIFF image, the retouched image will always be saved as a PEG image.) The retouched image will be given the next available image number on the memory card. If you have images numbered DSC_0001 through DSC_0100 on your card, and you are retouching image number DSC_0047, the resulting new JPEG image will have the number DSC_0101. The D300 looks to see how many images are on the memory card, then adds the retouched image like it was a brand new exposure, assigning it the next available image number.

I am going to approach this section of the chapter with the idea that you are using the menus directly. Experiment with displaying an image then pressing the *OK* button to open the *Retouch Menu* for that image. It works basically the same, except that the latter method leaves out the step of choosing the image, since one is already on the screen.

Retouching From the Playback Preview Screen

Just for fun, here are the steps to use if you want to work with an image you just took, or are looking at on your D300's Monitor. To use the *Retouch Menu* options, you'll do four basic steps (except with *Red-eye* and *Side-by-side* comparison):

1. Use *Playback Mode* to choose a picture by displaying it on your D300's Monitor.
2. Press the *OK* button to open the *Retouch Menu*.
3. Select one of the *Retouch Menu* functions.
4. Press *OK* to create the retouched copy.

Between #3 and #4 above, there can be extra steps if you want to modify the presented value. For instance, let's say you want to trim an image. You can simply press *OK* once you've selected *Trim*, and the D300 will trim the image inside the crop frame it shows you. If you want, you can use the Multi Selector to move the crop frame around before you press *OK*. Usually the default value is fine, so you can just press *OK* to complete the process.

Some of the retouch options are not available with this method, which is why I am using the full menus for this chapter. See below.

Using the Retouch Menu Items Directly

Let's consider each section of the *Retouch Menu* in detail.

D-Lighting

(D300 User's Manual page 334)

D-Lighting allows you to reduce the shadows and maybe even reign in the highlights a bit. It lowers the overall image contrast, so should be used sparingly. The D300 is not aggressive with its *D-Lighting* so you can use it quickly if needed. Also, please remember it will create a copy of the image, so your original is safe.

The steps to D-Light an image are as follows:

1. Select *D-Lighting* from the *Retouch Menu*.
2. Select the image you want to modify (*Figure 20*, screen 2).
3. Choose the amount of *D-Lighting* you want for the chosen image using the Multi Selector to scroll up or down. You'll choose from *Low*, *Medium*, or *High* (*Figure 20*, screen 3).
4. When the image on the right looks the way you want it to look, press the *OK* button to save the new file. The D300 will display a brief "Image saved" notice, then switch to displaying the new file in full screen *Playback* mode.

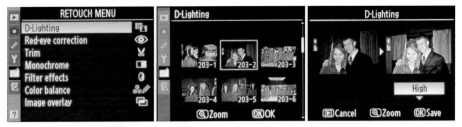

Figure 20 – *D-Lighting* screens

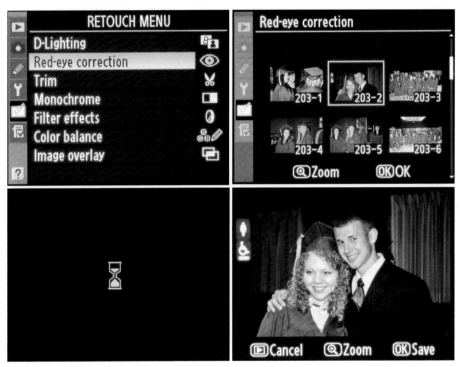

Figure 20A – *Red-eye correction* screens

Red-eye correction

(D300 User's Manual page 335)

If you have used flash to create a picture, the *Red-eye correction* function will work on the image if it can detect any red-eye. If it can't detect red-eye in the image it will not open the red-eye system, but will, instead, briefly display a screen informing you that the camera was "unable to detect red eye in selected picture." If you try to run the red-eye routines on an image where flash was not used, the D300 will inform you, "Cannot select this file."

The steps to execute the *Red-eye correction* function on an image are as follows:

1. Select *Red-eye correction* from the *Retouch Menu*.
2. Select the image you want to modify (*Figure 20A*, screen 2).
3. Press the *OK* button and the *Red-eye correction* routines will execute. You'll see an hourglass on your screen for three to five seconds.
4. After *Red-eye correction* is done you can use the normal zoom buttons to zoom in on the image to see how well it worked.
5. Press *OK* to save the file under a new file number, or you can press the *Playback* button to cancel (*Figure 20A*, screen 4).

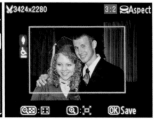

Figure 20B – *Trim* screens

Trim

(D300 User's Manual pages 336-337)
The *Trim* function allows you to crop an image in-camera, change its aspect ratio, and save the file out to a new image. Your original image is not modified.

Here are the steps to trim (crop) an image in the D300:

1. Select the *Trim* function from the *Retouch Menu*.
2. Select the image you want to modify (*Figure 20B*, screen 2).
3. You'll be presented with a screen that has a crop-outline in yellow. Using the normal zoom buttons, you can zoom in for a deeper crop, or zoom out for a lesser crop. You can use the Multi Selector to scroll the crop-outline to the desired location on the image. Zoom and scroll until you find your best crop position.
4. Select the aspect ratio of the crop by rotating the *Main command* dial. Your choices are 3:2, 4:3, or 5:4.
5. Once you have the crop correctly located and sized, and the aspect ratio set, press the *OK* button to save the new image under a new file number.

Monochrome

(D300 User's Manual page 337)
The *monochrome* functions in the D300 are fun to play with, and can make some nice images. You have the choice of three different types of monochrome:

1. *Black-and-White*
2. *Sepia*
3. *Cyanotype*

If you select *Black-and-White*, the D300 only provides one level of lightness and darkness. However, for *Sepia* (golden toned) and *Cyanotype* (blue toned) you can fine-tune the tint from almost-not-there, to pretty saturated.

Here are the steps to create a monochrome image from one of your color images on the memory card:

1. Select *Monochrome* from the *Retouch Menu*.
2. Select a *Monochrome* tone of *Black-and-White*, *Sepia*, or *Cyanotype* (*Figure 20C*, screen 2).
3. Select the image you want to modify (*Figure 20C*, screen 3).
4. For *Sepia* and *Cyanotype*, you can use the Multi Selector to saturate or de-saturate the tone. Use the Multi Selector to scroll up or down, and watch the screen until the tint is just where you want it to be. You can cancel with the *Playback* button (*Figure 20C*, screen 4).
5. Press the *OK* button to save the new image under a new file number.

Filter effects

(D300 User's Manual page 338)
Many times when shooting images outdoors under an overcast sky, or under certain types of artificial lighting, the image can have a bluish cast, or feel "cool." The *Filter effects* function can help with that.

The *Filter effects* selection is a simple way to apply two specific filter effects to an existing image as follows (*Figure 20D*):

1. *Skylight* – Provides an effect similar to a skylight filter, which removes some of the blue in an image.

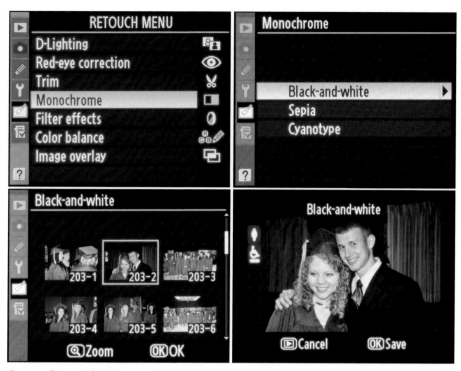

Figure 20C – *Monochrome* screens

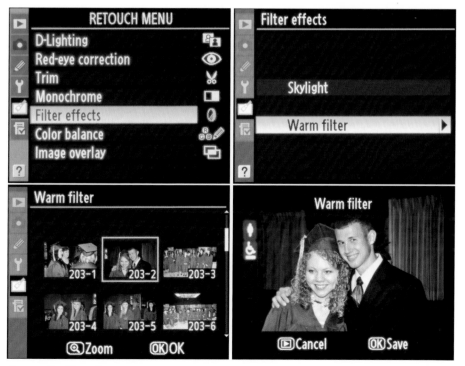

Figure 20D – *Filter effects* screens

2. *Warm filter* – Provides and even stronger warming effect by adding a reddish tint to the image. This is sort of like an 81A or Nikon A2 warming filter.

To execute the filter effect you'd like, follow these steps:

1. Select *Filter effects* from the *Retouch Menu*.
2. Select either *Skylight* or *Warm filter* (*Figure 20D*, screen 2).
3. Select the image you want to modify (*Figure 20D*, screen 3).
4. Press the *Playback* button to cancel, or the *OK* button to save the new image under a new file number.

Color balance

(D300 User's Manual page 338)

This is a useful function for people who do not like to use computers. You can visually add a light or strong color cast to your images. You might just want to warm things up a bit by adding a touch of red, or cool things down with a touch of blue. Or, you could get creative and simply add various color casts to the image for special effects. You'll see what I mean when you try it.

Figure 20E shows the *Color balance* screens to use.

To modify the color balance of an image, follow the steps below:

1. Select *Color balance* from the *Retouch Menu*.
2. Select the image you want to modify (*Figure 20E*, screen 2).
3. Use the Multi Selector to move the tiny black indicator square in the center of the color box toward whatever colors make you happy. Watch the histograms as they display the changing color relationships between the Red, Green, and Blue color channels. You can see the color changes as they are applied to the small version of your image in the upper left corner of the screen (*Figure 20E*, screen 3).
4. Press the *Playback* button to cancel, or the *OK* button to save the new image under a new file number.

Image overlay

(D300 User's Manual page 339)

The *Image overlay* function is a cool way to combine two RAW images as if they were taken as a multiple exposure. You can select a couple of images and combine them into a new image that is of higher quality than from graphic programs on a computer, because they are combined using RAW image data. *Figure 20F* shows the *Image overlay* screens.

To execute an image overlay and combine two images into one, do the following steps:

1. Select *Image overlay* from the *Retouch Menu*.
2. Select the first image in the *Image 1* box (outlined in yellow) by pressing the *OK* button and using the Multi Selector to select an image from the selection screen (*Figure 20F*, screen 3). Press *OK* again to return to the combination screen (*Figure 20F*, screen 4).
3. Use the Multi Selector to move the yellow box to *Image 2*. Press *OK* to move to the image selection screen, scroll to the desired image, then press *OK* again to select that image and return to the combination screen (*Figure 20F*, screen 7).
 Anytime that *Image 1* or *Image 2* is selected, you can use the Multi Selector to scroll image-gain either up or down, with the result being displayed in the *Preview* area.
4. Move the yellow box to the *Preview* area, and you'll see two selections below. The first is *Overlay*, and the second is *Save*. If you select *Overlay*, the D300 will present you with another screen that allows you to see the images more closely. You can press the *OK* button to save the new image under a new file number, or press the *Checkered Thumbnail* button to return to the previous screen (*Figure 20F*, screen 6).
5. If you choose to press the *OK* button instead of the *Overlay* button, the D300 immediately combines the two images, saves the new image out to your memory card under a new file number, and displays that new image in the Monitor (*Figure 20F*, screen 9).

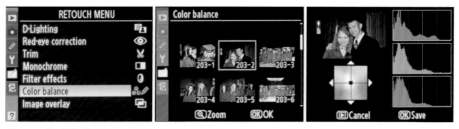

Figure 20E – *Color balance* screens

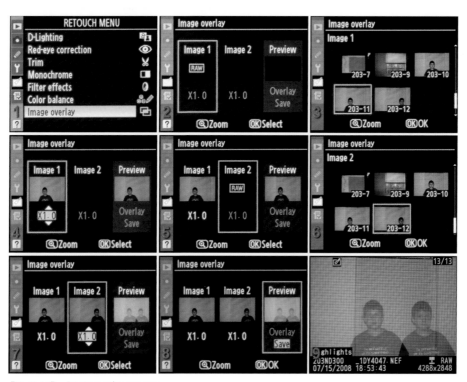

Figure 20F – *Image overlay* screens

Section 3: *My Menu*

The D300 is quite a complex camera. There are key functions and settings that each of us might use frequently. For instance, I often turn *Exposure delay mode (Custom Setting d9)* on and off. Instead of having to search through all those *Custom Setting* screens and options, and trying to remember which is *Exposure delay mode*, I simply added that custom setting to *My Menu*. Now, whenever I want to add a delay to my exposure so that mirror vibrations can settle down, I just go to *My Menu* and enable *Exposure delay mode*.

There are several other functions and settings I keep in *My Menu* along with *Exposure delay mode*. I'm sure you'll have a few you use often, too. Let's examine the screens to add and remove items from *My Menu*.

When you first open *My Menu*, you'll find only three menu choices, as shown in *Figure 21*:

1. *Add items*
2. *Remove items*
3. *Rank items*

Let's examine each of these menu choices in detail.

Add Items

To add an item to *My Menu*, you'll need to locate the item first. Search through the menus until you find the item you want to add and then make note of where it is located. You could do this from within the *Add items* screen, but I find that it is harder to find what I am looking for if I have not already confirmed in my mind where it lives. Is it under *Custom Setting Menu* or *Shooting Menu*, for instance?

Once I have found the item I want to add and made note of its location, I do the following:

1. Select *Add items* from the *My Menu* screen. You'll notice that I already have *Set Picture Control*, and *Active D-Lighting* added to *My Menu*. Let's add something else (*Figure 21A*).

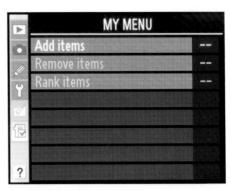

Figure 21 –*My Menu* screen

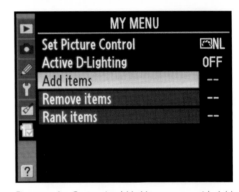

Figure 21A – Customized *My Menu* screen with *Add items* highlighted

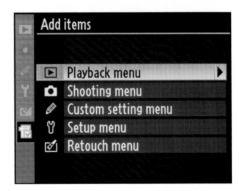

Figure 21B – *Add items* screen with *Playback menu* highlighted

2. Use the Multi Selector to scroll right and you'll find a list of menus to choose from. These menus are all the menus available in the D300 except *My Menu* (*Figure 21B*).

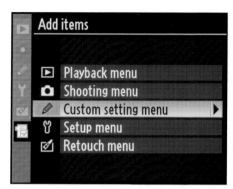

Figure 21C – *Add items* screen with *Custom setting menu* highlighted

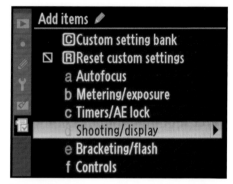

Figure21D – *Add items* screen with *Shooting/display* highlighted

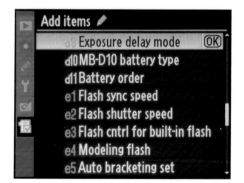

Figure 21E – *Add items* screen with *d9 Exposure delay mode* highlighted

3. I will add *Custom Setting d9 – Exposure delay mode* to *My Menu* as an example. I have already looked and know that *Exposure delay mode* is under the *Custom Setting Menu*, so

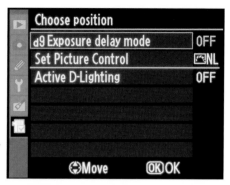

Figure 21F – *Choose position* screen with *d9 Exposure delay mode* highlighted

let's scroll down to it. After selecting it I'll scroll to the right (*Figure 21C*).

4. Now we see the *Custom Settings a-f* (*Figure 21D*). Scroll down to *Custom Setting d*. Scroll to the right again so that we can select the actual *Custom Setting* we want.

5. Now that I have found *Custom Setting d9* that I wanted to add, all I have to do is highlight it and press the *OK* button (*Figure 21E*). Once I've done that the D300 switches to the *Choose position* screen.

6. Since I already had a couple other items added to *My Menu*, I now have to decide in which order I want them to be presented. The new *d9 Exposure delay mode* is on top, since it is the newest entry. I think I'll move it down one slot and let *Set Picture Control* move to the top position. To move the position of the selected item, I simply scroll down. *d9 Exposure delay mode* stays highlighted with a yellow box surrounding it. As I scroll down, a yellow underline moves to the next position (*Figure 21F*). This yellow underline represents the place to which I will finally move *d9 Exposure delay mode*. Once I have decided on the position and have the yellow underline in place, I just press the *OK* button.

7. The screen pops back to the beginning *My Menu* screen as shown in screen 2 of *Figure 21G*, with everything arranged the way I desired.

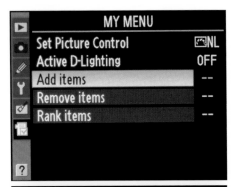

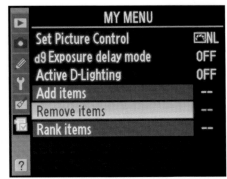

Figure 21H – *My Menu* with *Remove items* highlighted

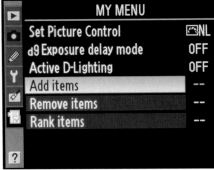

Figure 21G – *My Menu* screen, before and after adding and positioning an item

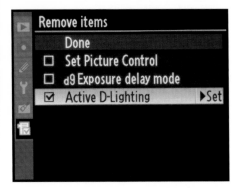

Figure 21I – *Remove items* screen with *Active D-Lighting* checked and highlighted

Remove Items

Now that we've figured out how to *Add items*, let's examine how *Remove items* works. I've decided that one of my items, *Active D-Lighting*, is not used often enough to waste a spot on *My Menu*, so I'll remove it. Here's how:

1. Select *Remove items* from *My Menu* (*Figure 21H*) and scroll to the right.

2. The *Remove items* screen presents a series of checkboxes. However many of them I check will be deleted when I select *Done*. You can check the boxes by scrolling to highlight the line item and then press the *OK* button, or you can scroll right on each item you want to check. I like to use the *OK* button method, since trying to uncheck a selection by scrolling left does not work, but takes you back to the *My Menu* screen. Pressing the *OK* button acts like a toggle and will check or uncheck a line item (*Figure 21I*).

3. Once I have the items I want to delete checked, I'll simply scroll back up to the *Done*

selection and press *OK* (*Figure 21J*). A small white box pops up and asks, "Delete selected item?" Press the *OK* button again, and the item is removed from *My Menu*. A box pops up informing you that the item has been deleted, and then the D300 switches to *My Menu's* main screen.

Rank Items

Rank items works very similarly to positioning new additions in *My Menu*. All the *Rank items* selection does is move the item up or down in *My Menu*. You can switch your most used *My Menu* items to the top of the list. Here's how:

1. Select *Rank items* from *My Menu* (*Figure 21K*) and scroll to the right.

2. Now you are presented with the *Rank items* screen and all the current *My Menu* items. I have decided that I use the *d9 Exposure delay*

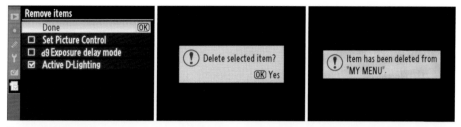

Figure 21J – *Remove items* screens with *Active D-Lighting* being deleted

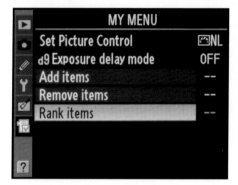

Figure21K – *My Menu* screen with *Rank items* highlighted

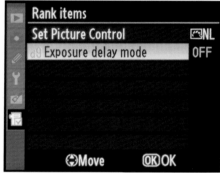

Figure 21L– *Rank items* screen with *Exposure delay* mode highlighted

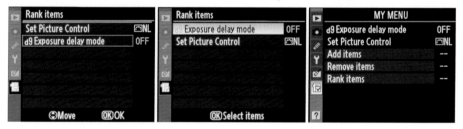

Figure 21M– *Rank items* screens

mode more than *Set Picture Control*, so I'll move the former to the top. I scroll my yellow highlight down to *d9 Exposure delay mode* and press the *OK* button to select it (*Figure 21L*).

3. A yellow underline can now be scrolled around with the Multi Selector. In screen 1 of *Figure 21M*, I've moved the yellow underline up to the top to represent where I am finally going to position *d9 Exposure delay mode*. (*d9 Exposure delay mode* is still highlighted with a surrounding yellow box.) Once my yellow underline is at the position I want, I press the *OK* button and *d9 Exposure delay*

mode moves to the top, as shown in screen 2. If I like the current order, I can simply scroll left and I'm back at *My Menu's* main screen, but with my new menu order, as shown in screen 3 (*Figure 21M*).

My Conclusions

Whew! The D300 may seem like a complex little beast, but that's what you get when you cram professional-level functionality into a relatively small DSLR body. Complex as it is, though, I'm certainly delighted with it.

Nikon Creative Lighting System

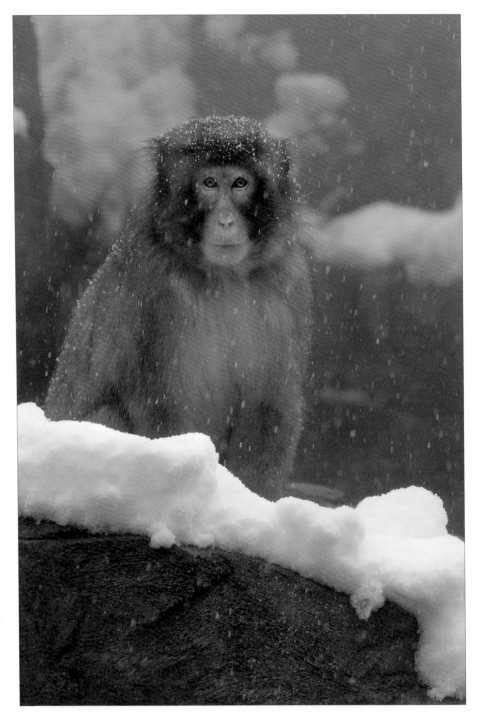

9

What is the Nikon Creative Lighting System (CLS)?

CLS is an advanced wireless lighting technology that allows you to use your imagination in designing "creative" lighting arrangements. No wires are used, and the CLS-compatible remote flash units are controlled by a "commander device", or what Nikon refers to as a "master flash unit". You can use the *Commander mode* built into the D300, or you can use a hotshoe-mounted commander device such as the SB-800 AF Speedlight or SU-800 Wireless Speedlight Commander unit. We'll look at all of these options in this chapter.

At the time of this publication, Nikon is announcing the new SB-900 AF Speedlight. As I've yet to get my hands on this new Speedlight, it is not covered in this chapter.

You can easily experiment with setups and flash output by using the visual preview combined with the pulsed modeling capability within Nikon's Speedlights when you press the D300's *depth-of-field preview* button.

There is no need to figure complex lighting ratios when you can control your flash groups right from the camera and see the results immediately. CLS simplifies the use of multiple flash-unit setups for portraiture, interiors, nature, or any situation where several Speedlights need to work in unison.

You can simply position the flash units where you'd like them to be, and let CLS automatically figure the "correct" exposure, or you can change the lighting ratios directly from the *Commander Mode* menu of your D300, or hotshoe-mounted commander device.

Nikon's Creative Lighting System is world-class in power, and not too difficult to use. The Nikon D300 camera contains everything you need to control a simple or complex CLS setup. Let's learn how to use it!

How Does the D300 Fit into the CLS Scheme?

In *Commander mode*, the Nikon D300 camera functions as a controller for multiple Nikon Speedlight flash units. While the professional-level Nikon D3 *requires* the separate purchase of a hotshoe-mounted commander device, the D300 body has full Nikon Creative Lighting System (CLS) technology built right into the camera.

You can use normal i-TTL flash technology with the D300's built-in flash (Nikon calls it a Speedlight) or use *Commander mode* and the built-in flash to control up to two groups of an unlimited number of external Nikon Speedlight flash units. Nikon makes the powerful SB-800 flash unit, along with its slightly less powerful SB-600 brother, and several other smaller Speedlight units, such as the SB-400 or SB-R200. Many of us using the D300 will have an external flash unit, and it will usually be the SB-800 or SB-600, so we'll consider those in detail in this chapter. The Nikon D300 is happy to let you arrange professional lighting setups using these relatively inexpensive and very portable Speedlights.

Later in the chapter, we'll also consider how the D300 can use the SB-800 Speedlight's *Master* mode or the SU-800 Commander unit instead of the camera's built-in *Commander mode*, since the external units provide maximum range and flexibility in large flash bank arrangements. The cool thing about the D300 is that it can *be* a CLS flash commander device or can *use* Nikon's other CLS flash commander devices at will. You have great control with this fine camera!

9

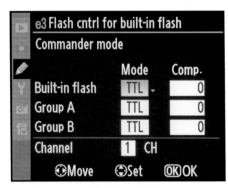

Figure 1 – *Commander mode* setup screen

What is Commander Mode and How Does it Work?

Commander mode is controlled from a screen on a menu of your D300. It looks like the screen in *Figure 1*.

If you examine this *Commander mode* screen, you will see that you have controls for the built-in flash, and two groups, or banks, for external flash units. You'll also see that you can set exposure compensation for either of these.

If you leave *Custom Setting e4 – Modeling Flash* set to the factory default setting of ON, you can test fire your Speedlight's built-in modeling light by pressing and holding the D300's *depth-of-field preview* button. Or, if you prefer, simply take a picture and look at it.

If the main light is too bright, you can either move it farther away, or dial its power down by setting compensation (*Comp*) to underexpose a little. You can set *Comp* in 1/3 stop increments, so you have very fine control of each group's flash output. The point is that you have control to experiment until you get the image just the way you want it. Sure, you could do things the old way, use a flash meter, or get your calculator and figure out complex fill ratios. Or, you can simply use CLS to vary your settings visually until the image is just right.

Isn't it more fun to simply put some initial settings in your *Commander mode* screen and then take a test shot? If it doesn't look right, change the settings and do it again. Within two or three tries you'll probably get it right, and will have learned something about the performance of your CLS system. In a short time you'll have a feel for how to set the camera and flash units, and will use your flash/camera combo with authority *(Figure 1A)*.

Using the Nikon D300 in Commander Mode

Gather up your Nikon D300, its User's Manual, and your external flash units with their manuals. Keep them close by since we will refer to the

Figure 1A – This sample CLS photo by J. Ramon Palacios required one SU-800 as the commander device, coordinating with two SB-800 Speedlights.

camera and flash unit menus and manuals for additional details.

Let's start by putting our Nikon D300 camera into *Commander mode*. We'll do that by changing *Custom Setting e3* to *Commander mode*. Look at *Figure 2* for the screen series to set this option.

Normally, *Custom Setting e3* defaults to TTL as shown in screen 2 of Figure 2. TTL represents the single-flash i-TTL technology used by your built-in Speedlight, or by any i-TTL compatible flash unit you put in your Nikon D300's hotshoe. Since this chapter is about controlling multiple flash units, we'll have to change that setting to *Commander mode* as shown in screen 3 of Figure 2.

Let's discuss the settings. First we'll look at the *Commander mode* in TTL, which is the easiest to use, since it allows you to set exposure compensation for the built-in flash as well as for each of your flash groups. Next, we'll look at M mode, since that gives you fiddly control of

your flash from full-power to 1/128 power. We'll briefly look at *AA* mode. Then finally, we'll consider the "--" mode, which prevents the D300 built-in flash from firing its main flash output,

User Manuals Reference Pages

- Look on pages 291-295 of your D300 User's Manual for detailed information on *Commander mode*.

- In the Nikon SB-800 manual, "wireless" information is found on pages 74-83.

- For the SB-600, look on manual pages 52-65.

- On page 294 of the D300 User's Manual, you will find a chart of settings that complement the *Commander mode* screen.

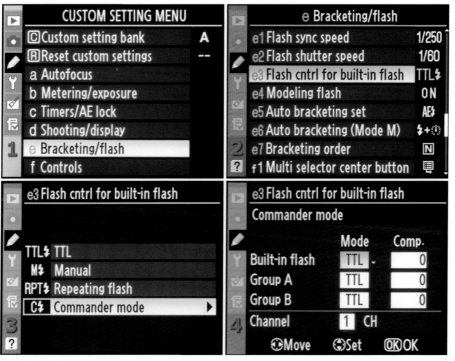

Figure 2 – *Commander mode* screens

Monitor Pre-Flashes

What are "monitor pre-flashes?" Here is a short tutorial. When you press the shutter release button with the flash open, the D300's built-in Speedlight fires several brief pre-flashes, then fires the main flash (unless the *Commander mode* screen has been set to put the built-in flash into "---" mode). These pre-flashes fire any time the built-in flash is open and your camera is set to i-TTL mode, even if your D300 is controlling multiple flash units. The camera can determine a very accurate exposure by pre-flashing your subject, adjusting the exposure, and then firing the main flash burst.

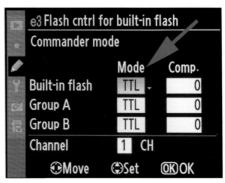

Figure 3 – Selecting the *Mode* option in the *Commander mode* screen

but does not stop the necessary monitor pre-flashes, nor the firing of the external flash units.

When your D300 is controlling external Speedlights, you must *always* raise the built-in flash on your D300. The D300 communicates with the external flash units during the monitor pre-flash cycle.

Speedlight Tip

Position the sensor windows on the external Speedlights where they will pick up the monitor pre-flashes from the built-in flash. Take particular care when not using a tripod.

Nikon D300 Commander Mode Settings

Basically, the *Commander mode* screen's *Mode* fields will display the selections listed below. Use the Multi Selector to change the values, as shown in *Figure 3*.

Mode Settings:

1. *TTL* or i-TTL mode
2. *AA* or Auto Aperture Mode
3. *M* or Manual Mode
4. "--" or Double-Dash Mode (what else would one call it?)

TTL Mode – The TTL setting represents using the full power of i-TTL technology. By leaving *Mode* set to *TTL* (as shown in *Figure 3*) on each of the Built-in or Groups A or B, you derive maximum flexibility and accuracy from all your flash units. In this mode, the *Comp* setting (*Figure 3*) will display exposure values from -3.0 EV to + 3.0 EV, a full 6-stop range of exposure compensation for each group of Speedlights. You can set the *Comp* in 1/3 EV steps for very fine control.

AA Mode – I am only briefly touching on the *AA* mode, since that is an older non-i-TTL technology included for those accustomed to using the older technology. With the SB-800, it is used primarily by cameras not compatible with the Creative Lighting System. It is not available for the built-in Speedlight on the D300, nor for the SB-600. You can safely ignore the *AA* mode, unless you want to experiment with it. It may not provide as accurate a flash exposure as *TTL* mode though, since it is not based on the amazing i-TTL technology. Otherwise, it works pretty much the same as *TTL* mode.

M Mode – This allows you to set different levels of flash output in 1/3 stops for the built-in flash or the Speedlights in groups A or B. The settings you can put in the *Comp* field are between 1/1 (full) and 1/128. The intermediate 1/3 stop settings are presented as decimals within the fractions. For example, 1/1.3 or 1/1.7 are 1/3 and 2/3 stops below 1/1 (full). Many people are

Effects of Pre-Flashes on Lighting

Since the built-in's monitor pre-flashes always fire, be careful that they do not influence the lighting of your image. Use a smaller aperture, or move the camera farther away from your subject if the pre-flashes add unwanted light.

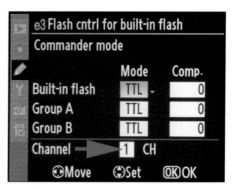

Figure 4 – *Channel* selection screen in *Commander mode*

used to working with flash units this way, so it seems more familiar. CLS is willing to oblige those experienced in working manually.

 -- Mode (Double-Dash Mode) – The built-in Speedlight will not fire its main flash in this mode. It will fire the monitor pre-flashes, since it uses them to determine exposure and communicate with the external flash groups. Be sure you always raise the D300's built-in flash in any of the *Commander mode* modes, otherwise the external flash groups will not receive a signal and won't fire their flashes.

When setting the *Mode* for Group A or B to *Double-Dash* "--" mode, that entire group will not fire any flash output. You can use this mode to temporarily turn off one of the flash groups for testing purposes.

Setting the Channel (CH) for Communication

Look at *Figure 4*, or your D300's *Commander mode* screen, and you'll notice that just below Group B you'll see a Channel 1 CH selection. The number "1" (factory default) is the communication channel your D300 is expecting to use to talk to the external flash groups.

You can select any number between 1–4. There are four channels available, just in case you happen to be working in the vicinity of another Nikon user who is also using *Commander mode*. By using separate channels you won't interfere with each other.

It is important that you realize that all your external flashes in all the groups must be on the same channel. This involves setting up your

individual flash units to respond on a particular channel. They might be in separate groups, but must be on the same channel.

We'll next examine how to do that for the SB-800 and SB-600 Speedlight units. We'll also look at using the SB-800 and SU-800 as commander devices.

This CLS reference section is quite long, so I have created a mini Table of Contents here. The sections that follow include:

Using the Nikon SB-800 AF Speedlight as a slave unit
The SB-800 flash unit makes an excellent slave unit too, and we'll configure it.

Nikon SB-600 AF Speedlight Slave configuration
The SB-600 is both affordable and a great CLS slave unit. Here are the details.

Using the Nikon SB-800 Speedlight as a commander device
The SB-800 flash unit can work as a master flash; here's how.

Examining the Nikon SU-800 Wireless Speedlight Commander unit
This helps with understanding and configuring the SU-800 Commander.

Using the Nikon SB-800 AF Speedlight as a Slave Unit

Now we'll turn to the setup of the Speedlight units themselves. Most of us have either a Nikon SB-800 or SB-600 with our Nikon D300 camera. If you have both that is even better.

Use the information below to configure each flash unit you have, and try to become familiar with the wireless slave mode entry and exit procedures. Once you learn how to get in and out, you can usually figure the rest out by scrolling through menus on the flash units.

The Nikon SB-800 Speedlight has built-in commander-device functionality, as we discussed above. Setting the Nikon SB-800 as a slave to be used in a group is quite easy.

The difference is in setting the SB-800 to *Remote* mode. When you are in *Remote* mode, the flash is ready to respond to input from an external controller. Here are the steps and LCD Panel views to prepare the SB-800 to be a slave controlled by a commander device.

Setting Remote Mode on the SB-800

Overview of Settings:

1. Turn the flash on with the *ON/OFF* button.
2. Press and hold the *SEL* button in the middle of the Multi Selector for about two seconds (SB-800 manual page 68).
3. Once you enter the next screen, press *SEL* once again and the current mode selection will become highlighted. Use the **Down**- button to scroll down to *Remote* and press *SEL* again to select it.

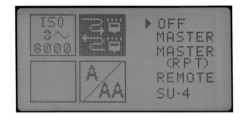

Figure 5 – SB-800 Speedlight controls

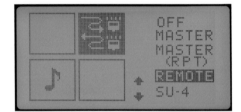

Figure 6

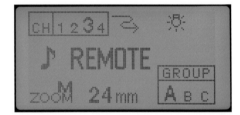

Figure 7

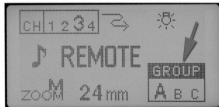

Figure 8

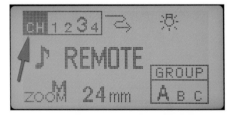

Figure 9

4. Hold *SEL* down for another two-second period, and the LCD Panel will switch to the *Remote* settings screen

5. Press *SEL* once and CH will be highlighted. Now use the Up+ or Down- toggle button to select the channel.

6. Press *SEL* once and *GROUP* will be highlighted. Now use the Up+ or Down- toggle button to select A or B. Don't use C, since the D300 cannot control that group.

Detail of Settings:

In *Figure 5*, you'll find a picture of the SB-800's controls. You'll use the *SEL* button and the Up+ and Down- buttons to configure remote mode.

Turn the SB-800 on, then press and hold the *SEL* button until the screen shown in *Figure 6* appears.

Now we'll set the SB-800 into *Remote* mode using the instructions below:

Press the *SEL* button once more and the current mode will be highlighted. Scroll Down- until *Remote* is highlighted (as shown in *Figure 7*), and press *SEL* to select it. When selected, the highlight will go away and an arrowhead will appear to the left of the word *Remote*.

Figure 8 shows the *Remote* screen, which we'll select by holding down the *SEL* button for about two-seconds.

You can move around this screen by pressing the *SEL* button. As shown in *Figure 9*, move to the *CH* setting on the top left, and select a channel with the Up+ or Down-buttons. Then use *SEL* to move down to the *GROUP* setting on the bottom right. Use the Up+ or Down- buttons to select a group.

You are now ready to shoot pictures with the SB-800 as a *Remote* wireless slave flash. Do a test shot to see if your D300 and the commander device will fire the SB-800 remotely. If not, check to make sure the Channel and Group on the SB-800 are set to the same settings as your camera's *Commander mode* Channel and Group.

How to Exit the Remote Mode on the SB-800 Flash

This drove me nuts for a while, since the manual never really tells you how to exit once you've set your SB-800 to *Remote* mode. Oh, it does tell you that you hold down the *SEL* button for two seconds, or press *ON/OFF* to return to the normal setting mode. However, what it does not tell you is that until you get the SB-800 out of *Remote* mode it will never go back to being a normal flash. Here's how to do it:

1. While in the *Remote* screen listing the channels and groups, hold down the *SEL* button for two seconds and it will switch back to the screen that allows you to select *Master*, *Remote*, or in this case the all-important *OFF* selection.

2. Press *SEL* again, and scroll up to *OFF*, then press *SEL* again to select *OFF*.

3. Hold down the *SEL* button for two seconds again, and it will then switch back to being a normal i-TTL stand-alone flash.

Nikon SB-600 Speedlight Slave Configuration

The Nikon SB-600 Speedlight is designed to be a stand-alone i-TTL flash, or a *Remote* wireless slave flash for the CLS system. It does not have a Master mode like the SB-800 does.

It is a simple but powerful Speedlight flash, and does a great job as a slave for your D300 or a commander device to control. Let's look at the configuration method for the SB-600. It is quite different from the SB-800.

Setting Remote Mode on the SB-600
Overview of Settings:

1. Turn the SB-600 on with the *ON/OFF* button on back.

2. Hold down the *ZOOM* and Down– buttons for about two seconds.

3. Use the *MODE* button to turn *Remote* mode on.

4. Hold down the *ZOOM* and Down– buttons for about two seconds again, and the flash will switch to the *Remote* screen.

5. You can move around this screen by pressing the *MODE* button.

6. Move to the *CH* setting and select the channel with the Up+ or Down- buttons.

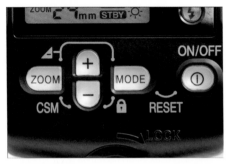

Figure 10 – SB-600 Speedlight Controls

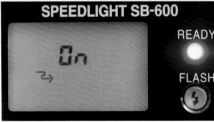

Figure 11 – Enabling *Remote* mode on the SB-600

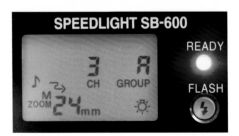

Figure 12 – SB-600 *Remote* mode Setup Screen

7. Press *MODE* again to move to the *GROUP* setting and select the group with the Up+ or Down- buttons.

8. Press the *MODE* button again to finish.

Detailed Settings with LCD Panel images:

Use the controls, as shown in *Figure 10*, to set the flash to *Remote* slave mode, so that your commander device can control it.

Turn the SB-600 on, then press and hold down the *ZOOM* and *Down*–buttons at the same time for about two seconds. It will switch to the screen as seen in *Figure 11*.

Now press the *MODE* button to change *Off* to *On* as shown in *Figure 11*'s right picture. This has enabled the *Remote* wireless slave functionality of the SB-600, but we need to validate the channels and groups settings to be sure they match our commander device's settings.

Hold down the *ZOOM* and Down– buttons again, for a couple of seconds, and the SB-600 will switch to the screen that allows you to set the channel (*CH*) and *GROUP* (*Figure 12*).

Use the *MODE* button to move around this screen (*Figure 12*). Move between the *CH* and *GROUP* settings, while making sure they match your commander device's settings.

Press the *MODE* button until you see the channel (*CH*) number flashing. Now use the Up+ or Down- button to change the channel number.

Press the *MODE* button again until you see the *GROUP* letter flashing. Now use the Up+ or Down- button to change the GROUP letter to A or B.

Press *MODE* again to finish and you are ready to take some pictures.

Do a test shot to see if your D300 will fire the SB-600 remotely. If not, check to make sure the channel and group on the SB-600 are set to the same settings as set in your commander device (D300 in *Commander Mode*, SU-800, or SB-800).

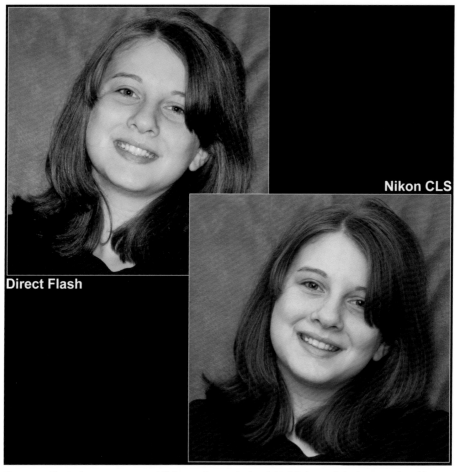

Nikon CLS

Direct Flash

Figure 13– Notice how proper use of CLS can take out the harsh highlights and shadows produced by conventional direct flash

How to Exit the Remote Mode on the SB-600 Flash

It is relatively simple to turn off *Remote* mode on the SB-600. Simply follow these steps and the SB-600 will return to a normal iTTL stand-alone condition:

1. Hold down the *ZOOM* and Down- buttons for about two seconds. The screen will change to the remote *On/Off* screen.
2. Push the *MODE* button once to change *On* to *Off*.

Hold down the *ZOOM* and Down- buttons for about two seconds again and the SB-600 is now back to iTTL standalone mode.

Using the Nikon SB-800 Speedlight as a Commander Device

Nikon refers to commander mode on the SB-800 Speedlight flash unit as the "Commander Function", or Master Flash. We'll use the term "Master mode", for clarity.

When using the SB-800 Speedlight as a commander device controlling one or more other Speedlights, it is important not to allow the SB-800 to fire its main flash, unless you really want to use this flash on the camera as one of the units that light the subject. We'll discuss how to disable the SB-800's main flash as we proceed, if you want to do that.

Another concern is the monitor pre-flash from the SB-800 in Master mode. Even though the SB-800's main flash is turned off, the pre-flash puts out quite a bit of light. If the subject is too close, the pre-flash could make a bright spot, or even influence the exposure in an undesireable way.

The SB-800 Instruction Manual says this is not a problem unless the ISO is set to a high sensitivity, or the subject is very close. The solution offered is to tilt the flash unit up into bounce mode, and/or move the subject farther away from the main flash. (Use a longer lens.)

With this fact in mind let's look at how to configure the SB-800 as a commander device, so that we can use it to control multiple groups of other Speedlight flash units.

Configuring the SB-800 as a Commander Device

To start our configuration process we'll need to get out of normal flash mode and into Master mode.

Setting Master Mode on the SB-800

Let's look at a brief overview of the configuration steps, and then we'll go into more detail. Please get your SB-800 flash unit so that we can apply what we cover below directly to the flash. It's a lot easier to remember this information if applied immediately.

Overview of Settings:

1. Turn the flash on with the *ON/OFF* button.
2. Press and hold the *SEL* button in the middle of the Multi Selector for about two seconds until the LCD Panel switches screens.
3. Once you enter the next screen press *SEL* once again and the currently active mode will become highlighted. Use the Down- button to scroll down to *Master* and press *SEL* again to select it.
4. Hold *SEL* down for another two-second period, and the LCD Panel will switch to the *Master* settings screen.
5. Press *SEL* again and "M TTL 0.0" will be highlighted. This is where we turn off the SB-800's main flash.

6. Press *MODE* three times, or until "M ---" is displayed. This actually disables the main flash to prevent a direct flash look on your subject.
7. Press *SEL* again to scroll down one place to "A TTL 0.0" to configure the first group of flash units (group A).
8. Press the *MODE* button numerous times to scroll through the various flash modes. Stop at the mode you want. (*TTL, AA, M, ---*)
9. Press the Up+ button or Down– button to select the Flash Output Value, which determines exposure compensation.
10. Press the *SEL* button to select group B, which defaults to "B ---" unless configured previously.
11. Press the *MODE* button to select a flash mode, and then the Up+ or Down- buttons to set the Flash Output Value. Repeat 10 & 11 for group C, if needed. (You only need to configure as many groups as you'll need.)
12. Press the *SEL* button multiple times until "CH 1" (or some other number) is selected. Use the Up+ or Down- buttons to select a communications channel (1-4).
13. Configure the slave units, and take your pictures.

Detail of Settings:

To work on any of the following settings you'll have to take these four basic steps first. This switches the SB-800 Speedlight out of its normal flash mode, and into Master mode. *Figure 14* shows the controls you'll use to set your SB-800 to Master mode.

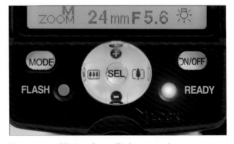

Figure 14 – SB-800 Speedlight controls

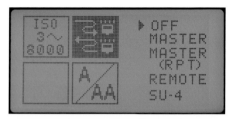
Figure 15

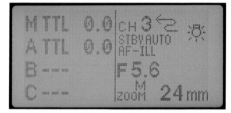
Figure 16

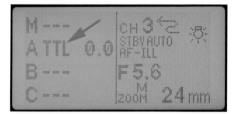
Figure 17

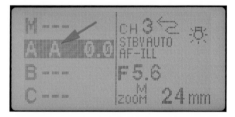
Figure 18

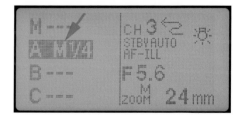
Figure 19

Enter the Master mode steps:

1. Turn the flash on with the *ON/OFF* button.

2. Press and hold the *SEL* button in the middle of the Multi Selector for about two seconds until the LCD Panel switches screens. *Figure 15* shows what you'll now see:

3. Once you enter the next screen, press *SEL* once again and the currently active mode will become highlighted (*Figure 15*). Use the *Down-* toggle button to scroll down to *Master* and press *SEL* again to select it.

4. Hold *SEL* down for another two-second period, and the LCD Panel will switch to the *Master* settings screen (*Figure 16*).

Now we'll need to configure the following modes for the Master Flash (*M*) and all three slave groups A, B, and C.

Flash Modes: The selections you'll find under the flash modes are as follows:

1. **TTL mode**: The image in *Figure 17* shows group A in TTL mode. In Master mode, this is the normal i-TTL automatic mode of the SB-800, and causes the slave units to use i-TTL in measuring the flash output. You can adjust the Flash Output Level of each of the groups of slave Speedlights directly on the SB-800 LCD Panel. See Flash Output Level below.

2. **AA mode:** The image in *Figure 18* shows group A in *AA* mode. This "Auto Aperture" mode is only available if you have a *CPU* lens mounted on your D300. If a non-CPU lens is mounted, the slave units switch to non-TTL auto flash, instead. *AA* mode works similarly to TTL mode.

3. **M Mode:** The image in *Figure 19* shows group A in *M* mode. This is Manual mode, which means you can control the group in fractions of full-power light values. This mode is for those who are used to controlling flash power levels by setting different levels of power, like ½ or ¼ power. Notice how the image shows ¼ power has been set. Look just after the M at the small 1 and large 4. It may look weird but it is functional.

4. **--- Mode:** This is a simple mode. It means the group is disabled and will not fire any slave

units in that group. In *Figure 20*, you'll see that I have set all the groups, including group A, to --- mode. This setup is not very useful since *no* flash unit will fire, but it does illustrate the idea.

Let's see how to configure the flash mode on one of our groups, and disable the SB-800's main flash output. Any information learned in these steps can be applied to any of the groups A, B, C, or even M for the *Master* flash on camera. (M is normally not used, and left at --- mode, but it can be used if you need direct flash in addition to your slave units.)

First use the "**Enter the *Master* mode steps**" listed above. See *Figure 14* for the controls.

Once you are in Master mode, you will see the following screen shown in *Figure 21*.

First, we'll normally disable the M group on top (if it's not already disabled). Press the *SEL* button on your SB-800 until you scroll to the M selection in the top left of the screen. You may only have to press *SEL* once, if you've never been in the Master screen before.

Once M is selected you will need to change it from "M TTL 0.0" to "M ---", as shown in *Figure 22*. Press the *MODE* button numerous times until "M ---" appears. This disables the M or master flash from firing its main flash burst, but not its monitor pre-flash. Remember, the master flash is the one mounted on your camera.

Now we'll configure one of the main groups, such as group A. Repeat these steps for groups B and C, if needed.

Since we are already in the Master Screen, just press the *SEL* button until you've highlighted the A group. Press the *MODE* button until the Flash Mode you desire (as described above) is showing (*TTL, AA, M, or ---*). Notice in *Figure 23* that I have group A set to *TTL* with 0.0 or no flash output compensation. Group B is also set to *TTL*, but it has -1.0 Ev or -1.0 stops of compensation. Group A is main light, and group B is fill light. We'll talk more about adjusting the compensation or flash output level in the next section.

Repeat the steps in the last paragraph until all three groups are set to your desired modes. If you do not need to use any groups besides group A (one group of flash units) simply set B and C to "---" using the *SEL* and *MODE* buttons. Notice in *Figure 24* how I only have group A active, and all the other groups are in --- mode, or disabled.

Often a group might only have one flash unit, and another group might have a different

Figure 20

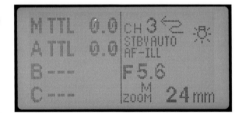
Figure 21

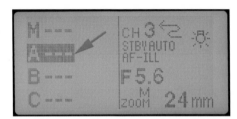
Figure 22

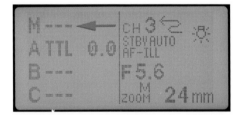
Figure 23

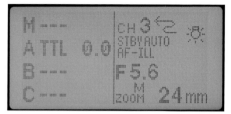

Figure 24

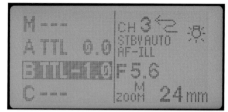

Figure 25

single unit. If you want to control the flash groups individually, so that one group has less or more power output for main or fill purposes, you'll need to configure at least two groups. That allows you to control them on an individual basis.

Flash Output Level: Now we'll configure the flash power output levels for each group.

Let's say you want to set group A as the main flash, and group B as the fill flash. We'll configure groups A and B in that manner as a learning exercise. Later you can experiment with various power levels and group combinations.

You have already set your flash mode (*TTL, AA, M, or ---*) in the previous section, so now you will set the flash output level for this group. Really, you could have set the flash output level just after setting the flash mode, but we separated the events for learning purposes.

To set the flash output level on our main flash group "A", press the *SEL* button until you have highlighted the group you want to modify. Now, press the Up+ button to add Ev (more light), or the Down- button to remove Ev (less light).

If you are using *TTL* or *AA* mode, you will see that you have the following stop values available in a plus or minus direction:

0.0, 0.3, 0.7, 1.0, 1.3, 1.7, 2.0, 2.3, 2.7, 3.0
If you are using M mode instead, you will find the following fractional power setting range is available:

1/1, 1/2, 1/4, 1/8, 1/16, 1/32, 1/64, 1/128
Since group A is our main light source we should leave it set to flash output level "0.0" in *TTL* or *AA* modes and "1/1" in M mode, which means use normal power for the main group.

To configure our fill light source we will set the power output on group B to a somewhat lower value, such as -0.7 in *TTL* or *AA* modes, or -1/2 in *M* mode. Notice in *Figure 25* that I have group A set to *TTL* with 0.0 or no flash output compensation. Group B is also set to *TTL*, but it has -1.0 Ev or -1.0 stops of compensation. This is a good example of using main and fill lights. Group A is the main light with normal power, and group B is a fill, with 1-stop less light output.

You can simply play with the values, shooting test exposures and examining them on the camera's Monitor LCD, or break out a handheld light meter and do it the old-fashioned way. The powerful thing about using Nikon CLS, though, is to control the slave units from your commander device and adjust the exposures on the fly, using the histogram in your camera to judge proper exposure, and using your camera's Monitor LCD to zoom in and view light and shadow. Why go to all the trouble of figuring out complex lighting ratios, when the camera and flash units will do it for you? Of course, you may be the type of person that enjoys doing it yourself. Nikon CLS gives you that choice!

Channel Number: This is a critical setting, since it describes to your commander device what channel to use for communicating with the groups of slave flash units.

Once you've set this value, you'll need to set the slave units to the same channel, or they will just stand there grinning at you and whispering silently among themselves about the nut fiddling with his camera.

I normally leave my channel set to 1, but that's just my preference. Yours may be

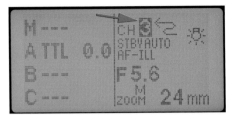

Figure 26

different. The point is to get your commander device and all slaves on the same channel. *Figure 26* shows how to set the channel number.

Referring to *Figure 26*, press the *SEL* button until the cursor moves to the top right of the Master screen, where the number "1" stands between the "CH" and that squiggly looking S-shaped arrow. That digit is the channel number. Once you have the cursor there, simply press the Up+ or Down- buttons to select your favorite channel number. You can select any number from 1 to 4.

Your SB-800 is now fully configured, and ready to control all those pesky little SB's sitting out there on their stands, waiting patiently. Be sure your slave units are segregated by group, and all are assigned the correct channel number. Now go experiment and enjoy your powerful CLS system!

To exit Master mode and return your SB-800 to regular flash unit functionality, simply follow these steps:

1. While in the Master screen with the channels and groups, hold down the *SEL* button for two seconds and it will switch back to the screen that allows you to select *Master*, *Remote*, or in this case the all-important *OFF* selection.
2. Press *SEL* again, and scroll up to *OFF*, then press *SEL* again to select *OFF*.
3. Hold down the *SEL* button for two seconds again, and it will then switch back to being a normal i-TTL stand alone flash.

Examining the Nikon SU-800 Wireless Speedlight Commander Unit

In case you choose to use the more powerful SU-800 Commander unit, instead of the built-in D300 *Commander mode*, I've included some information on it here. *Figure 27* shows a front/back picture of the SU-800 Wireless Speedlight Commander unit.

This small unit is less costly than buying an SB-800 Speedlight. It is considerably lighter and smaller, and has twice the commander-to-slave range: 66 feet compared to 33 feet (20 m versus 10 m).

Most professionals will purchase this unit if they are interested in doing professional flash output, since the SU-800 does not use pre-flash to control the flash units in its groups. It uses infrared instead. This doubles the range, and does not output an unnecessary flash burst that wastes battery power.

The SU-800 uses a small CR-123 type Photo Lithium battery that lasts a long time. This saves considerable weight compared to using alkaline batteries.

What is the Scope of This Section?

Our primary concern in this section is using Commander units to control groups of Speedlights to light up large and small areas. For that reason, we will focus our discussion on commander-mode shooting. I will briefly discuss a couple of other modes that are available with the SU-800, in case you are interested. Below is a brief discussion of two of the SU-800's modes—Close-up and Repeating—and a very detailed discussion of our main concern, Commander mode. I wish that we had room for considering the additional functionality; however, CLS is a very complex subject, and this chapter couldn't begin to cover it all.

Close-up Mode Shooting: If you are a heavy macro shooter you can purchase one of two Nikon kits, which vary in what they contain. The R1C1 Close-up Speedlight Commander Kit, and the R1 Close-up Speedlight Remote Kit (both of

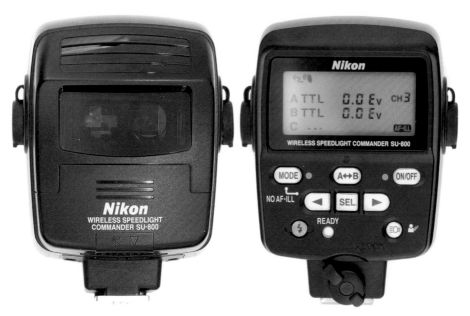

Figure 27 – SU-800 Wireless Speedlight Commander unit

which include two SB-R200 Speedlights), give your D300 complete control of various macro shooting arrangements. The close-up mode is beyond the scope of this chapter, since macro shooting is a highly specialized and less-used functionality.

For macro shooting with the kits and their SB-R200 Speedlights, you'll need to take your SU-800 out of Commander mode by flipping a small switch just inside the battery cover (see *Figure 29*), which puts the SU-800 into Close-up or macro mode, but allows the SU-800 to continue to function as a commander device for the SB-R200 units.

Repeating Mode Shooting: There is another mode in your SU-800 that is enabled by turning the unit on, then holding down the *SEL* button for several seconds. This is called *RPT* or repeating flash mode. It allows you to cause your Speedlight flash units to pulse their flashes in various output levels and frequencies. You can set the SU-800 unit to cause the Speedlights to output anything between 1/8th power and 1/128th power, flashing or pulsing from 1 to 100 times per second, resulting in repeating the

flashes from 1 to 90 times for each image. The SB-800 Speedlight, in Manual mode, also provides this stroboscopic flash. I have no idea what this type of flash photography is used for, but if you need it, it's there. In any case, it is beyond the scope of this chapter.

Commander Mode Shooting: Since we're concerned with using the SU-800 as a camera-attached commander device, let's consider its configuration and use in detail.

The primary purpose of the SU-800 Commander unit is to be used as a controller for groups of Speedlights, supporting up to three groups (A, B, C) and up to four communication channels (1, 2, 3, 4). You can set up "groups" of an "unlimited number" of Speedlights to light up large areas, like a factory, or just a few for product shots or portraits. The SU-800 is limited to firing Speedlights located up to 66 feet (20.1 meters) away.

When you plug an SU-800 unit into the hot-shoe of your D300, you can rest assured that it becomes the Speedlight "boss".

The SU-800 is designed to let you control individual groups right from the back of the

| Commander Mode | Close-up Mode | Repeating Flash Mode |

Figure 28

unit. You don't have to walk to each Speedlight and set light values, or use a light meter. Instead, you simply take a picture, zoom in and look at it on the Monitor LCD of your camera, then adjust the power of individual groups from the SU-800 until you have just the light balance you want. Very convenient!

Configuring the SU-800 Wireless Commander Unit

Turn your SU-800 unit on and verify that the LCD Panel looks similar to the Commander mode image in screen 1 of *Figure 28*, and shows groups A, B, C. If not, your unit is probably in close-up mode (screen 2), or repeating flash (RPT) mode (screen 3).

The reason I mention this is that my SU-800 came from the factory switched to close-up mode, and I was quite confused trying to figure out why my screens didn't work like the commander mode on my SB-800 Speedlight and Nikon D300. Later, in the manual, I found out about the little hidden Close-up/Commander switch, and set it to the correct mode.

If your SU-800 is in close-up mode (as shown in screen 2 of *Figure 28*), be sure to open the battery compartment and flip the switch to Commander mode. See *Figure 29* for the location of the switch.

Open the battery door on the front lower side of the SU-800, and find the switch on the left. Flip it toward the bottom of the Commander

Figure 29 – *Close-up & Commander mode* switch

unit, away from the "Close-up" flower symbol. The symbol you want looks like a small SU-800 Commander unit blasting a wave of light.

To get out of repeating flash mode, simply hold down the *SEL* button until the screen looks like the Commander mode screen in *Figure 28*.

Now that the unit is configured for Commander mode, let's configure it as if we had two groups of Speedlights. We'll use groups A and B, and channel 3. Get your SU-800 so that you can follow the instructions below with an actual unit, which makes it much easier to understand and remember.

We'll need to consider setting the following items at least once before using the SU-800 as a controller.

Overview of Settings:
1. **Flash Mode**
 - *TTL*
 - *AA* (with SB-800 slaves and CPU lenses only)
 - *M*
 - --- (This means No Flash for this group; disables the group)
2. **Group Name**
 - A, B, C
3. **Flash Output Level**
 - Varies according to flash mode above (see detail below)
4. **Channel Number**
 - 1, 2, 3, 4

Detail of Settings:
Flash Mode: We'll set the A group initially. Press the *SEL* button on the back of the SU-800 until the group's row starts blinking. Now press the *MODE* button repeatedly to scroll through the various flash modes. Once selected, wait a second or two until the group stops blinking, or immediately press the arrow buttons, < left or right >, to set the compensation value. If you wait too long, you'll have to press the *SEL* button again to use the arrow buttons. Press the *SEL* button to tab between the groups and repeat for groups B and C.

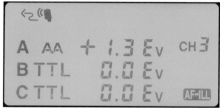

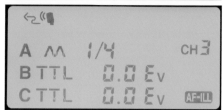

Figure 30

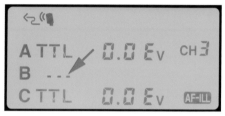

Figure 31

Look at the top screen in *Figure 30*. See how the A group is now set to *AA* mode, and the compensation is set to +1.3 Ev? Now look at the bottom screen in *Figure 30*, and notice how the A group is now set to M mode, and ¼ of full power output. Groups B and C are still at the default of *TTL* with no compensation set, in both screens.

Group Name: This is where you'll set the number of groups you want to use in this session. Select the triple-dash "---" mode for any groups you do not want to use. If there are any Speedlights on that group, they will no longer fire. See, in *Figure 31*, how A and C have *TTL* mode selected and 0.0 Ev compensation values, while B is set to "---" mode, and is now disabled.

Flash Output Level: This varies according to which flash mode you have selected. Look at *Figure 32* as we work through the various output levels.

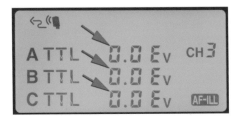

Figure 32

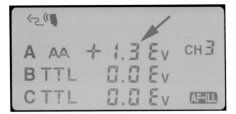

Figure 33

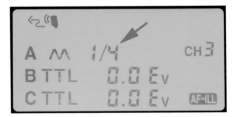

Figure 34

TTL Mode: You can set the following compensation levels using the *SEL* and < arrow > buttons. These go in a +Ev direction with the right > arrow button, and a –Ev direction with the left < arrow button. "+" means more light, "-" means less light. So +1.3 Ev means you are adding one and a third stops of light to that group (1.3 stops). Here are the available Ev steps <-/+>:

0.0, 0.3, 0.7, 1.0, 1.3, 1.7, 2.0, 2.3, 2.7, 3.0
Look at the screen in *Figure 32*. See how the compensation (or, flash output level) is set to +0.0 Ev on all three groups? This means that the flash will use whatever output it needs to make a proper exposure. There is no compensation applied, so a normal flash output level is being used. Notice there is no + or – sign between *TTL* and 0.0!

AA Mode: If you are using SB-800 Speedlights and CPU lenses you can use this mode to set the following compensation levels using the *SEL* and < arrow > buttons. Like *TTL* above, these go in a +Ev direction with the right > arrow button, and a –Ev direction with the left < arrow button:

0.0, 0.3, 0.7, 1.0, 1.3, 1.7, 2.0, 2.3, 2.7, 3.0
In *Figure 33*, notice the plus "+" sign is between the *AA* and 1.3 Ev, which means this is a +Ev operation and that 1.3 stops more light are being applied.

M Mode: This works similarly to *TTL* and *AA* above. You'll use the *SEL* and < right- and > left-arrow buttons to select the group and set the compensation level. This is a manual mode, which means you can control the group in fractions of full-power light values. For instance, the default is 1/1, which means full power output, while ½ means one-half of full-power output for the whole group. If you use either the < left or right > arrow buttons you can scroll through the following power values:

1/1, 1/2, 1/4, 1/8, 1/16, 1/32, 1/64, 1/128
Notice in *Figure 34* how the flash output level is set to ¼ of full-power output.

I think they left this mode in our CLS system since so many people have used this very method to control various flash units for so many years. It is second nature to some, especially those who like to use a handheld flash meter to critically control light values on the subject. The cool thing is that your Speedlights will obey you from the SU-800 unit without having to go to each flash unit and set up 1/2 or 1/4 flash power.

---: (triple-dash) This is the simplest of all settings. It means "do nothing!" Any groups you set to this value do not fire their flash output at all. With this setting, you could use all three groups at once, then select any two, or just one. You can vary your flash output for testing or creative purposes. This acts like a light switch for an entire group of Speedlights: On or off!

Channel Number: This is pretty simple, since you only have four choices. Press the *SEL* button until the *CH* number starts blinking. Only the number will blink. Use the arrow

Figure 35

buttons to scroll through the four available channels. Your selections are:

CH 1, CH 2, CH 3, CH 4

Each of these numbers represents a communications channel. You can only use one communications channel per session. This is a very similar idea to the channels on the portable phones we carry around the house. I suppose one could use a different channel if there were several people using CLS in the same area. It certainly would be aggravating if every time your neighbor pressed his shutter release, all your groups of Speedlights fired too.

Notice in *Figure 35* how I normally leave my SU-800 set to Channel 3, and have my flash units programmed to receive commands on that channel too. You choose your favorite channel, and make sure that your SU-800 and Speedlights are on the same one.

Invariably, if one of my Speedlights is not firing, I find that it is no longer on its assigned channel for some reason. Once you have found the channel number you want to use, you'll need to program that number into your external Speedlights.

Using the SU-800 Commander Unit

At this point, you should understand how to configure your SU-800. It is not all that hard, and all this instruction becomes unnecessary after you've done it a couple of times.

Just be sure that all your Speedlights are on the same communications channel. You can set your Speedlights to groups A, B, or C, according to how you have the SU-800 configured. You can vary the output of any of the groups by Ev stop values in *TTL* and *AA* modes, or by fractions of

full power in *M* mode. You can even turn a group off with "---" mode.

Experiment with this as soon as you can and you'll have a better understanding of the configuration steps.

My Conclusions

Once you've mastered the settings, I suggest you get a good book on lighting techniques and study it well. You'll have to learn how to control shadows and reflections. Plus, you'll have to understand something about lighting ratios so that you can recognize a good image when you see one.

Buy a couple of light stands and some inexpensive white flash umbrellas and set up some portrait sessions of your family, or even some product shots. With the Nikon D300 and even one extra Speedlight, you can create some very impressive images with much less work than ever before.

The really nice thing is that the Nikon Creative Lighting System, executed by your Nikon D300's *Commander mode* or a hotshoe-mounted commander device with external Speedlights, will allow you to shoot without worrying so much about detailed exposure issues. Instead, you can concentrate on creating a great looking image.

Nikonians Gold Membership

Enter the following voucher code to obtain a _50%_ discount for a Nikonians Gold Membership:

~ _G2044_ ~

gold

Nikonians® - Worldwide home for Nikon users
nikonians.org

With over 140,000 members from over 160 nations, Nikonians.org is the largest Internet community for Nikon photographers worldwide.

member

Credits for Chapter Opening Images

Chapter 1
Victor Newman (vfnewman)
CCS Motorcycle Racer
D300 with Nikkor 600mm f/4D ED-IF II AF-S
Lens
ExposureTime: 1/500"
Aperture: F5.0
ISO: 450

Chapter 2
Mark Amy (Mark Amy)
Bruce Lee Statue, Hong Kong
ExposureTime: 0.3"
Aperture: f/2.8
ISO: 200
WhiteBalance: Auto

Chapter 3
Jerric Ramos (jemaerca)
Icicle Drop
NIikon D300
ExposureTime: 1/2000"
Aperture: f/10.0
MeteringMode: Center-weighted average
Flash: No Flash
ISO: 1250

Chapter 4
James "Jay" Miller (jaym)
Outreach
D300
ExposureTime: 1/500"
Aperture: F4.8
ISO: 200

Chapter 5
Jim Hammer (t1up4me)
My Eye on You
D300
ExposureTime: 1/60"
Aperture: F7.1
ISO: 200

Chapter 6
Daniel Stainer (spiritualized67)
White Pocket Wilderness Area - Paria Canyon,
Arizona
D300 on tripod
17-55 f/2.8 lens @ 38mm
F/10 @ 1/125s
ISO 100 (1 EV under 200)
Matrix Metering / Aperture Priority

Chapter 7
Williams J. Claff (bclaff)
Shell Ginger
D300 with Micro-Nikkor 70-180mm f/4.5-5.6D
ED @70mm
two SB-R200s hand-held
ExposureTime: 1/250"
Aperture: F/11.0
ISO: 100

Chapter 8
Alex Rosen (klrbee25)
Eyes on You
D300 with Nikon 70-200VR +TC 17
1/250s @ f/5.6, 270mm
ISO 1000

Chapter 9
Albert Valentino (Valentino)
Snow Monkey
D300 handheld
Nikon 70-200 + 1.4x TC
ISO 560, f/5.6 at 1/350 sec

Index